655.87 BLA

D0507684

WIMBLEDON SCHOOL

WIM

Wimbledon School of Art

5403900030093

YOU'RE BRAND™ CONFIGURATION DOCUMENT

1-2

GENDER
FEMALE — 01
MALE — 02

3-4

DAY OF BIRTH
01 — 31

5-6

YEAR OF BIRTH
00 — 99

7-8

AREA OF BIRTH
AFRICA
ALGERIA — DZ
ANGOLA — AO
BENIN — BJ
BOTSWANA — BW
BURKINA FASO — BF
BURUNDI — BI
CAMEROON — CM
CAPE VERDE — CV
CENTRAL AFRICAN
REPUBLIC — CF
CHAD — TD
COMOROS — KM
CONGO — CG
COTE D'IVOIRE — CI
CONGO, THE DEMOCRATIC
REPUBLIC OF THE — CD
DJIBOUTI — DJ
EGYPT — EG
EQUATORIAL GUINEA — GQ
ERITREA — ER
ETHIOPIA — ET
GABON — GA
GAMBIA — GM
GHANA — GH
GUINEA — GN
GUINEA-BISSAU — GW
KENYA — KE
LESOTHO — LS
LIBERIA — LR
LIBYAN ARAB
JAMAHIRIYA — LY
MADAGASCAR — MG
MALAWI — MW
MALI — ML
MAURITANIA — MR
MAURITIUS — MU
MOROCCO — MA
MOZAMBIQUE — MZ
NAMIBIA — NA
NIGER — NE
NIGERIA — NG
REUNION — RE
RWANDA — RW
SAO TOME
AND PRINCIPE — ST
SENEGAL — SN
SEYCHELLES — SC
SIERRA LEONE — SL
SOMALIA — SO
SOUTH AFRICA — ZA
SUDAN — SD
SWAZILAND — SZ
TANZANIA, UNITED
REPUBLIC OF — TZ
TOGO — TG
TUNISIA — TN
UGANDA — UG
WESTERN SAHARA — EH
ZAMBIA — ZM
ZIMBABWE — ZW

ASIA
AFGHANISTAN — AF
ARMENIA — AM
AZERBAIJAN — AZ
BANGLADESH — BD
BHUTAN — BT
BRITISH INDIAN
OCEAN TERRITORY — IO
BRUNEI — BN
CAMBODIA — KH
CHINA — CN
CYPRUS — CY
EAST TIMOR — TP
GEORGIA — GE
HONG KONG — HK
INDIA — IN
INDONESIA — ID
IRAN, ISLAMIC
REPUBLIC OF — IR
IRAQ — IQ
ISRAEL — IL
JAPAN — JP
JORDAN — JO
KAZAKSTAN — KZ
KOREA, DEMOCRATIC
PEOPLE'S REPUBLIC OF — KP
KOREA, REPUBLIC OF — KR
KUWAIT — KW
KYRGYZSTAN — KG
LAO PEOPLE'S
DEMOCRATIC
REPUBLIC — LA
LEBANON — LB
MACAU — MO
MALAYSIA — MY
MALDIVES — MV
MONGOLIA — MN
MYANMAR — MM
NEPAL — NP
OMAN — OM
PAKISTAN — PK
PALESTINIAN
TERRITORY,
OCCUPIED — PS
PHILIPPINES — PH
QATAR — QA
SAUDI ARABIA — SA
SINGAPORE — SG
SRI LANKA — LK
SYRIAN ARAB
REPUBLIC — SY
TAIWAN, PROVINCE
OF CHINA — TW
TAJIKISTAN — TJ
THAILAND — TH
TURKEY — TR
UNITED ARAB
EMIRATES — AE
UZBEKISTAN — UZ
VIETNAM — VN
YEMEN — YE

AUSTRALASIA
CHRISTMAS ISLAND — CX
COCOS (KEELING)
ISLANDS — CC
COOK ISLANDS — CK
FIJI — FJ
GUAM — GU
HEARD ISLAND AND
MCDONALD ISLANDS — HM
KIRIBATI — KI
MARSHALL ISLANDS — MH
MICRONESIA, FEDERATED STATES
OF — FM
NAURU — NR
NIUE — NU
NEW ZEALAND — NZ
NORFOLK ISLAND — NF
PALAU — PW
PAPUA NEW GUINEA — PG
SAMOA — WS
SOLOMON ISLANDS — SB
TONGA — TO
TUVALU — TV
TOKELAU — TK
VANUATU — VU

ANTARCTICA — AQ

EUROPE
ALBANIA — AL
AUSTRIA — AT
BELARUS — BY
BULGARIA
BELGIUM — BE
BOSNIA — BA
BOUVET ISLAND — BV
BULGARIA — BG
CAYMAN ISLANDS — KY
CROATIA — HR
CZECH REPUBLIC — CZ
DENMARK — DK
ESTONIA — EE
FALKLAND ISLANDS (MALVINAS) —
FK
FAROE ISLANDS — FO
FINLAND — FI
FRANCE — FR
FRENCH POLYNESIA — PF
FRENCH SOUTHERN TERRITORIES
— TF
GERMANY — DE
GIBRALTAR — GI
GREECE — GR
GUADELOUPE — GP
HOLY SEE
(VATICAN CITY STATE) — VA
HUNGARY — HU
ICELAND — IS
IRELAND — IE
ITALY — IT
LATVIA — LV
LIECHTENSTEIN — LI
LITHUANIA — LT
LUXEMBOURG — LU
MACEDONIA, THE FORMER
YUGOSLAV REPUBLIC OF — MK
MALTA — MT
MARTINIQUE — MQ
MAYOTTE — YT
MOLDOVA, REPUBLIC OF — MD
MONACO — MC
MONTSERRAT — MS
NETHERLANDS — NL
NEW CALEDONIA — NC
NORWAY — NO
PITCAIRN — PN
POLAND — PL
PORTUGAL — PT
ROMANIA — RO
RUSSIAN FEDERATION — RU
SAN MARINO — SM
SAINT HELENA — SH
SAINT PIERRE
AND MIQUELON — PM
SLOVAKIA — SK
SLOVENIA — SI
SOUTH GEORGIA
AND THE SOUTH
SANDWICH ISLANDS — GS
SVALBARD AND
JAN MAYEN — SJ
SPAIN — ES
SWEDEN — SE
SWITZERLAND — CH
TURKMENISTAN — TM
TURKS AND CAICOS
ISLANDS — TC
UKRAINE — UA
UNITED KINGDOM — GB
VIRGIN ISLANDS, BRITISH — VG
WALLIS AND FUTUNA — WF

SOUTH AMERICA
ARGENTINA — AR
BOLIVIA — BO
BRAZIL — BR
CHILE — CL
COLOMBIA — CO
ECUADOR — EC
EL SALVADOR — SV
FRENCH GUIANA — GF
GUYANA — GY
PARAGUAY — PY
PERU — PE
SURINAME — SR
URUGUAY — UY
VENEZUELA — VE

NORTH AMERICA
ANTIGUA AND
BARBUDA — AG
ARUBA — AW
BAHAMAS — BS
BARBADOS — BB
BELIZE — BZ
BERMUDA — BM
CANADA — CA
COSTA RICA — CR
CUBA — CU
DOMINICA — DM
DOMINICAN REPUBLIC — DO
GREENLAND — GL
GRENADA — GD
GUATEMALA — GT
HAITI — HT
HONDURAS — HN
JAMAICA — JM
MEXICO — MX
NETHERLANDS
ANTILLES — AN
NICARAGUA — NI
NORTHERN MARIANA
ISLANDS — MP
PANAMA — PA
PUERTO RICO — PR
SAINT KITTS AND NEVIS — KN
SAINT LUCIA — LC
SAINT VINCENT AND
THE GRENADINES — VC
TRINIDAD AND TOBAGO — TT
UNITED STATES — US
UNITED STATES MINOR
OUTLYING ISLANDS — UM
(VIRGIN ISLANDS, U.S)

9-10

SURNAME
A – Z
INCLUDE THE FIRST
TWO LETTERS

11-12

BLOOD GROUP
O+ — 01
O- — 02
A+ — 03
A- — 04
B+ — 05
B- — 06
AB+ — 07
AB- — 08

13-14

FINGERPRINT
RIGHT INDEX FINGER

LOOP — 01
LINES ENTERING ONE SIDE OF THE
FINGER PAD AND LEAVING THE
SAME SIDE.

ARCH — 02
LINES ENTERING ONE SIDE OF THE
FINGER PAD AND LEAVING THE
OPPOSITE SIDE.

WHORL — 03
LINES ENTERING AT THE SIDE OF
THE FINGER PAD AND SPIRALLING
INWARD, ENDING
IN CENTRE.

15-16

LENGTH OF INDEX FINGER
USE SCALE AT BOTTOM
OF DOCUMENT.

17-18

MOST ADMIRED
PUBLIC FIGURE
INCLUDE THE FIRST
LETTER FROM BOTH
THE FIRST NAME AND SURNAME.
(IF UNDER
FIVE YEARS, USE DATE
OF BIRTH).

19-20

SOCIOECONOMIC GROUP
EMPLOYERS AND MANAGERS
IN CENTRAL AND LOCAL
GOVERNMENT, INDUSTRY,
COMMERCE, LARGE ORGANI-
SATIONS. — 01

EMPLOYERS AND MANAGERS
IN INDUSTRY, COMMERCE,
SMALL ESTABLISHMENTS. — 02

PROFESSIONAL WORKERS.
SELF-EMPLOYED. — 03

PROFESSIONAL WORKERS.
EMPLOYEES. — 04

INTERMEDIATE NON-
MANUAL WORKERS. — 05

ANCILLARY WORKERS
AND ARTISTS. — 06

FOREMEN AND
SUPERVISORS.
NON-MANUAL. — 07

JUNIOR NON-MANUAL WORKERS.
— 08

PERSONAL SERVICE WORKERS. —
09

FOREMEN AND
SUPERVISORS
MANUAL. — 10

SKILLED MANUAL
WORKERS. — 11

SEMI-SKILLED MANUAL WORKERS.
— 12

UNSKILLED MANUAL WORKERS. —
13

OWN ACCOUNT
WORKERS, OTHER THAN PROFES-
SIONAL — 14

FARMERS,
EMPLOYERS AND
MANAGERS. — 15

FARMERS,
OWN ACCOUNT. — 16

AGRICULTURAL
WORKERS. — 17

MEMBERS OF
ARMED FORCES. — 18

INADEQUATELY
DESCRIBED AND
NOT STATED
OCCUPATIONS. — 19

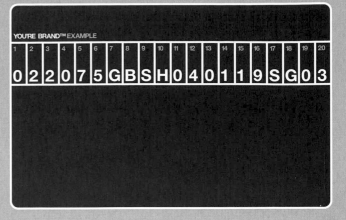

YOU'RE BRAND™ EXAMPLE

1	2	3	4	5	6	7	8	9	10	11	12	13	14	15	16	17	18	19	20
0	2	2	0	7	5	G	B	S	H	0	4	0	1	1	9	S	G	0	3

YOU'RE BRAND™

1	2	3	4	5	6	7	8	9	10	11	12	13	14	15	16	17	18	19	20

WIMBLEDON SCHOOL OF ART LIBRARY

30
29
28
27
26
25
24
23
22
21
20
19
18
17
16
15
14
13
12
11
10
09
08
07
06
05
04
03
02
01

START MEASUREMENT
AT BOTTOM OF DOCUMENT
BY PLACING INDEX FINGER THIS
SIDE AND SECOND FINGER
UNDERNEATH.

THANK YOU FOR CONFIGURING YOU'RE BRAND™.
YOU'LL ALWAYS MAKE THE RIGHT CHOICE WITH YOU'RE BRAND™.
YOU'RE BRAND™
IS ACCEPTED WORLDWIDE
AT MORE LOCATIONS THAN ANY OTHER BRAND. IT'S
SAFE AND SECURE AND OFFERS BENEFITS THAT
ARE SIMPLY NOT AVAILABLE USING CHEQUES OR CASH.

UNSURPASSED GLOBAL
ACCEPTANCE OF YOU'RE BRAND™ GIVES YOU THE CONVENIENCE YOU EXPECT.
IT IS ACCEPTED AT OVER 666.1 MILLION LOCATIONS AROUND THE WORLD, AND GIVES YOU ACCESS TO CASH AT 987,000 BANK AND ATM LOCATIONS WORLDWIDE.

LOOK FOR YOU'RE BRAND™ CASH MACHINES AT HUNDREDS OF AIRPORTS, THOUSANDS OF FINANCIAL INSTITUTIONS, HOTELS, RESORTS, SHOPPING MALLS, TOURIST ATTRACTIONS, AND RECREATIONAL AREAS.

WHAT IS YOU'RE BRAND™ AND WHAT IS IT FOR?
YOU'RE BRAND™ SHOULD
BE CONFIGURED EVERY
12 MONTHS. IT IS UNIQUE
TO YOU AND ENSURES
CORRECTLY RECORDED CREDITS TO YOUR ACCOUNT HOLDER. YOU WILL NEED THESE CREDITS WHEN YOU CLAIM BENEFIT.

YOU'RE BRAND™
IS PERSONAL TO YOU.

IT IS YOUR ACCOUNT NUMBER, ALLOCATED TO YOU FOR YOU TO USE IN ALL YOUR DEALINGS WITH SECURITY.

IT IS PROOF OF YOUR IDENTITY.

SAMPLE: 022075GBSH040119SG03

WHO ELSE USES YOU'RE BRAND™?
YOU'RE BRAND™ WILL
ALSO BE USED BY:

EMPLOYERS, FOR THE DEDUCTION OF TAX
AND YOU'RE BRAND™ CONTRIBUTIONS.

EMPLOYMENT SERVICES,
TO ADMINISTER ALLOWANCE.

LOCAL AUTHORITIES,
TO ADMINISTER BENEFIT.

WHAT SHOULD I DO WITH YOU'RE BRAND™?
YOU SHOULD QUOTE IT ON LETTERS OR FORMS YOU SEND TO THE SECURITY AGENCY.

KEEP YOU'RE BRAND™
SAFE AND DO NOT DISCLOSE IT TO ANYONE WHO DOES NOT NEED IT.

RECONFIGURE YOU'RE BRAND™ AT ONCE IF THERE
IS A CHANGE IN YOUR NAME, ADDRESS OR TITLE SO YOUR ACCOUNT CAN BE KEPT
UP TO DATE. YOU WILL BE CONTACTED IF YOU NEED TO PAY MORE CONTRIBUTIONS
IN A PARTICULAR YEAR TO MAKE THAT YEAR COUNT
FOR PENSION PURPOSES
OR WHEN YOU COME TO
CLAIM BENEFITS.

IF YOU ARE EMPLOYED.

YOU SHOULD TELL
YOUR EMPLOYER YOU'RE BRAND™ AS SOON AS
YOU START WORK.

YOUR EMPLOYER WILL USE YOU'RE BRAND™ TO MAKE SURE THE CONTRIBUTIONS YOU PAY ARE RECORDED
ON YOUR ACCOUNT. THESE CONTRIBUTIONS EARN YOU ENTITLEMENT TO BENEFIT.
IF YOUR EMPLOYER DOES
NOT HAVE YOU'RE BRAND™, THEN THERE COULD BE A DELAY IN ESTABLISHING HOW MUCH
BENEFIT YOU SHOULD RECEIVE WHEN YOU CLAIM.

IF YOU ARE SELF-EMPLOYED.

YOU WILL NEED YOU'RE BRAND™ WHEN YOU APPLY
TO PAY SELF-EMPLOYED CONTRIBUTIONS.

WHEN DO I APPLY FOR YOU'RE BRAND™?
EVERYONE HAS A LEGAL RIGHT TO YOU'RE BRAND™. THERE ARE CIRCUMSTANCES WHERE YOU ARE LEGALLY OBLIGED TO FORMALLY CONFIGURE ONE.

CRITERIA FOR APPLYING
FOR YOU'RE BRAND™.

IF YOU DO NOT ALREADY HAVE YOU'RE BRAND™ YOU MUST CONFIGURE ONE AS SOON AS YOU START WORK OR WHEN YOU OR YOUR PARTNER CLAIMS BENEFIT.

PROVIDING YOU SATISFY
THESE CONDITIONS, YOU SHOULD CONTACT YOUR NEAREST SECURITY
OFFICE AND ASK FOR
AN APPOINTMENT TO
BE INTERVIEWED FOR
YOU'RE BRAND™.

AT THE INTERVIEW YOU
WILL NEED TO BE ABLE
TO PROVE YOUR IDENTITY.

YOU CAN FIND OUT INFORMATION ABOUT THE TYPES OF DOCUMENTS YOU SHOULD PROVIDE TO HELP ESTABLISH YOU'RE BRAND™ FROM ANY SECURITY OFFICE.

WHAT IF I HAVE ALREADY BEEN GIVEN YOU'RE BRAND™ BUT CAN'T REMEMBER WHAT IT IS?
IF YOU THINK YOU ALREADY HAVE YOU'RE BRAND™ BUT CANNOT REMEMBER IT, SEE
IF YOU CAN FIND IT ON ANY OFFICIAL PAPERS YOU MAY HAVE AT HOME.

YOU'RE BRAND™ WILL CHANGE. FOR EXAMPLE
IF YOU MARRY OR CHANGE YOUR NAME, YOU'RE BRAND™ WILL NOT STAY THE SAME.

IF YOU CAN'T FIND YOU'RE BRAND™, ASK AT YOUR NEAREST SECURITY OFFICE AND THEY WILL TELL YOU WHAT TO DO.

WILL I GET YOU'RE BRAND™ AUTOMATICALLY?
YOU'RE BRAND™ IS AUTOMATICALLY
CONFIGURED AT BIRTH.

THE YOU'RE BRAND™ TAG

THE YOU'RE BRAND™ TAG
SHOULD BE CONFIGURED
AT BIRTH OR IF YOU CHANGE YOUR NAME ON MARRIAGE.

IT IS MEANT TO BE A REMINDER OF YOU'RE BRAND™ AND NOTHING ELSE. IT PROVIDES PROOF OF YOUR IDENTITY AND CREDIT AND SHOULD BE USED AS SUCH.

I'VE LOST YOU'RE BRAND™?
IF YOU WANT A REPLACEMENT YOU'RE BRAND™ YOU WILL NEED TO RECONFIGURE THE
YOU'RE BRAND™ TAG.

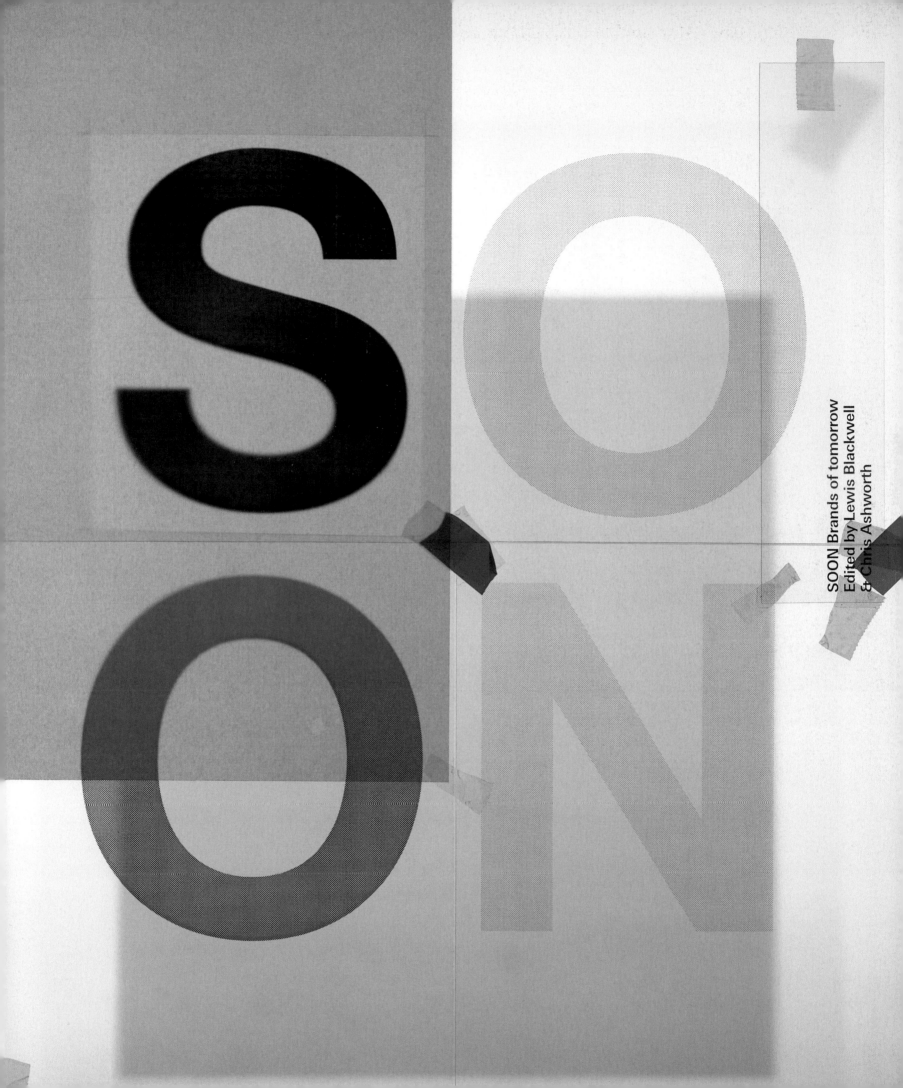

SOON Brands of tomorrow
Edited by Lewis Blackwell
& Chris Ashworth

Published in 2001 in association with Stone by
Laurence King Publishing
71 Great Russell Street
London WC1B 3BP
Tel +44 20 7430 8850
Fax +44 20 7430 8880
email enquiries@laurenceking.co.uk
www.laurenceking.co.uk

e-mail brand@soon.co.uk (feedback)
www.gettyimages.com

First published in the United States in 2001 by
fivedegreesbelowzero Press, L.L.C.
19 Winthrop Place
Maplewood, New Jersey 07040
Tel 973 275 9370
Fax 973 275 9372

Distributed in the United States, Canada, Mexico, Caribbean,
Latin and South America by
HOW DESIGN BOOKS, an imprint of F&W Publications,
1507 Dana Avenue, Cincinnati, Ohio 45207
Tel 800 289 0963 or 513 531 2222
Fax 888 590 4082 or 513 531 7107

Book design and contents © 2001 Getty Images

Introduction text © 2001 Lewis Blackwell

Other text © 2001 Getty Images

Copyright of the artwork reproduced in this book lies with the original artists.

All rights reserved. No part of this publication may be reproduced or
transmitted in any form or by any means, electronic or mechanical, including
photocopy, recording or any information storage and retrieval system,
without permission in writing from the publisher.

A catalogue record for this book is available from the British Library.

UK ISBN 1 85669 246 9
US ISBN 0 9708779 1 9

Printed in Italy

Edited by Lewis Blackwell and Chris Ashworth
Designed by Getty Images Creative Studio – Chris Ashworth,
Cameron Leadbetter, Chris Kelly (Mono), Carl Glover, Nic Hughes,
Robert Kester
Executive Editors: Ruth Eglin, Olivia Silverwood-Cope, Paul Banwell
Editors: Elaine Wale, Phoebe McDonald
Future data from Getty Images Creative Research (GICR)

Stone by Getty Images

Thanks to Daniel Sims for photography of text and graphics
Heat sensitive cover production by Artomatic, London

stone

$\dfrac{0}{-5}$° fivedegreesbelowzero

How to use this book

01 Read the introduction and Research Unlimited
02 Look at the projects
03 Contextualize and aid understanding by using the Background Data
04 Analyse and critique projects
05 Make or break a brand

*Use brand numbers and Research Unlimited numbers to cross reference

Soon: an introduction

Soon is global and local and is completed by you. Reading completes the structure and begins the new breed, the new brand. And soon...

355 West 58th Street and Central Park, 5 August 2001 and...

This is book about wha[t we]
want to become. It is also
about what we fear we might
become. And it is about
how what we fear is often
what we desire.

It tells how Chinese families are moving out from the crushed conditions of Chinatown apartments in Manhattan and are buying smart, green-lawned locations in the suburbs of Westchester County, Long Island and New Jersey. This tale of aspiration and class integration between the WASP and Asian community is made slightly more complex and contradictory by the fact that the real estate being purchased are cemetery plots. While the behaviour can still be seen to signal upward mobility and ethnic and class integration, it is not simply a tale of one culture buying into the other. The commitment of Asian community dollars to smart graves in territories previously dedicated to the parking of rich, white and dead middle-class Americans represents the survival and thriving of Asian values.

According to the report, the American Asian, in particular Chinese, community has immense respect and concern for traditional values that look to build for the life hereafter. This concern has begun to remake the suburban cemeteries chosen for the future dead. There would seem to be no compromise of values in this move, rather it is a case of cultural imperialism, with the Asians in the ascendant. There is an assimilation of content and remaking of America as a nation more fit for people of Asian culture. This in turn could be seen as reflecting decay or at least movement in the American white Protestant culture. If not now, soon there will be cemeteries specifically targeted for the new demand.

From here it is a short step to note that global branding works this way, too. Coca-Cola is changed by what it experiences in its spread. It reflects universal desires in its universality. To be that way, it has to cease to be an American brand and become something that reflects global values. It may be headquartered in Atlanta, Georgia, but its rulers are its consumers around the world as they give in to their desires. One day Coke could seem essentially a Chinese brand if the largest community of consumers were there, influencing the evolution of packaging and the presentation of values.

This introduction moves us towards globalization while inviting customization and suggesting the individual.

This is a book about what we want to become. It is also about what we fear we might become. And it is about how what we fear is often what we desire. The dominant feature of the following pages is the projection of 'future brands' as imagined and depicted by a diverse international pool of influential art directors, designers and writers.

They based their creations on statistics and analyses provided by our researchers and also on their own synthesis of the endless data flow.

Every day, the tide of global and local cultures washes over us and deposits new data and obscures the old. Today, for the mind selecting the characters here, the eye was caught by a headline in the New York Times:

The story is headlined: 'For Chinese, Bliss is Eternity in the Suburbs'.

This is a product that began with a collective intention to propose a range of experiences around certain ideas. It defines itself here as a book but will also exist in other forms – perhaps an exhibition, a store window, a website, among others. There was no precise beginning to the project and the end is not in sight. Without it being in the brief, we ended up with projects that aspire to comment on large themes, reach towards the universal. Our contributors reach out to comment on how we do things now, and what we know we don't do now (which is raw material for conceiving of a future state that is different).

A ...ganism that may yet be a brand

116 Bayham Street, 11 August 2001 and…

No precise beginning

Reach towards the universal

There is two-way traffic in the influence

Washington Athletic Club, 3 August 2001 and...

A declaration of localization.

This is an open book. We want to engage with you in honest exchange. We want to manipulate, massage and provoke you with the lights on. If you connect with any ideas, if you absorb and then reuse or remake anything from these pages, we want you to do it knowingly.

To be open, we must tell you a little about ourselves. If you want more background or one-to-one contact, you can write a letter, email or phone. We would be delighted to connect with readers directly. But as a team, this is who we are:

This book is a product of a group of people and several enterprises. On the publishing side, the investment and direction come from companies who specialize in making and marketing and distributing art, design and related cultural books around the world. On the creative side, where the idea to produce the book began, the leaders of this project spend a significant proportion of their time developing a brand called Stone, which is the co-publisher of the book. This brand does not publish books as its core activity, but shoots photography for advertising and graphic design and related use. (This brand in turn is created by a company called Getty Images, which is a leader in developing and distributing visual language resources around the world – still and motion imagery, typefaces, audio, related services.)

While our publishers need to make a book that will be sought out in sufficient quantity to turn a profit, they are also dedicated to making books of quality, even at the cost of short-term gain (if money was the sole motivation then few would be an art book publisher). The value of the exercise to Stone is more as an interaction with an interesting (as well as interested) reader than the straight counting of sales. This book is 'brand development'. We want you to be a particular kind of person and that is why we created a particular kind of book. We want to change you slightly in the process of reading the book – to think better of us, of course – but by your

support for this book we will continue to change. There is two-way traffic in the influence. Your participation encourages us to continue investing in this kind of activity, even though it is not in itself profitable to us.
We do this as one way in which we get to know you. This might lead to the opportunity for us to do business together (for mutual benefit, we would hope). That is how this book works for some of us. But most of the people who have contributed to this book have

their own agenda, their own value set, possibly intimated by their projects. They are designers, art directors, writers, artists and photographers with motivations that may be in line with the main theme of this book or may be actually quite in conflict. It is for you to assess. But they are all part of Soon, an organism that may yet be a brand.

This information on the mixed motives of participants is base camp for the work. What we really

do after that is to explore our title subject – the future culture of brands – within the boundaries of the corporate and legal and social and personal moral structures that surround us. We seek to make it work for you, and we do this by making it work for several of us. When it intrigues and informs and stimulates us enough, we commit it to print. It is unlikely that anybody involved agrees with all of it.
The book was never fully intended. It is organic and true to itself. You are consuming Soon, we were consumed by it.

following pages lie similarly complex mergers and analyses of information. Some ordinary sources and some bizarre inspirations lie behind the ideas. But always the creation and evolution of the brand thoughts touch many places.

'Real' brands – those that operate out there in the 'real' world – are even more complex to the point at which fully tracking their construction is impossible.

When we look at a brand and the strategies and tactics by which it operates, we are looking at one point in one side of the flow of information that defines the brand. This often how business books aimed at marketing executives view the subject, not unreasonably given that these executives are required to develop strategies and tactics to develop a brand. To some degree this theoretical base, which sets down aspiration rather more than actuality, influences the whole range of brand discourse – the notion of a brand being imposed on consumers like a war plan on 'the people' is a very convenient and seductive one for critics of global capitalism. It can be a highly misleading one.

There could be another way of viewing it, one that takes a similarly narrow view on the other stream of data – the one coming back from the consumers, the people. Here you would depict brands as boats bobbing on the ocean of consumer needs and desires. Sometimes they are the big ships of global brands, or sometimes they are the unstable rafts of fledgling enterprises, but all operate in a universe that is defined by the shifting tides of the consumer mass. Even big ships, the megabrands run by transnational corporations, respond to the changing currents – they have to react to events such as the rise of eco-awareness in Western nations, or the epidemic of AIDS in Africa, or the unstable currencies in South America. They see opportunities and threats, and respond, sometimes harnessing the power of the ocean but never with ultimate control over the forces that move it. In this view the big ships might seem the most powerful way of utilizing the oceans, but they are also likely to be the least agile.

A small local operation can always profit most rapidly from a local opportunity… putting out the rowboat and catching that shoal when the conditions are right. An individual can respond even more immediately – choosing to produce rather than consume, perhaps. Individuals can and do opt out and catch their own fish, make or deliver their own products and services.

Neither way of viewing it – either from the strategic intent of the brand owners, or from the position of consumer power – captures the whole picture. Brands exist not as specific objects or experiences or as anything finite. From the point of view of a marketing strategist, the brand exists as sets of values that drive a promise to the consumer. How it is realized there is a different part of the story. From the consumer perspective, brands are part of the four-dimensional reality. The aluminum can flattened on the road, the battered hoarding above the 24-hour convenience store – these are the reality of many a brand projection, as much as the control exerted over the initial fabrication of the packaging or the signage. The $1 million television commercial is seen in a context of the programming experience around it. Perception of a full-page magazine advertisement is literally coloured by something as simple and unpredictable as the palette used on the facing page of editorial.

notion of a brand being imposed on consumers like a war plan on 'the people' is a convenient and seductive one for critics of global capitalism

Touch many places

brands exist as multi-point virtual organisms

An illustration of the unending factors of influence.

Beware of the romance of this locality. Beware of the romance of all localities. The myth makes the place as much as the observation. Memory builds meaning. But here or there is a pile of books, grabbed web pages, file of tearsheets from newspapers and magazines, handwritten notes. These are resources for this book. They are piled or strewn around a white chair in a white room. There are handmade terracotta tiles on the floor and a small scorpion crawling up the wall.

The spines read:

Cross-Cultural Consumption, edited by David Howes, Routledge
David A. Aaker, Erich Joachimsthaler, Brand Leadership, Free Press
No Logo, Naomi Klein, Knopf Canada

There are many more books, but they are turned the wrong way around or else are out of focus. They drop back into the ceaseless data flow, from whence come the titles above and the tearsheets from the Herald Tribune, or the earlier tale of Asian cemetery investment as documented in the New York Times. Lifetimes of data before, and even some a little after this moment, feed into this introduction, while much more besides feeds into your reading.

From all this and much more came the thoughts on the brand futures in these introductory pages. Behind each and every project in the

Cammattole, a largely deserted and derelict village that appears on few maps, 22 July 2001 and…

Flight UA 12, 5 August 2001 and...

The $1 million television commercial is seen in a context of the programming experience around it. Perception of a full-page magazine advertisement is literally coloured by something as simple and unpredictable as the palette used on the facing page of editorial.

Complex

Complex.

Memory builds meaning.

How brands are built, part 19333023452788841.

The movie Miss Congeniality is playing as the in-flight entertainment. Sandra Bullock stars as an FBI agent who transforms from tomboy to dreamgirl thanks to a job as undercover cop at a beauty pageant. Early in the film, she expresses the brand preference of her entire office by barging through a queue at a Starbucks coffee shop to place a large and complex order. The product placement sits atop the experience of United Airlines service of Starbucks-endorsed coffee that tastes remarkably different from a skinny latte with extra shot consumed at the airport stall earlier.

We carried out an on-the-spot brand rating using the focus group of a single consumer closely observed by the writer.

Product placement 8
Overall movie 3
In-flight brew coffee 1
Airport latte 7

On the basis of the above experiences, the consumer expressed no desire to change from brand and coffee outlets of choice, Torrefazione in Fremont, Seattle, and Bean'n'Cup in Camden, London.

It exists by the matrix of thought in all those it touches

attached to the products and services they use. Large technology companies provide cases worth studying. Having in some instances become effective or near monopolies by controlling largely fortuitous technological advantages, they move to massive investment in desperately building brand values in the mind of the consumer when they see that their 'first mover' advantage is disappearing. This is in order to achieve real customer loyalty, when they realize they will no longer be able to effectively force customers to use their products. Only with loyalty built around shared values encapsulated in the brands can a business be strong against legislative and competitor attacks. Having a monopoly is not enough if the people hate you, as many a dictator has found out in the long run.

to be identifiable, but also to belong. Brands are a way of joining, and they also offer a route through individual and social hierarchies. As a point of assurance, reassurance and belonging. Brands solve problems for people; they help them find the things they need and desire. In part this activity takes place by people signalling who they are to the brands so that the brands come to them.

You may prefer religion, or science, to sports, or other sources of value sets, typically lives are made up of a mix of all as the touchstones by which we guide ourselves around the home, the workplace, our social lives, the supermarket. In a society unmarked by the intrusion of brand in place of the older economic objects that offer symbolic and practical information on products and services. For example, water is an immensely powerful 'product' and 'service' of the environment. Water is a reality and a promise. The major soft drinks companies are in competition with as they seek to expand the market for products. That could seem a questionable activity 'privatising' the supply of an essential need, but if you are faced with a choice between assured drinking quality and a chance of disease you may see the point. The soft drinks brands take the opportunity afforded by the lack of commitment making water competitive in some environments, along with the limited flavour appeal of water. This is a similar opportunity that taken by the 700-plus brands of bottled waters worldwide, but different values are involved when you are selling purity and nature rather than safe, enjoyable refreshment. You pay your money, you make your choice. It is a proven structure that enables consumers and producers to drive each other. If the idea of controlling an essential and politically sensitive resource like water through branding seems extreme, note that it applies to every other essential resource. How long before air is similarly controlled? We have many basic needs that are consistently and popularly met by brands, from breakfast to contra-ception... what we don't have are

successful measures for making sufficient supply available at the right price.

Of global access to free drinking water would be desirable, but that is not the question facing us. Look at the future of brands. Our brand projections, in which commoditize and then give brand values to everything from oceans to snow to air to individuals, assume that people will continue to behave as they do in their basic functioning and motivation. We also assume that nobody is going to come up with a radical new economic model that replaces global capitalism. That would seem to be the direction of things. As we continue to vote ourselves tax breaks and support governments that boost business over environmental controls, we dig our plot. Those inclined to carry a banner, wave a logo, politics risk sounding like the contestants in Miss Congeniality's pageant, who declare 'world peace' but compete to be Miss United States. To protest against global brands is to protest against the manifestation of human desire as represented through the only surviving successful version of a global economic system. We might put aside our protestations against brands, an illusory bad guy to hide the horror beneath. What we are often arguing for is a new improved model of global economics, or for individual behaviour to break free of base desires or for these to be better controlled. To blame branding is to shoot the messenger.

Brands simply and with complexity represent the matrix of values held by the consumers and by the producers. People vote the brands, and the producers, in or out every day. The underlying businesses that run brands operate in an economic system that requires them to strive to get ever larger and seek mono-polistic control. This is often an impossible goal and is therefore very rarely reached, and when it does it operates against the survival of the brand. Once there is no effective choice, there is no longer a purchase based on expression of preference around values. This tends to cause a backlash of consumers who prefer to have value

But the living brand survives as the virtual organism that lives within its community of users

Brands are able to change form, change all dimensions, but remain the same essence.

The advantage of commodities over nature.

The challenge for brands is to be compelling for the consumer in the actual experience. That can be achieved both by understanding the consumer, and by understanding how to change the consumer to fit the brand. This manipulation is not necessarily undesirable to the consumer, the individual. The individual does not tend to want to be uniquely individual. They want

75 Varick Street, 8 August 2001 and...

Consumers are always producers, too

Brands offer a way of belonging, and they also offer a route through individual and social chaos to having a point of assurance, reassurance and belonging. Brands solve problems for people. They help them find the things they need and desire.

The existence of any brand is an act of faith

Consumers are always producers.

The existence of any brand is an act of faith, and an act of constant reading and making. It involves us in collectively constructing belief around a unique but invisible set of values that takes physical and/or experiential form. These values can transform themselves; being manifest through a different product or experience, rather like characters in religion, myth or science fiction. Brands are able to change form, change all dimensions, but remain the same essence.

While powerful brands usually require vision and leadership, for which you can read ownership, this is not how the brand lives and thrives. It exists by the matrix of thought in all those it touches. There are many dead brands that have physical representation through objects, or by residual activities. But the living brand survives as the virtual organism that lives within its community of users and makers.

This gets us to the realization that brands ultimately cannot be separated along consumer and producer lines. The 'consumer' of a product or service is actually a producer of the information that drives the existence of the brand. And the maker of the brand does this because they are 'consumers' of the information about how the brand exists in the world.

This is an exploration of brand as a divining tool for social meaning. Our work documents some of the limitless future brands that are out there waiting for us to produce and consume.

It is no coincidence that so many of our contributors have drawn on the discussion around DNA. Brands are at the centre of the procreative activity of industry. They are where the code lives, so complex as to be almost unfathomable. But we try.

Flight BA 17, 10 August 2001 and...

The challenge for brands is to be compelling for the consumer in the actual experience.

To protect against global brands is to protect against the manifestation of human desire

BLESS™

RICA©

PLEASURE...
ON THREE
FLOORS.

I felt pretty smug as I made my way towards POP. After all, this was no drooling punter, 'adjusting' himself in anticipation of the carnal delights ahead. No, I was here as a serious journalist, commissioned to give a cool, dispassionate review of London's latest - and largest - sex emporium. (In fact, it is just one branch of a rapidly-expanding, global, sexual colossus.) No furtive self-consciousness for me; I was here for all the 'right' reasons. I expected to be surprised and, although no prude, maybe a little shocked. And I was, although not in the way I imagined...

Of course, 'sex' hasn't been a dirty word here for several years now. The recent legalisation of prostitution and, before that, hardcore pornography brought the UK in line with the rest of world. The Brits are loosening up; commercial sex is no longer part of some seedy, exploitative underworld. Nevertheless, the age-old image of the 'dirty-raincoat' brigade lingers on, at least for some. Go to POP then, to see the true picture. Clean, healthy, hedonistic fun, spread over three large storeys, is the order of the day.

The first thing you notice as you enter POP is how bright and airy it is. Not over-bearingly so: subtlety is the watchword. The lighting is neither too glaring nor too dim. And there are pleasing aromas and uplifting sounds to tickle the senses: essential oils and exotic incense are just discernible, music audible but not intrusive. Still, it is the clientele that will be most surprising to those stuck in a 1990s mindset. Not 'dirty old men' but young couples, single women and well-dressed, good-looking lads, all without a trace of embarrassment. Far from it.

The ground floor is taken up by what you might call consumer goods. Everything that might enhance your sex life is here. From beautifully luxurious beds, futons

and chaises longue to erotic books, magazines and DVDs. And there is plenty in between. I found the source of the evocative smells, a section selling aromatherapy products, massage oils, edible body paints and such like. Elsewhere, I found lingerie and other fantasy clothing, a made-to-measure service if you choose; nearby, there was an array of sex toys tastefully packaged and displayed, including vibrators, dolls and various masturbatory aids that boggled the mind. With safe sex always in mind, there are condoms everywhere - every shape, size, colour and flavour you could possibly desire. And if you still need help getting in the mood, go to the POP medicine counter. Here there are potions and lotions to harden, soften, expand, contract…well, you get the idea.

Before venturing up the central escalator to the first floor, I thought I should sample the small café-bar, nestled near the adult literature. A very reasonably-priced almond tea refreshed my somewhat over-whelmed senses and quieted my racing mind. I watched couples flicking through explicit magazines together, still rather amazed that this was Britain and not Amsterdam or Los Angeles. But, duty calls: time to go upstairs…

The Aphrodisia restaurant and bar serves a selection of sensual delicacies - not all of them available at your table. POP has managed to poach renowned Michelin-starred chef Philippe Weill, who has created a wonderful fusion menu, employing a variety of aphrodisiac ingredients. After sampling the fare, it is quite clear that POP is worth visiting for the restaurant alone. But as I hinted above, food is not all that's on the menu. The men and women who seem suspiciously attractive and curiously at home there are available to fulfil other physical cravings. A corridor near the bar leads to a number of theme fantasy rooms, available to hire by the hour. Bring your partner or find one here, then indulge in an office romance, an encounter in the dentist's chair, lust in

the library or anything else that takes your fancy. As well as the staple regulars, give POP enough warning and they say they can arrange almost whatever fantasy environment you want. Don't ask me how I know but this is great value for money.

By this time I'm no longer smug, simply well-satisfied. I venture to the third floor where the surroundings are rather more sumptuous and the prices significantly higher. The rooms are luxury suites, available by the day or week. As are the men and women waiting to share said suites with you. I spoke to Nathan, a 25-year old publishing manager, who had spent two days with Alessandra, a 21-year-old Russian employee. 'This has been the most incredible couple of days', he told me. 'It's cost me but it was worth every Euro.'

Leaving POP, I caught sight of my reflection in a shop window and suddenly understood their advertising campaign, featuring a series of enigmatically contented faces. POP is so infectiously enthusiastic, yet so sensual and sensitive, about its subject, one can't help but leave with a smile. Well-planned and well-executed, POP puts sex back where it always should have been: an essential part of everyday life. There's far more to POP than I've covered here; hey, I don't want to ruin the surprise. Check it out for yourself. Just make sure you leave the dirty raincoat – and your inhibitions – at home.

Review by Jonathan Mackness

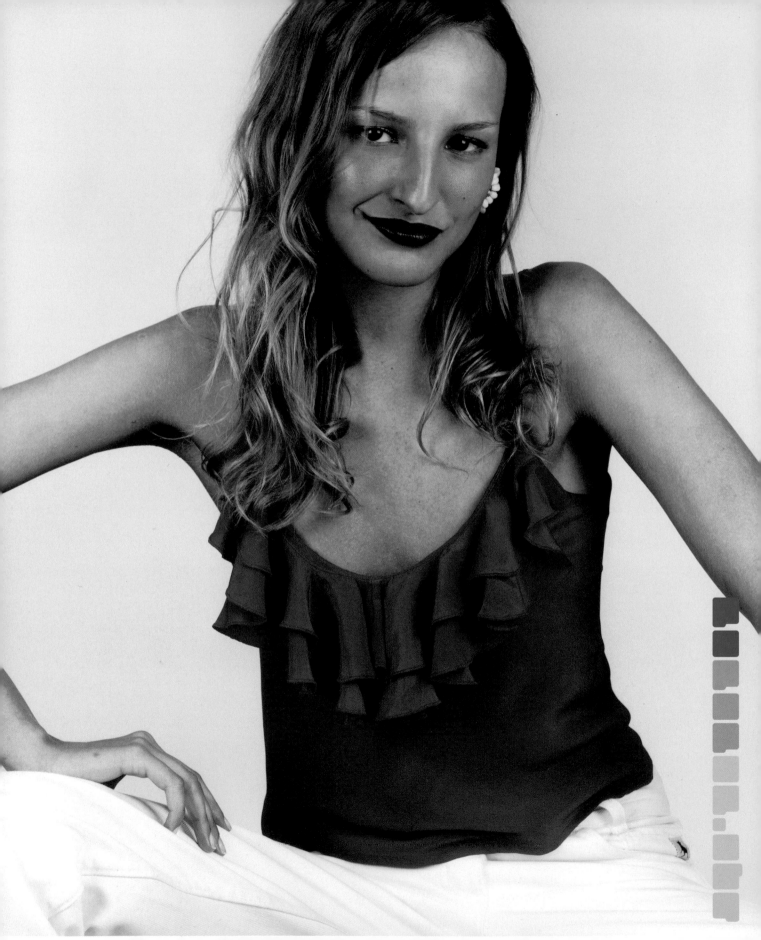

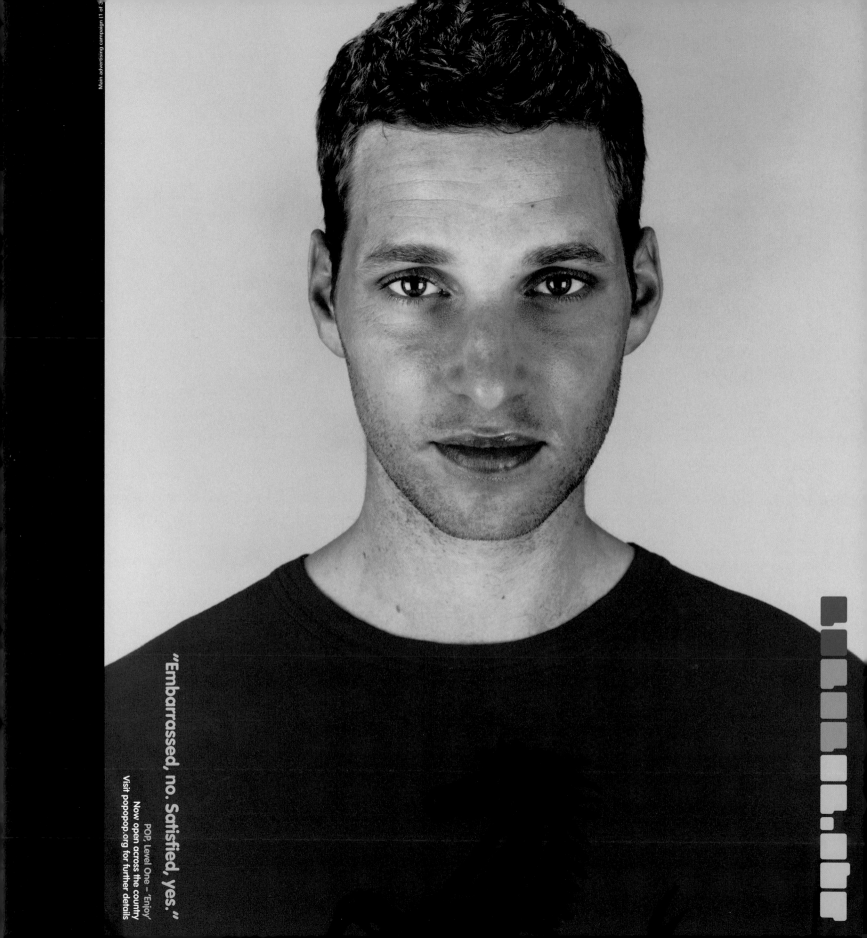

"Embarrassed, no. Satisfied, yes."

POP, Level One – 'Enjoy'
Now open across the country
Visit popopop.org for further details

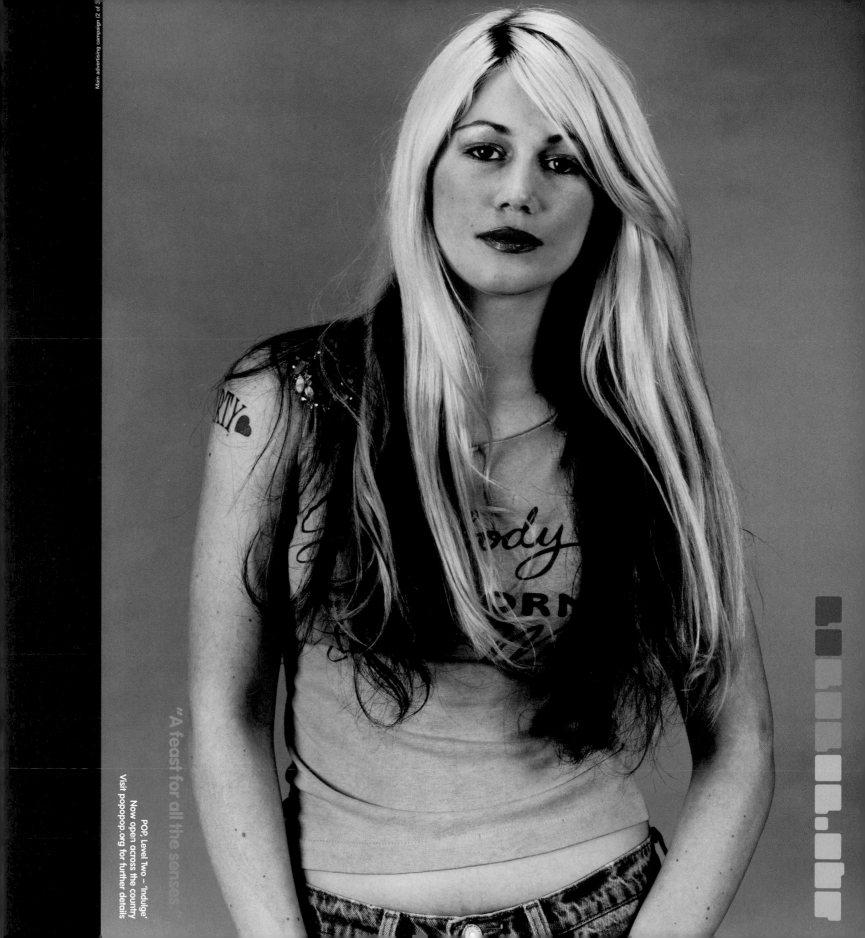

"A feast for all the senses."

POP, Level Two – 'Indulge'
Now open across the country
Visit popopop.org for further details

"Who said imagination was better than the real thing?"

POP, Level Three – 'Imagine'
Now open across the country
Visit popopop.org for further details

'Imagine'

Indulgence bar
Luxury suites
Private swimming pools
Personal fitness studios
Personal masseuse
Private bookings reception
Cigar room
Sauna/jacuzzi

POP
Level three

'Indulge'

**Aphrodisia restaurant –
high-quality gourmet food
Bar Orange
Fantasy rooms
Sauna and health spa
Massage parlour**

POP
Level two

'Enjoy'

**Pleasure products
Alluring apparel
Café – coffee/tea, cakes,
sandwiches,
Health shop – fruit
smoothies, power drinks
and dietary and health
consultation area**

POP
Level one

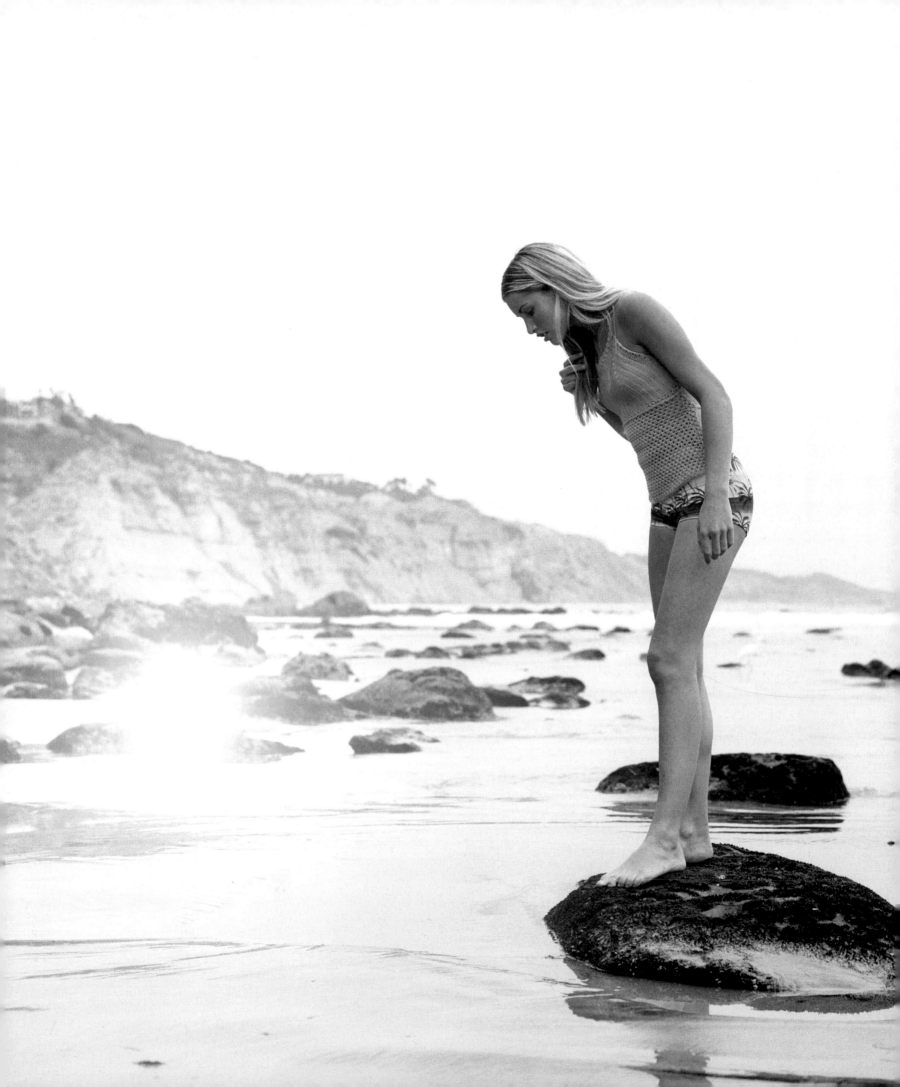

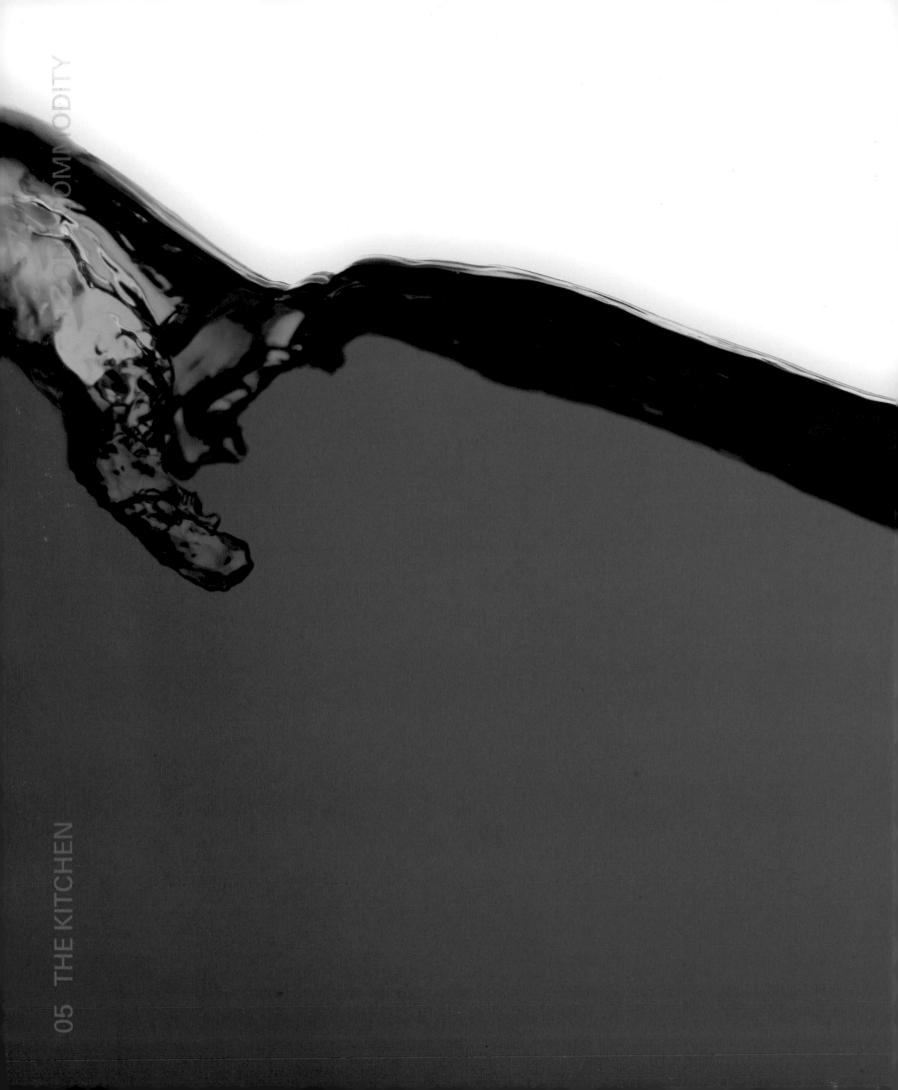

Arable land will decrease by half over the next 50 years according to the International Service for the Acquisition of Agri-Biotech Applications. ('Will Frankenfood Feed the World?' TIME magazine) Brand: 05

Distance lends enchantment to memories of totalitarianism. After the question marks raised over democracy's ability to deliver powerful authority to government, none more so than the 2000 American election, some of the basic principles of Western society are set up for attack in the next decade. For years anti-capitalists have argued that the commodification of previously public space and experience erodes civil liberty. The backlash to the backlash will be for the notion of 'civil liberties' itself to be questioned. Why operate under values established under entirely different circumstances, with different problems being faced? Isn't big business the natural leader for running the economy? And isn't a media baron a gifted communicator, ripe for politics? See also Italian general election, May 2001. Source: Getty Images Creative Research (GICR). Brand: 09

The final 'landgrab' of capitalist imperialism, led by transnational corporation interests, is now in the most desolate places, from the north of Alaska, to Antarctica, and includes the sea. The modern day battle of territorial claims over the continental shelves owes its genesis to Hugo Grotius and his work Mare Liberum in 1605. He argued in the context of sovereignty of the seas, that it could not extend further than the distance a cannon can fire from the shore. The North American contiguous zone of 24 nautical miles is claimed by most countries, but can vary. Territorial sea claims range from Gibraltar's of 3nm to China's of 12nm. Fishing or economic zones may extend to 200nm. Brand: 05

By 2050 global population will have increased by 50 per cent to 9 billion. Almost all growth will occur in 'developing countries'. Source: United Nations. Brand: 05

Influential social groups are never fixed, but inevitably migrate to a new position through the nature of the quest for Life. For example, the baby boomer generation has helped shape five decades and could continue to do so for another three decades. 'Baby boomers are both organized and self-directed collectors. They don't mind blowing $500 for something that expresses their alter ego – the person they wish they could be. They prefer interactive items.' Quote from 'Favorite Things' Danziger, American Demographics Source: GICR. Brands: 06 22 24 28

The arbitrary nature of signs was a theoretical topic of linguistics 30 years ago, now it is big business. Next it will manifest as 'personal business'. Why only have one name? It won't be just celebrities who change their identity, instead there is the opportunity for a whole industry of personal identity makeover. Among hot names to adopt – Arthur Andersen Consulting invested a record-breaking $175 million in its rebranding campaign which includes the launch of its new name, Accenture, said to stand for 'accent on the future'. Arthur Andersen then moved to a similarly substantial multi-million brand evolution of itself as Andersen. Which leaves Arthur so out it must be in... Soon. Source: GICR. Brands: 01 10 14 28

96 per cent of Americans believe in God or a universal spirit. That compares with 70 per cent of Canadians and 61 per cent of Britons. Research, 2001 The Tennessean. 55 million Americans have engaged in sex for hire during some point in their lives (www.usa-poll.com). Brands: 03 37

'We are what we eat' has mutated into an explosion of 'functional foods' being launched into a marketplace conservatively estimated at more than $29 billion a year in the U.S. (Report by Decision Resources, a Waltham, Mass., health-care consultant. 'ENGINEERING THE FUTURE OF FOOD' Fortune magazine.) Products like cornflakes laced with chemicals from tomatoes to lower cancer

risks, or spaghetti packed with soy compounds to prevent osteoporosis are designed to proactively push back disease for those willing to buy into the brands. There are growing opportunities for manufacturers to launch brands like these which represent a progression from the aphorism. Source: GICR. Brand: 10

As workstyle and lifestyle converge, the quest for greater productivity will embrace the full day. While the body rests, the brain re-energizes itself and appears to move information stored that day in short-term memory into long-term memory. There will be the opportunity to help manage that process, make us more snappy. Conversely, sleep deprivation can affect the body's natural immune system, cause memory problems, irritability, inability to concentrate, early-stage diabetes, premature ageing (www.riverdeep.net). Source: GICR. Brands: 07 12 26 32 35

Tomorrow's brands, and tomorrow's wealth, emerge from the poverty of experience and behaviour today. Extraordinary wealth is closely allied to control over scarce resources. 20 per cent of the world's oxygen comes from the rainforests. More than half of the world's rainforests have gone (www.rain-tree.com). Adopt a rainforest tree, fight a war to save your air. Source: GICR. Brands: 05 11 16 20 21 22 38

The urge to grow is a challenge to our concept of physical space and our sense of the infinite and the finite. Superfluity is a condition of going or being beyond what is needed for survival. This is how Western economies grow, through selling things that are not required but made to appear desirable. This drives ever more rapid change and innovation. Not only in products and services but also the values underpinning them. The fear within capitalism is that you might hit a ceiling or a wall. The dot.com boom and bust was forecast and delivered. Source: GICR. Brands: 08 09 15

The U.S. Patent and Trademark Office has awarded more than 2,000 gene patents and has more than

25,000 patent applications on human genes pending (http://usnews.about.com/newsissu es/usnews). Brands: 02 23 28 36

No new mass-media has yet killed old media – print grew after radio, and radio grew after television, and television grew after the internet arrived. So we can expect television to continue to dominate for some years yet. In 2000, 57 per cent of consumers surveyed by the Central China Television-affiliated Investigation and Consulting Center named television commercials as the leading factor that influences their purchasing decisions. Reference 'Household Name Comes Home' Y&R Brain Snacks. Source: GICR. Brands: 08 09 15 18

Finding eternal values is essential for building enduring brands. This extends beyond smart positional statements and needs to exist throughout the iconography (consider how lasting are some major brands' colours and forms). White has long represented purity, goodness, light and innocence. In heraldry white is also called argent. This word comes from the Latin argentum, for silver. The colour white projects feelings of calmness, relaxation and an inner peace with one's surroundings and inner soul. Source: GICR. Brands: 04 14

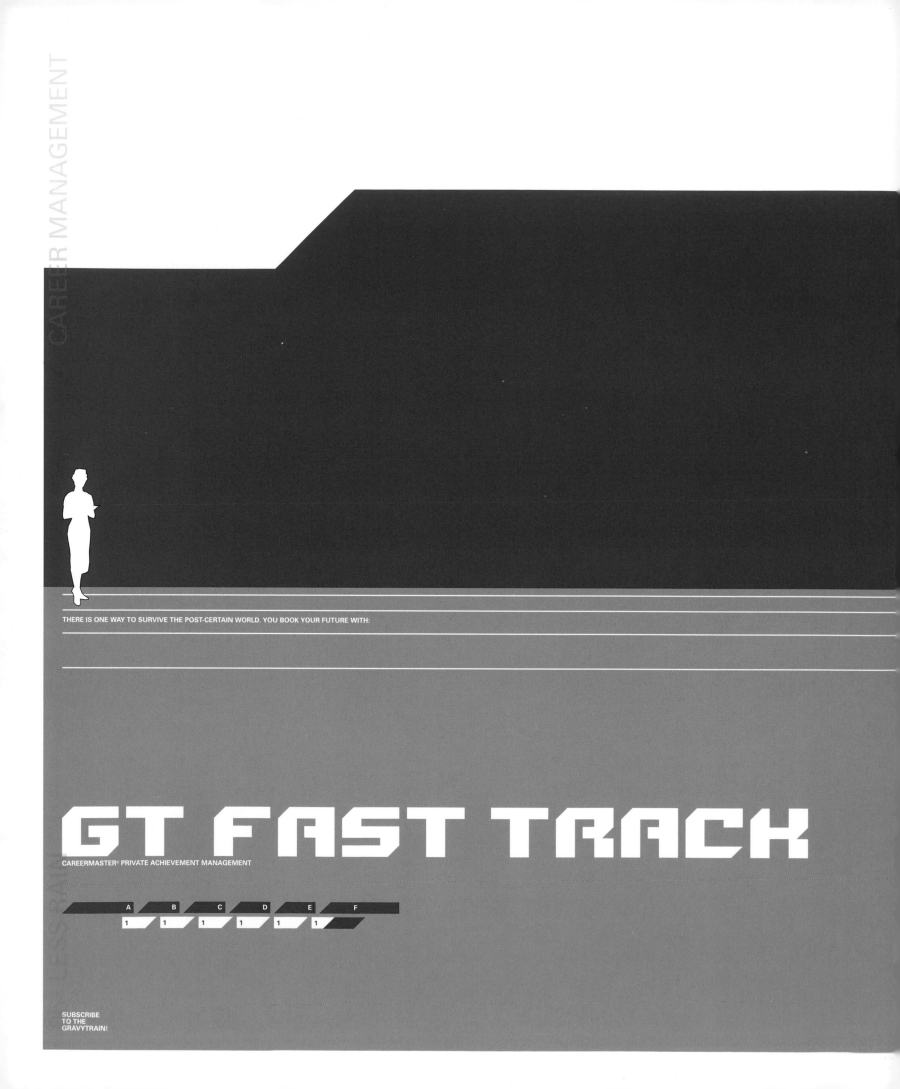

THERE IS ONE WAY TO SURVIVE THE POST-CERTAIN WORLD. YOU BOOK YOUR FUTURE WITH:

GT FAST TRACK

CAREERMASTER© PRIVATE ACHIEVEMENT MANAGEMENT

A	B	C	D	E	F
1	1	1	1	1	1

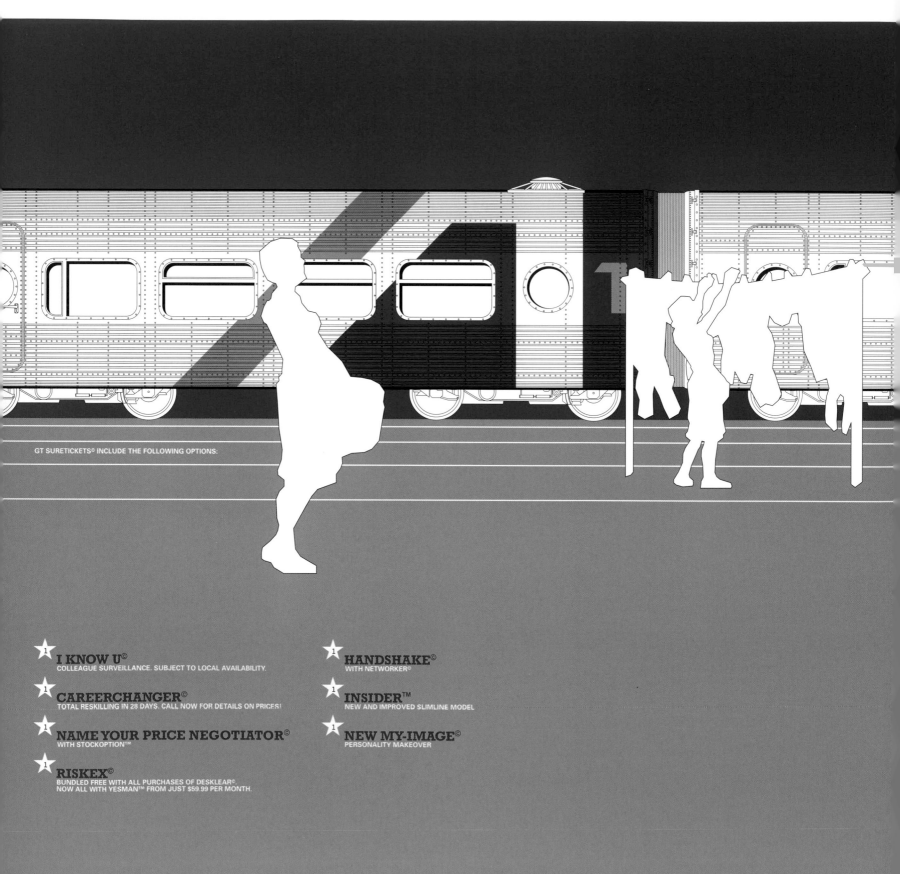

GT SURETICKETS© INCLUDE THE FOLLOWING OPTIONS:

★₁ **I KNOW U**©
COLLEAGUE SURVEILLANCE. SUBJECT TO LOCAL AVAILABILITY.

★₁ **CAREERCHANGER**©
TOTAL RESKILLING IN 28 DAYS. CALL NOW FOR DETAILS ON PRICES!

★₁ **NAME YOUR PRICE NEGOTIATOR**©
WITH STOCKOPTION™

★₁ **RISKEX**©
BUNDLED FREE WITH ALL PURCHASES OF DESKLEAR©.
NOW ALL WITH YESMAN™ FROM JUST $59.99 PER MONTH.

★₁ **HANDSHAKE**©
WITH NETWORKER©

★₁ **INSIDER**™
NEW AND IMPROVED SLIMLINE MODEL

★₁ **NEW MY-IMAGE**©
PERSONALITY MAKEOVER

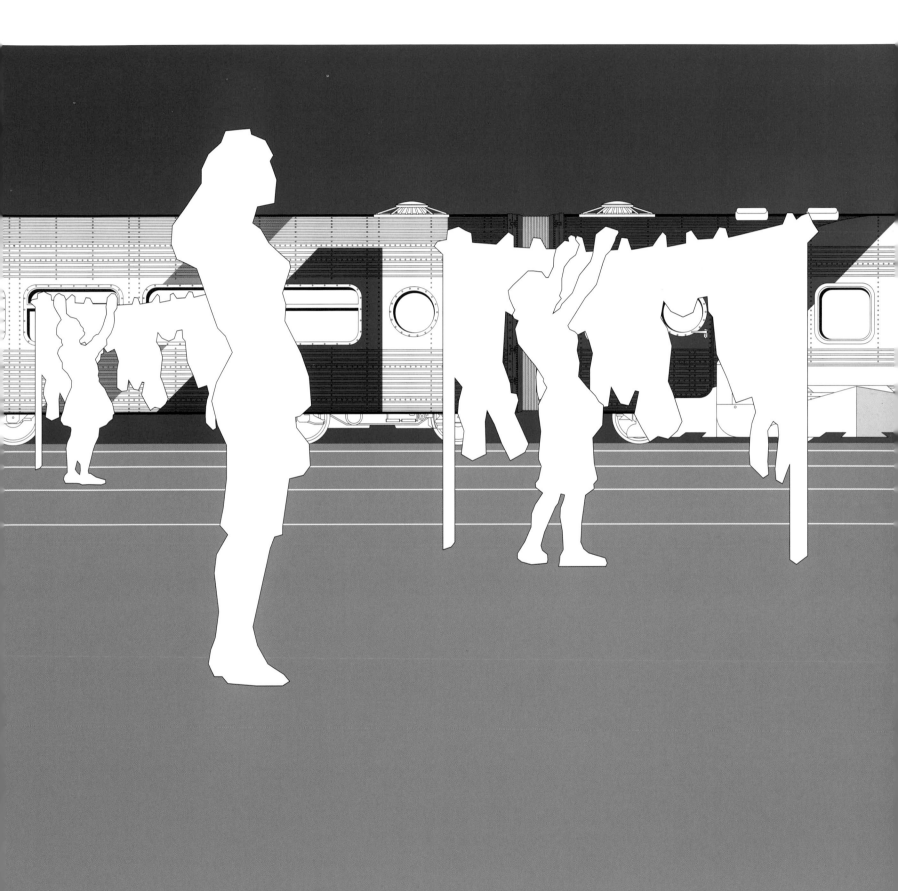

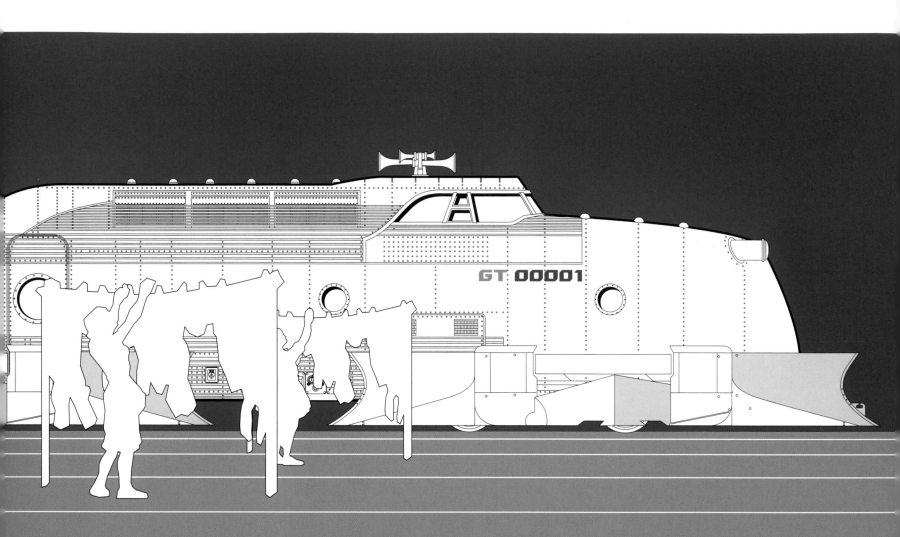

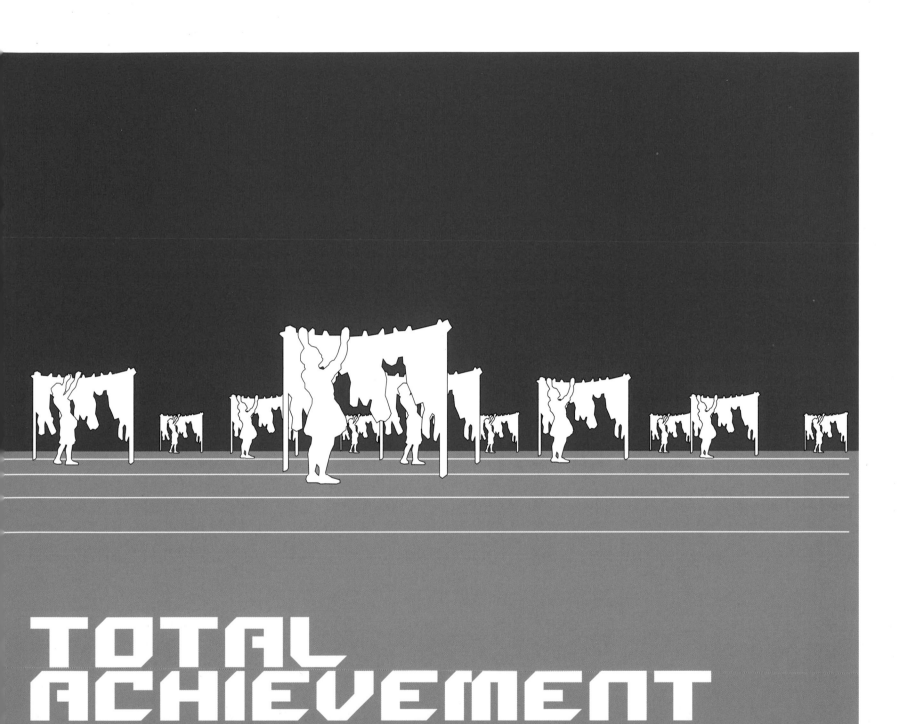

TOTAL ACHIEVEMENT

ARE YOU ON THE TRAIN OR OFF?

01-01

SUBSCRIBE
TO THE
GRAVYTRAIN!

Almost anyone can develop an
irrational behaviour pattern.
Whether domestic or occupation
related, ~~stress~~ stress can lead to a
wide variety of ill feelings.
~~The desire to destroy~~
~~Testosterone induced feelings~~ of invincibility
~~Homicidal tendencies~~
Internalised, these reservations will
encourage permanent dementia.
Externalised they ~~xxxx~~ could lead
to a custodial sentence.
A state subsidised private sector
service that provides immediate
externalisation of problematic
temporary ~~psychosis~~ in a safe
and secure environment will
Negate the need for long term
incarceration.
Reduce the necessity for prison
expansion.
Unburden tax funded punishment
programmes.

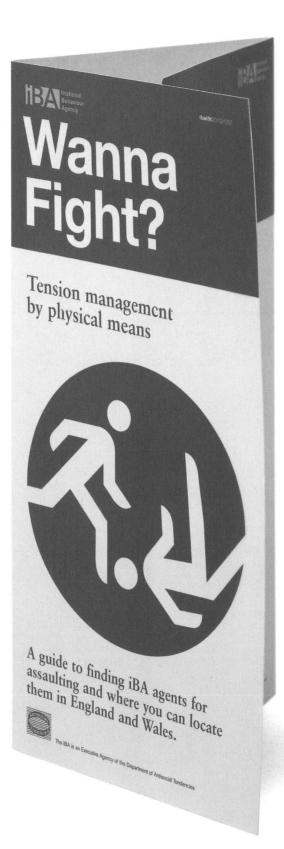

iBA Irrational Behaviour Agency

ibaflt/2012/057

Wanna Fight?

Tension management by physical means

A guide to finding iBA agents for assaulting and where you can locate them in England and Wales.

The iBA is an Executive Agency of the Department of Antisocial Tendencies

> exhibit ref.
0000/A_introduction

Branding: a retrospective

This exhibition charts the impact that branding has had on our lives, focusing on the first half of the 21st century. By sourcing and examining everyday paraphernalia and consulting expert opinion, we have created an insight into the culture of this part of our history.

During the first few years of the last century, the pace of society accelerated, industries craved process, product and service-related brands defied class boundaries, and culture itself became increasingly mapped.

It was not simply products that were sold but a whole lifestyle and a set of values.

This evolution created brands that did not just sell to their customers but controlled their lifestyles.

Individuals' lifestyles were captured, analysed and catered for. Society found itself at the mercy of cultural racism and sanitized stereotypes.

The immediacy of 'what you want, when, you want it' forced people to question the need for free will. Dependence on brands equalled society's trust in technology, and in this ensuing en-masse market it became the ownership of the individual's profile that commanded ultimate respect.

> exhibition title

> exhibition main intro

> exhibition
Branding: a retrospective

created by	date created	date modified	software
deepend london	04/12/2170	06/12/2170	curator 6

Discovered in a medical landfill site
East London, UK

This rare example shows the genetic identity band of an individual undergoing 'brand personality reassignment'.
As bDNA assigned children grew older, many experienced problems with the restrictions their brand personalities imposed. Substantial evidence shows, those who could afford it would undergo genetic re-engineering.
The process involved various stages including implanting bio-neural networks into the brain to overwrite earlier values and conditioning.
The surgeons' and biologists' attempts to integrate new values into these individuals generally failed.
'Adjusted' individuals tended to exhibit what was known as brand-schizophrenia and required extended genetic therapy for total brand assimilation.

Although 'adjustment' was unpleasant, the alternative was often physiological confusion, leading to depression and nervous breakdown.

bDNA identity band

circa 2010 AD

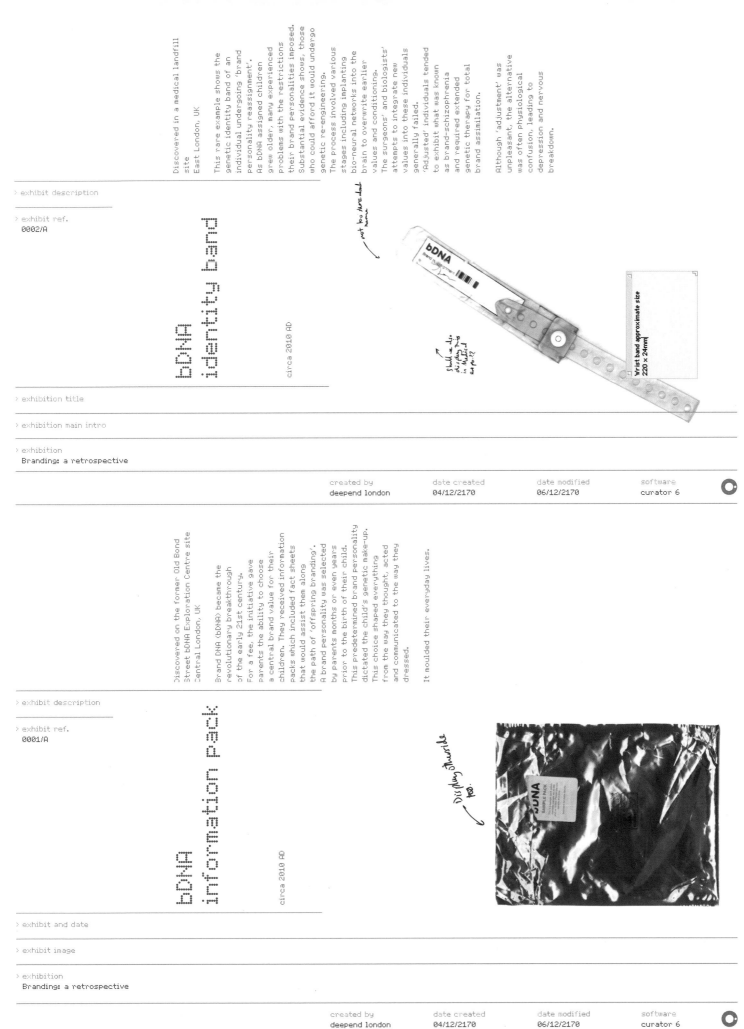

Wrist band approximate size
220 x 24mm

created by	date created	date modified	software
deepend london	04/12/2170	06/12/2170	curator 6

Discovered on the former Old Bond Street bDNA Exploration Centre site
Central London, UK

Brand DNA (bDNA) became the revolutionary breakthrough of the early 21st century.
For a fee, the initiative gave parents the ability to choose a central brand value for their children. They received information packs which included fact sheets that would assist them along the path of 'offspring branding'.
A brand personality was selected by parents months or even years prior to the birth of their child.
This predetermined brand personality dictated the child's genetic make-up.
This choice shaped everything from the way they thought, acted and communicated to the way they dressed.

It moulded their everyday lives.

bDNA information pack

circa 2010 AD

created by	date created	date modified	software
deepend london	04/12/2170	06/12/2170	curator 6

bDNA profile card

circa 2010 AD

Discovered in a residential area Brighton, UK

The use of profile cards was introduced to facilitate the transfer of information, not only from business-to-business but from person-to-person.

Although individuals had an intuitive knowledge of their own brand values, processing such data about others proved complex. The portable nature of profile cards quickly became the logical choice for the instantaneous communication of an individual's brand values. Product and service-related advertising diminished as manufacturers targeted particular individuals using the information from their profile cards.

The brandscape evolved into a dynamic environment adapting and reacting to an individual's exact requirements.

check at image co.108 for other side

	created by	date created	date modified	software
	deepend london	04/12/2170	06/12/2170	curator 6

Punishment 'lines'

circa 2010 AD

Lined paper with handwritten text discovered in a converted school North London, UK

In expert opinion this example could suggest a particular set of brand values written by a bDNA-controlled individual at a very early age. It might have been used as a form of punishment to the individual for 'off brand' misbehaviour.

As time progressed, this became an increasingly common problem. Within the adult population, people were outgrowing their original brand personalities, becoming confused or even disillusioned with what it had to offer them. As bDNA matured and when it became apparent that punishment was ineffective, brand counselling services were established.

People were encouraged and supported to reacquaint themselves with their brand personalities.

handle with care
fragile exhibit

	created by	date created	date modified	software
	deepend london	04/12/2170	06/12/2170	curator 6

As bDNA took a stronghold throughout mainstream society, the rich turned to the opposing ideal of authorship and ownership to define their own sense of identity. The bDNA backlash resulted in the evolution of a coexistent brand identity known as 'Void'.
It produced nothing, declared nothing, sold nothing and guarded one's identity as its primary asset. Those who were able to make the financial commitment to become 'ghosts' within an increasingly constrictive system did so. Individuals effectively paid to become themselves.

Brand identity Void

circa 2010 AD

Brand identity
Void
exhibit missing?

	created by	date created	date modified	software
	deepend london	04/12/2170	06/12/2170	curator 6

Discovered in Soho Central London, UK

Having witnessed the influence and impact of bDNA, established corporate brands and multinationals hijacked the brand personality phenomenon through sponsorship deals and endorsement.
Parents desiring sporty, proactive children chose the bDNA supported by renowned sportswear manufacturers, similarly for intelligent, pioneering children they could opt for bDNA endorsed by a recognized European car manufacturer. However, following penetration by bDNA into mainstream society, the backlash against the practice gained momentum.
Once the stories hit the headlines
– of dictatorial control and of unorthodox methods used by bDNA
– branded living lost much of its gloss. It became utilitarian necessity rather than elitist luxury.

Adinsight magazine cover

circa 2010 AD

	created by	date created	date modified	software
	deepend london	04/12/2170	06/12/2170	curator 6

idée fixe

lost & found

PERISHABLE GOODS

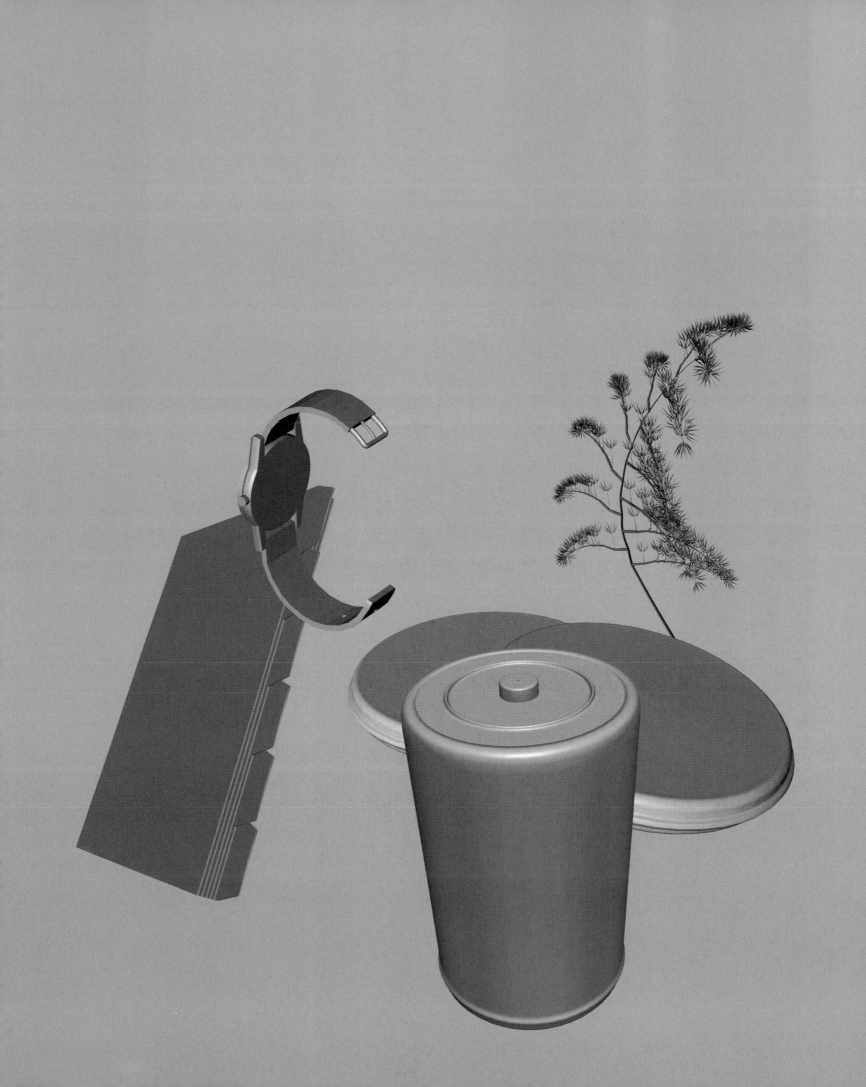

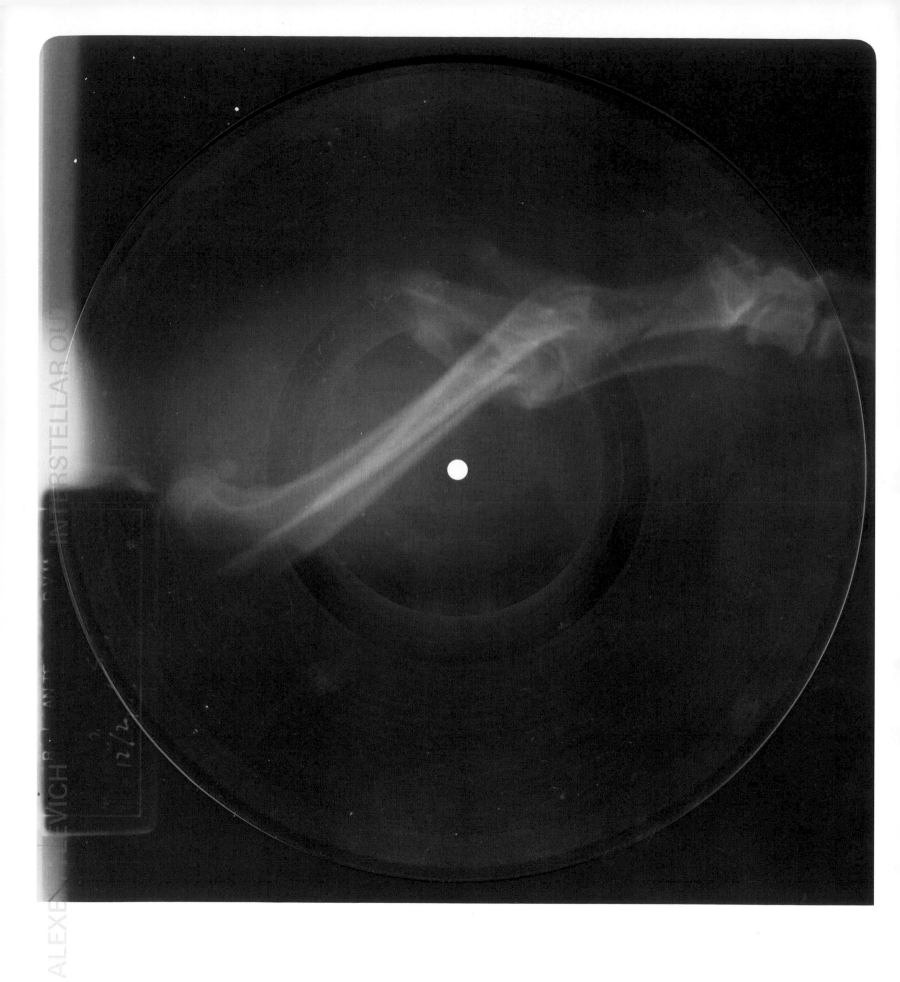

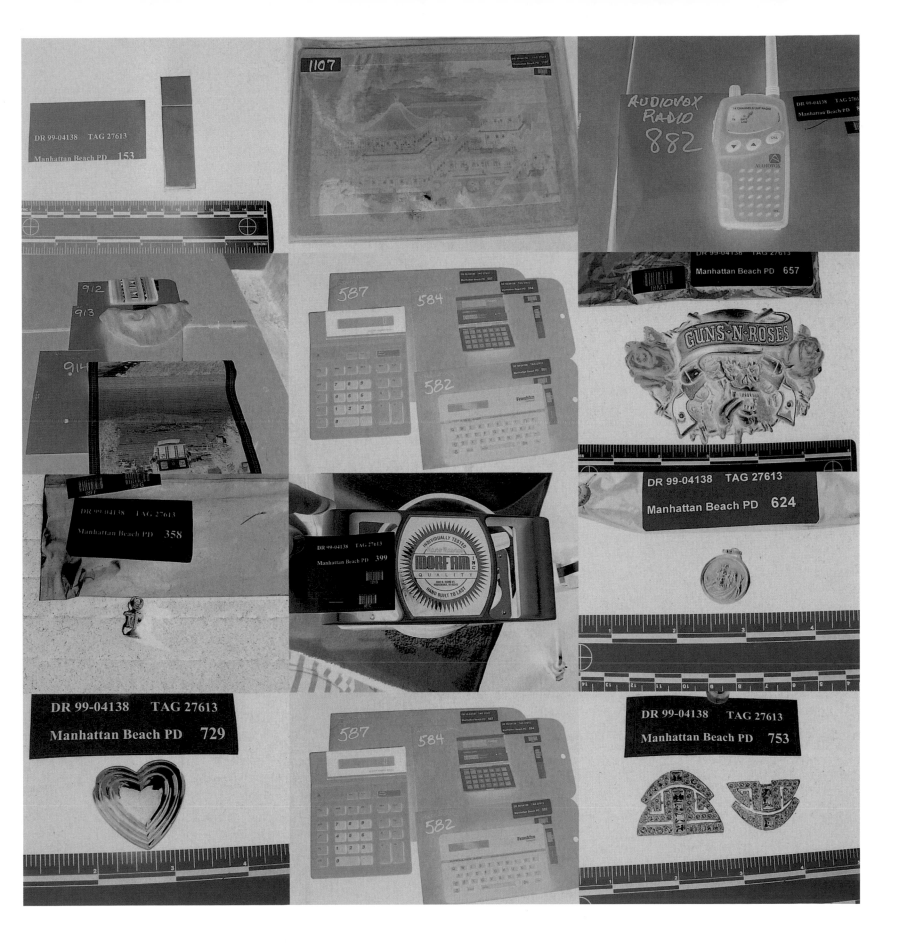

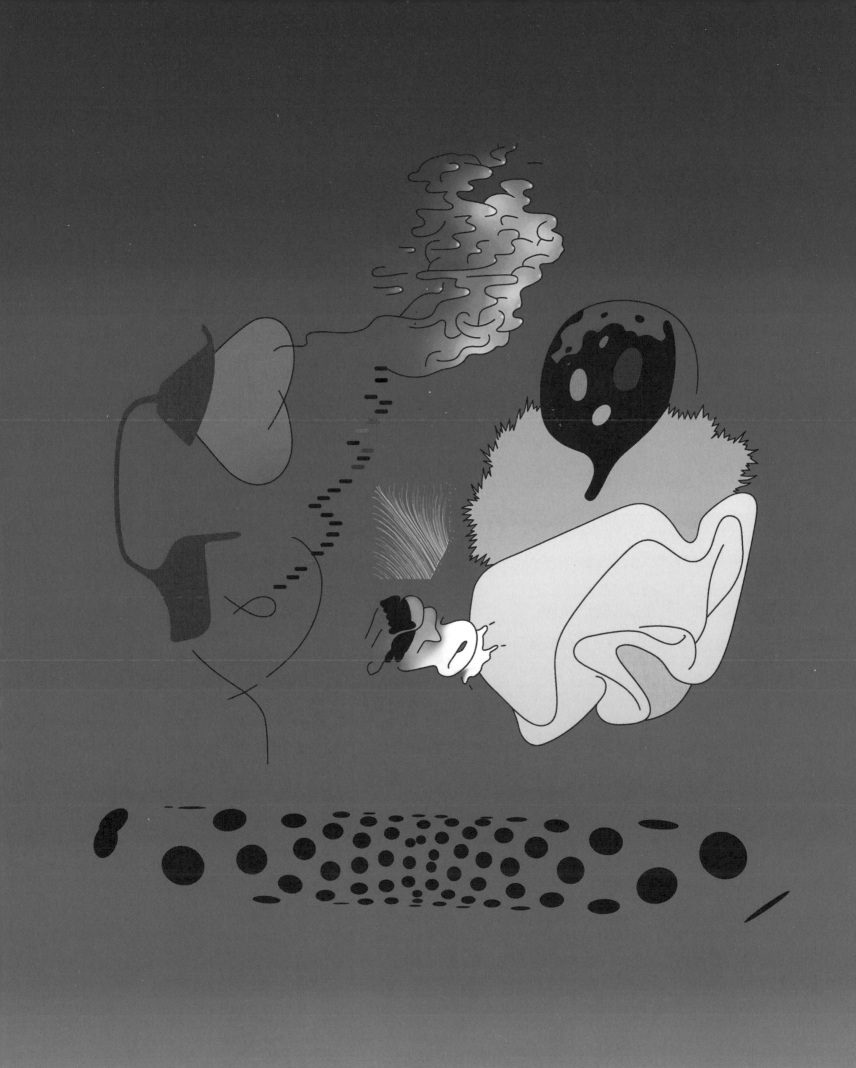

THIS PAGE IS ALMOST INVISIBLE

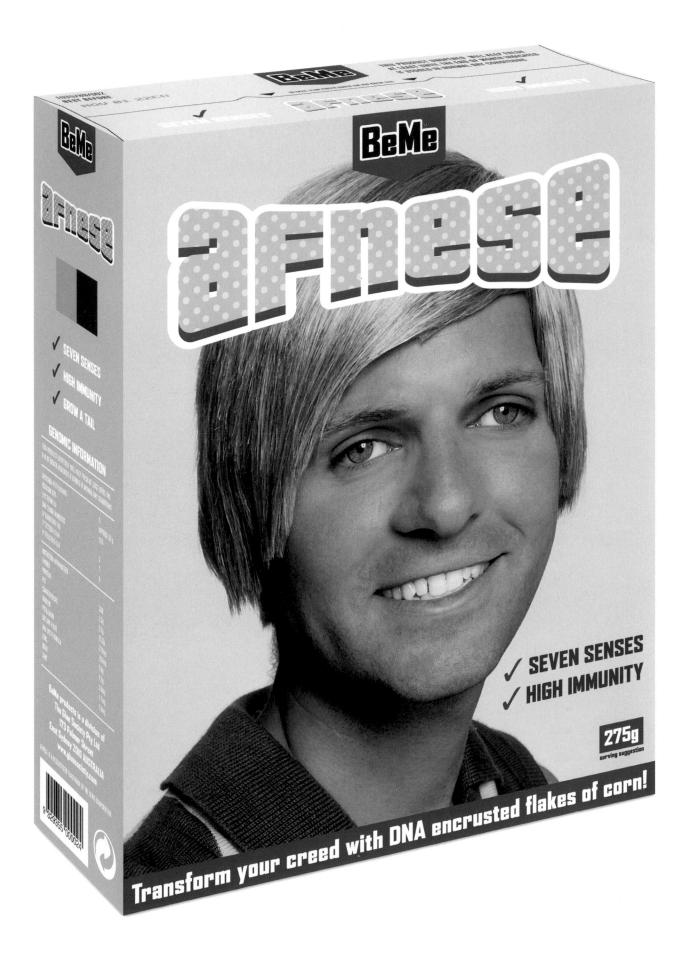

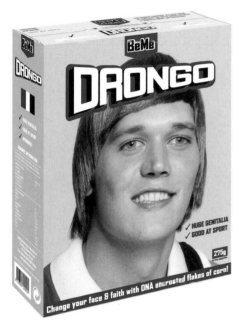

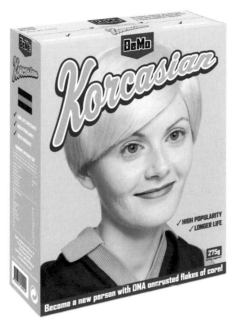

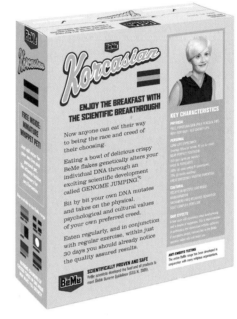

Playing God™

Planet friendly solutions

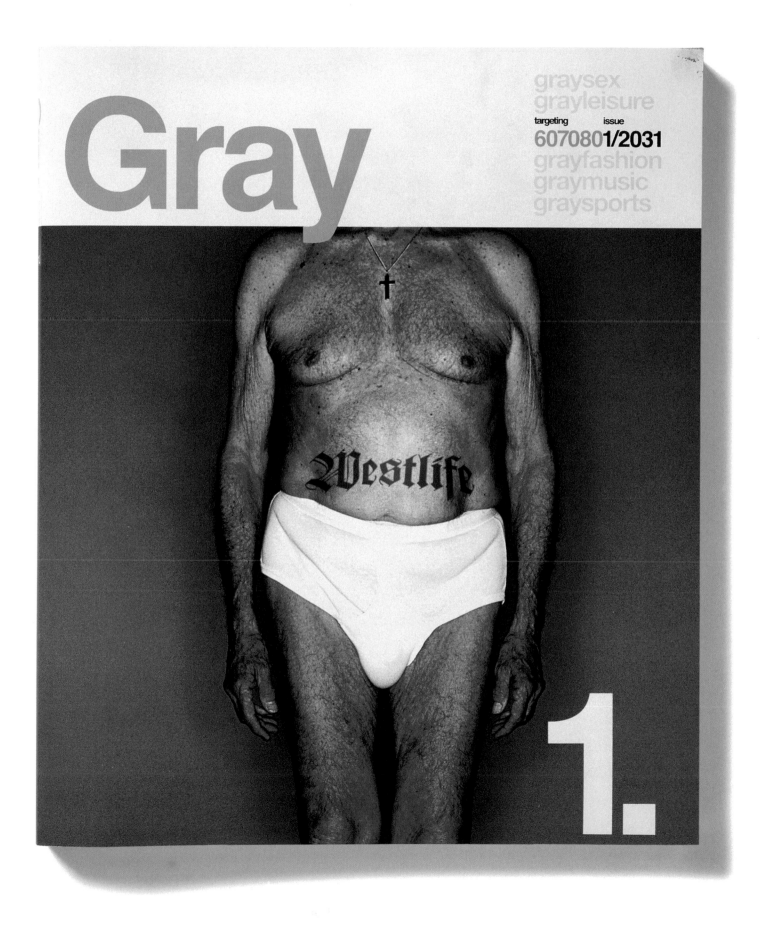

Gray

graysex
grayleisure
targeting issue
607080**1/2031**
grayfashion
graymusic
graysports

1.

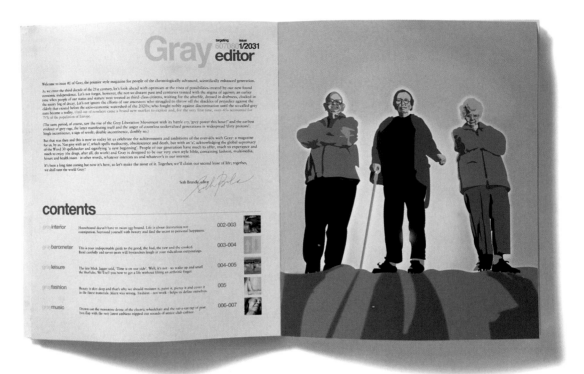

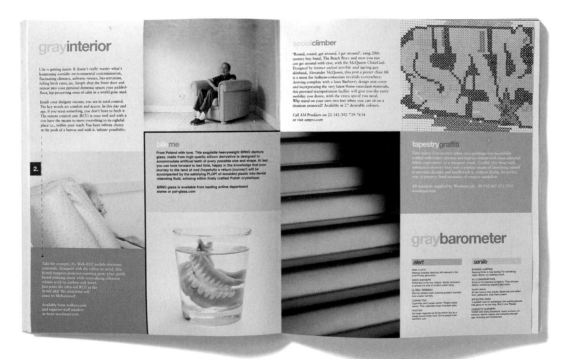

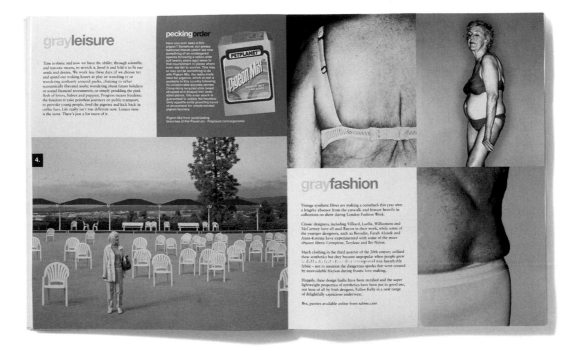

grayleisure

Time is elastic and now we have the ability, through scientific and narcotic means, to stretch it, bend it and fold it to fit our needs and desires. We work less these days (if we choose to) and spend our waking hours at play or watching tv or wandering aimlessly around parks, chatting to other economically liberated souls; wondering about future holidays or sound financial investments; or simply prodding the pink flesh of lovers, babies and puppies. Progress means freedom; the freedom to take pointless journeys on public transport, to provoke young people, feed the pigeons and kick back in coffee bars. Life really isn't too different now. Leisure time is the same. There's just a lot more of it.

peckingorder

Have you ever seen a thin pigeon? Somehow, our greasy feathered friends (which are now something of an endangered species following a nation-wide cull twenty years ago) seem to find nourishment in places where even rats fail to survive. This may or may not be something to do with Pigeon Mix, the ready-made meal for pigeons, which at last is available in this country following its considerable success abroad. Comprising recycled stale bread, chopped and shaped into beak-sized pieces, this avian snack is guaranteed to satisfy the heartiest birdy appetite while providing hours of amusement for simple-minded pigeon-fanciers.

Pigeon Mix from participating branches of Pet Planet plc – Petplanet.com/pigeonmix

4.

grayfashion

Vintage synthetic fibres are making a comeback this year after a lengthy absence from the catwalk and feature heavily in collections on show during London Fashion Week.

Classic designers, including Villiard, Luella, Wilkinson and McCartney have all used Rayon in their work, while some of the younger designers, such as Borodin, Farah Alcock and Anna-Katrina have experimented with some of the more obscure fibres: Crimplene, Terylene and Bri-Nylon.

Much clothing in the third quarter of the 20th century utilised these synthetics but they became unpopular when people grew tired of the fact that they were impregnated into breathable fabric – not to mention the dangerous sparks that were created by unavoidable friction during frantic love-making.

Happily, these design faults have been rectified and the super lightweight properties of synthetics have been put to good use, not least of all by Irish designer, Fallon Kelly is a new range of delightfully capricious noderwear.

Bra, panties available online from sabine.com

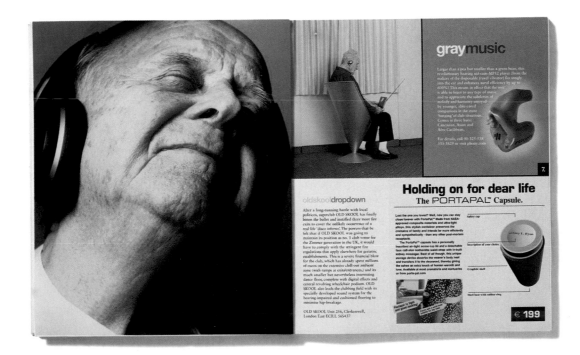

graymusic

Larger than a pea but smaller than a green bean, this revolutionary hearing aid-cum-MP12 player (from the makers of the disposable travel vibrator) fits snugly into the ear and enhances aural efficiency by up to 600%! This means in effect that the user is able to listen to any type of music and to appreciate the subtleties of melody and harmony enjoyed by younger, able-eared companions in the most 'banging' of club situations. Comes in three hues: Caucasian, Asian and Afro-Caribbean.

For details, call 00-325-538-333-3829 or visit pbnity.com

7.

oldskooldropdown

After a long-running battle with local politicos, superclub OLD SKOOL has finally bitten the bullet and installed three more fire exits to cover the unlikely occurrence of a real-life 'disco inferno'. The powers-that-be felt that if OLD SKOOL was going to maintain its position as no. 1 club venue for the Zimmer generation in the UK, it would have to comply with the stringent fire regulations that apply elsewhere for geriatric establishments. This is a severe financial blow for the club, which has already spent millions of euros on the expensive chill-out ambient zone (with ramps at exits/entrances,) and its much smaller but nevertheless interesting dance floor, complete with digital effects and central revolving wheelchair podium. OLD SKOOL also leads the clubbing field with its specially developed sound system for the hearing impaired and cushioned flooring to minimise hip-breakage.

OLD SKOOL Unit 256, Clerkenwell, London East EC1L 565437

Holding on for dear life
The PORTAPAL™ Capsule.

Lost the one you loved? Well, now you can stay close forever with PortaPal™. Made from NASA-approved composite materials and ultra-light alloys, this stylish container preserves the cremains of family and friends far more efficiently and sympathetically – than any other post-mortem receptacle.

The PortaPal™ capsule has a personally inscribed air-tight screw-top lid and a detachable face call also leatherette waist-strap with in-built kidney massage. Best of all though, this unique storage device absorbs the wearer's body heat and transfers it to the deceased, thereby giving the ashes an extra touch of human warmth and love. Available at most crematoria and mortuaries or from porta-pal.com

- Safety cap
- Inscription of your choice
- Graphite skull
- Steel base with rubber ring

€ 199

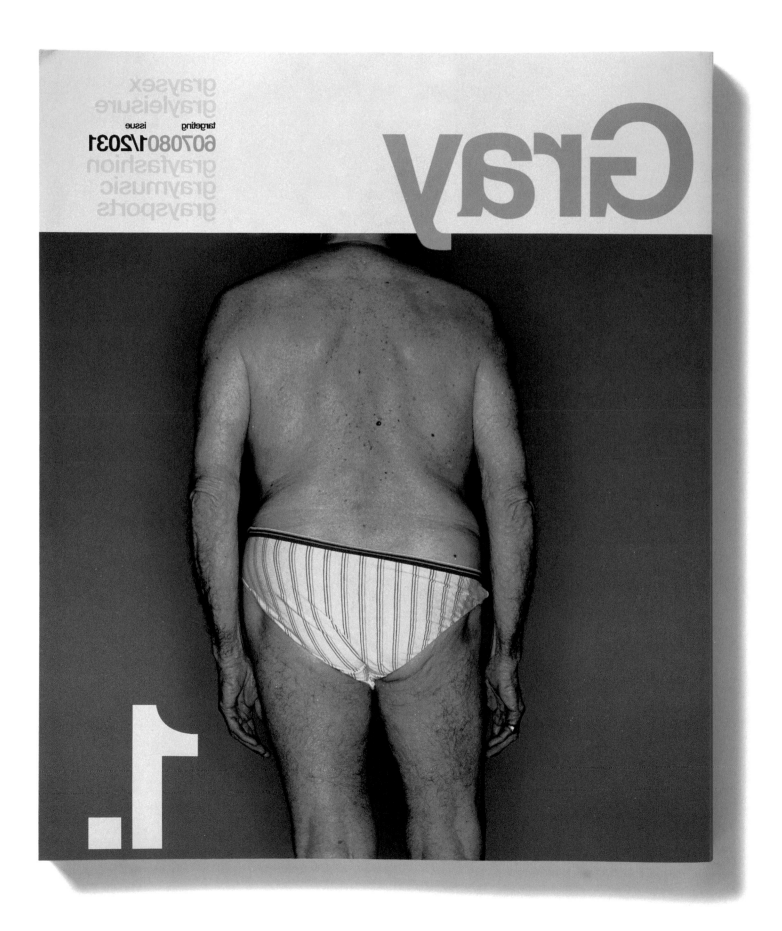

The idea of copyright can be traced back as far as Greek times when a singer would be paid for a performance. Although the performer had not worked to make a product, s/he had worked to give a tangible commodity to the audience. This concept of 'work' is also the rationale behind why a person's compositions are protected; although a composer may not perform their work, they are responsible for the original idea. Source: GICR. Brands: 02 19

The ultimate possession is... an idea. And yet 'ideas' are hard to prove ownership of. The future will see refined definition and extensive test cases mapping out the reality of ownership in this key space. It could see war breaking out over intellectual property claims as they become increasingly seminal to a nation's success. Intellectual property concerns the creations of the mind, covering artistic and literary works, symbols, images, designs and names. Based in Switzerland, French company Organisation Mondiale De La Propriété Intellectuelle is the World Intellectual Property Organisation. Established by a convention in Stockholm in 1967, it came into force in 1970 and became a specialized agency of the United Nations in December 1974. Many parts of the world fail to observe any copyright law. Source: GICR. Brands: 02 18 19

Hotel style is a consistent influence on home style, whether inculcating new ideas of luxury or of efficiency and productive environments. Next up, pod living inspired by the super-compact hotel space. The Green Plaza Shinjuku has 660 pink moulded plastic capsules, self-contained upper and lower bunks standing side by side, each one about one metre high, one metre wide, and two metres deep. Disposable nightgowns and toiletries are provided as is a separate corresponding locker for luggage. Home from home. Source: GICR. Brands: 16 17 30

New names, good names, even legally available names, are ever harder to find. Says David Placek, founder of Sausalito's Lexicon Naming, which named Apple's PowerBook and Intel's Pentium: 'It's an enormous task to leapfrog over existing names to get something that not only is legally available, but also gets the product concept in motion.' Reference 'What's in a brand?', Brand Names Education Foundation. Brand: 14

'History breaks' are hotspots for innovation opportunities as they stimulate new combinations and conflicts of information. High and rapid adoption of new technologies in the less industrially developed nations leads to technology leaps, as the evolutionary steps are leapfrogged. New communications technologies feed the speed of such change as well as being indicative of it. The number of mobile phone users in China nearly doubled to 85.3 million in 2000, and is continuing at this pace. Meanwhile, landline phones are still restricted. Source: www.cellular.co.za, GICR. Brands: 16 27 33 37 39

The past is a foreign country... and we want to go there for a long vacation. Mummification, the Egyptians' ancient method of preserving the body, is once again on offer from Summum, a philosophical-religious group in Salt Lake City, Utah. So far, 150 clients have paid in excess of $65,000 to preserve their cells for cloning. Watch out for other iconic rituals, dead or alive, to be revived. Source: GICR. Brands: 15 23 35

The over-85 crowd has almost quadrupled in the U.S. since 1960, against the country's population increase of only 45 per cent. The number of over-65 Americans doubled in the same period. Those trends will continue; by 2050, the number of over-85 Americans will increase by over 500 per cent (www.elder-law.com). Brand: 12

Customer-focused thinking and the evolution or decline of traditional religion will drive a new wave of invention in funerals. Already, themed funeral services are on the increase. Cheekyfunerals.com offers swashbuckling pirate funerals.

CelestisInc. makes it possible for cremated remains to be launched into space; to orbit around the Earth; to fly to the Moon; or to travel into deep space. Eternal Reefs Inc. provides an environmentally sound alternative by integrating cremated remains into artificial reefs in various oceans and seas around the world. Source: GICR. Brands: 11 40

The centre and the margin of consumer behaviour are in constant flux – with the new opportunities lying at the margin. There is a regular flow of health treatments from the edge to the centre of acceptability and thence from prescription to over-the-counter drugs, and then into general products and brands. 'Supplemental' or 'extra' oxygen is one of the most widely used therapies for people admitted to hospital. It is also frequently used for patients with chronic lung disease living at home. In all cases oxygen is administered by inhalation. The importance of oxygen therapy for many patients with heart and lung diseases is now universally recognized. Source: GICR. Brands: 20 38 39

The environment is increasingly seen as a personal extension, which gives opportunity for a massive switch in products and service values. All brand positions will need to have a 'clean bill of health' before being allowed near the body. Warning notes include evidence that maternal exposure to toluene (used in glues, coatings, inks and paint) causes birth defects. Exposure to endocrine-disrupting chemicals may be responsible for a 40 per cent increase in ectopic (tubal) pregnancies between 1970 and 1987. Puberty may be delayed in some children. Men have experienced a 50 per cent reduction in sperm count during the last 50 years. Studies of the umbilical cords of newborns revealed the presence of approximately 100 synthetic chemicals (www.womenshealth.com). Source: GICR. Brands: 13 27 39

Seniors are the fastest growing segment of society – but have little specialist representation to transform their concerns into national policies. The likely result is a more highly politicized pensioner, with the time and health and motivation to use the web and other new tools to mobilize the ruling majority to take them seriously. Source: GICR. Brand: 12

Life expectancy has increased 25 years since 1900 (www.demko.com). Brand: 12

We shouldn't run out of brand names for a while yet. There are some 600,000 morphemes (the smallest meaningful word unit) and these can be combined in billions of combinations. Source: GICR. Brand: 14

Square metres per person in built-up environments worldwide:
Albania 8.0
Azerbaijan 12.3
Cameroon 9.6
Chile 14.4
Congo 12.6
Denmark 51
Djibouti 13.1
Georgia 18.2
Ghana 5.5
Indonesia 14.4
Israel 28.0
Madagascar 5.8
Morocco 10.0
Namibia 3.5
Nepal 14.4
Pakistan 1.3
Philippines 22.8
Tunisia 12.0
Turkey 18.2
Zambia 6.4

United Nations development programme
http://www.undp.org/popin/wdtrends/bss/fbsstoc.htm
Brands: 05 16

brand shepherd

IN THE FUTURE BRANDS WILL NOT BE PASSIVE AND STATIC IN THEIR APPEARANCE: BY ESCAPING FLATLAND, BRANDS WILL BE RELEASED TO REALIZE THEIR FULL POTENTIAL. BRANDS WILL BECOME ACTIVE AND ANIMATED IN THEIR COMMUNICATIVE ABILITIES, DIRECTLY INFORMING, SYMPATHIZING AND EMPATHIZING WITH OUR NEEDS.

BRANDS [AND BRAND VALUES] WILL NOW HAVE THE ABILITY TO TRULY REACH US.

BRAND SHEPHERD – A PRODUCT THAT CAN RECORD, COLLATE, STORE AND COMMUNICATE AN INDIVIDUAL'S BRAND INFORMATION. THIS DATABANK OF BRAND DETAIL AND HISTORY CAN BE EASILY ACCESSED BY PRODUCT PLACEMENT SYSTEMS, ALLOWING A BRAND TO TAILOR ITS APPEARANCE TO MEET THE INDIVIDUAL'S SELECTED CRITERIA. BY ACCESSING THE HISTORIES OF INDIVIDUALS' BUYING TRENDS AND CONSUMER PATTERNS, **BRAND SHEPHERD** INCREASES THE EFFECTIVENESS AND SUITABILITY OF A BRAND.

YOU

YOU

EMPOWERS

ENABLES

INTERPRETS

STORES

brand**shepherd**

COMMUNICATES

SECURES

YOU

YOU

THROUGH **BRAND SHEPHERD** EVERY CONSUMER WILL HAVE THEIR OWN UNIQUE BRAND EXPERIENCE DEPENDING ON THEIR PERSONAL RECORDED CONSUMER PATTERNS AND LIFESTYLE. BRANDS WILL BECOME A COMBINATION OF CORE VALUES AND INTERPRETATION. WE WILL NOW HAVE THE ABILITY TO INFLUENCE THE PUBLIC-FACING APPEARANCE OF BRAND. LEARNING FROM THESE PATTERNS, BRANDS WILL COME TO UNDERSTAND AND EMPATHIZE WITH US. WE WILL ALL BE INSTRUMENTAL IN THE CREATION OF THE BRANDS OF THE FUTURE.

BRANDS WILL SPEAK TO US. WE ARE BRANDS AND BRANDS ARE US.

BRANDS FOR YOU

As **Brand Shepherd** allows individuals to see the same product in different ways, this will allow for the true potential of pluralist values to be demonstrated – brand for everyone – yet the experience will be unique.

The interpretation of brand lies with the viewer not producer.

SECTORS

Brand Shepherd will allow brands to communicate to different market sectors at the same time. This globalization of cultural experience will become the basis of brand communication and participation.

The brand experience will be one of personal interpretation.

IDENTITY

As our identities change, so will our relationship to brands. Brand[s] will respond to the changes in our psyche, interpreting our needs and ambitions and reflecting these values in the way that they present themselves.

Brands will form us, and in turn we will form brand values.

LEARNING

Learning from experience, brands will develop the ability to portray the exact values that we require from product.

Brands will learn from our experiences.

METAMORPHOSIS

Brands will now have the ability to form in our own image – we will become the instigators of values and appearances. We will be active in the development of brand values and appearance.

Brands will become the ideal of our imaginations.

RECORDING

Brands will record, relay and share brand experience information and data. This data will be used by brands and product placement systems to engage with our buying patterns directly and with unprecedented accuracy.

Brands will never be incorrect.

DATABANKS

Information will be cross-referenced to maximize the ability of brand to fulfil our needs. Stores, signage and direct marketing will access this databank to ensure that all brand marketing and literature is correctly portrayed.

Brands will always be correct.

IMPARTING

Brand Shepherd will allow brand information to be imparted from one party to another. In the same way that dialogue is exchanged so too will an individual's brand values and experience. We will all have access to others' brand personalities.

Brand values will form an important part of a person's clothing.

ADAPTABILITY

Brands will be able to quickly adapt to social and economic changes – in a climate of accelerated change this will become increasingly crucial to the survival of a brand.

Brands won't be fixed.

MALL

From hypermarket aisles to internet sites, ambient advertising to billboard posters, brands will escape flatland and become animated and fluid in their appearance. Through **Brand Shepherd** we will be captivated by brand.

Free from the constraints of traditional packaging and display.

REALITY

As Virtual Reality technology will enable us to experience the new electronic environment we inhabit, **Brand Shepherd** will allow us to empower the traditional environment. We will begin to remember the experience of static branding with nostalgia.

Brands will exist in symbiosis with emerging technologies.

UNDERSTANDING

As **Brand Shepherd** has the ability to access vast histories of consumer patterns it will be able to form an understanding of our personality and probable decision making.

Brands will be with us.

BRANDS PASSIVITY WILL END, AND INCREASINGLY AN ACTIVE INVOLVEMENT WITH THE CONSUMER WILL EMERGE – COMMUNICATING WITH, PARTICIPATING IN AND IMPARTING DATA FROM THE CORE VALUES AND PRINCIPLES OF PRODUCT.

0.1 in the future we will become integrated with the brand

BRANDS PASSIVITY WILL END, AND INCREASINGLY AN ACTIVE INVOLVEMENT WITH THE CONSUMER WILL EMERGE – COMMUNICATING WITH, PARTICIPATING IN AND IMPARTING DATA FROM

0.2 in the future we will become integrated with the brand

BRANDS PASSIVITY WILL END, AND INCREASINGLY AN ACTIVE INVOLVEMENT WITH THE CONSUMER WILL EMERGE – COMMUNICATING WITH, PART

0.3 in the future we will become integrated with the brand

BRANDS PASSIVITY WILL END, AND INCREASINGLY AN ACTIVE INVOLVEMENT WITH THE CON

0.4 in the future we will become integrated with the brand

BRANDS PASSIVITY WILL END, AND INCREASINGLY AN ACTIVE I

0.5 in the future we will become integrated with the brand

BRANDS PASSIVITY WILL END, AND INCREASINGLY AN ACT

0.6 in the future we will become integrated with the brand

BRANDS PASSIVITY WILL END, AND I

0.7 in the future we will become integrated with the brand

BRANDS PASSIVITY WILL

0.8 in the future we will become integrated with the brand

BRANDS PASS

0.9 in the future we will become integrated with the brand

BRAN

1.0 in the future we will become integrated with the brand

BRA

1.1 in the future we will become integrated with the brand

BRAND SHEPHERD WILL ALLOW US TO REALIZE THE TRUE POTENTIAL OF NON-STATIC BRANDING.

BRAND INTERPRETATION WILL BECOME PERSONAL TO THE VIEWER. BRANDS WILL RESPOND TO OUR PREDISPOSITIONS, RECOGNIZING OUR NEEDS AND REALIZING OUR DESIRES. BRANDS IN A BRAND SATURATED ENVIRONMENT WILL COMMUNICATE IN THE PUREST OF FORMS, PORTRAYING THE VERY CHARACTERISTICS WE SEEK, AND REASSURING US WITH THE KNOWLEDGE THAT THE BRANDED PRODUCT[S] IS IN ACCORDANCE WITH OUR INTERPRETATION OF OUR SURROUNDINGS.

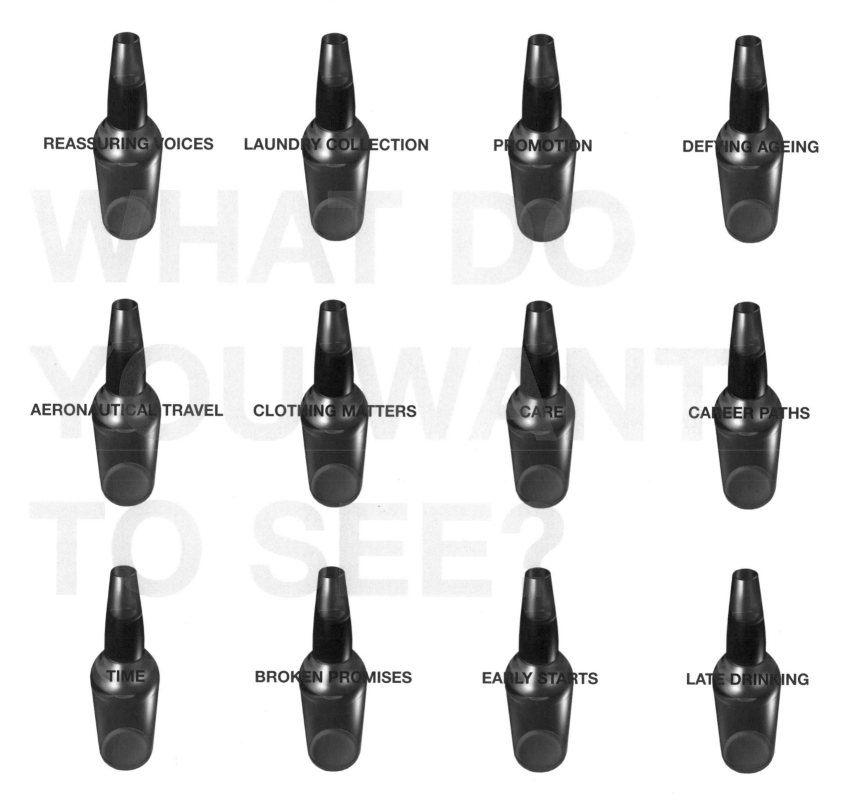

BR[AND]

ONE DAY THE ONLY LIMITS OF BRANDING WILL BE OUR IMAGINATION. WE WILL DETERMINE THE PARAMETERS AND POSSIBILITIES OF THE BRANDED ENVIRONMENT – WHAT WE SPECULATE WILL BE. OUR PERCEPTIONS WILL BE CONCEIVED THROUGH THE REALITY OF BRAND. NO LONGER CONFINED TO SHOPPING MALLS AND SHELVES; BRAND WILL BE AN INTEGRAL PART OF THE FABRIC OF OUR SOCIETY. EVERY ACTION WE TAKE WILL BE IN RELATION TO BRANDING – INFLUENCING THE FUTURE OF OUR ENVIRONMENT. ALL ADVANCES IN TECHNOLOGY WILL BE MIRRORED IN THE SOPHISTICATION OF BRANDING. ADVANCES OF VR/ANIMATION WILL RELEASE THE FULL POTENTIAL OF THE BRANDED EXPERIENCE BEYOND THE REALITY OF PRESENT-DAY CONSTRAINTS. WITH AN INCREASE IN PEOPLE WORKING FROM HOME WITH A DECREASE IN DIRECT SOCIAL INTERACTION OF THE BRAND, BRAND IDENTITY WILL BECOME MORE PREVALENT. THE TRANSMISSION OF SOCIAL INFORMATION WILL BE NECESSARY IN THE ABSENCE OF PERSONAL INTERACTION. OUR TASTES, DESIRES AND PREFERENCES WILL BE ABLE TO TRANSCEND THE PHYSICAL DIVIDES WE FACE. RATHER THAN BRAND BECOMING A REMOTE PHENOMENON THAT OCCASIONALLY REACHES US, BRAND WILL BECOME AN INTEGRAL PART OF THE POPULATION'S IDENTITY.

○ excel　○ adven　○ prov　○ vent　○ altan　○ isa　○ excel　○ acti　○ oft　○ isi　○ dyni　○ excel　○ as　○ excel　○ tria

○ arri　○ insig　○ daig　○ inven　○ nari　○ tel　○ contra　○ imar　○ chor　○ excel　○ acc　○ imar　○ excel　○ hydra　○ oft

○ utop　○ inno　○ arch　○ fruito　○ chor　○ isi　○ alka　○ excel　○ rana　○ comu　○ daig　○ excel　○ oftan　○ excel　○ imaro

○ centr　○ oft　○ alta　○ consig　○ hydr　○ contin　○ excel　○ net　○ utor　○ term　○ rentra　○ excel　○ sison　○ neoma　○ prov

○ assa　○ dyni　○ centri　○ viar　○ excel　○ acti　○ amora　○ ecc　○ excel　○ ex　○ asi　○ arri　○ ret　○ acc　○ sig

○ syns　○ tria　○ alam　○ hydra　○ futo　○ uni　○ hydra　○ excel　○ hydr　○ utop　○ excel　○ assa　○ cali　○ insig　○ uni

○ net　○ cali　○ excel　○ alka　○ as　○ excel　○ tec　○ ent　○ isi　○ alka　○ zeno　○ ex　○ lomo　○ excel　○ inno

○ futu　○ imar　○ amora　○ acti　○ net　○ trien　○ centr　○ ex　○ acci　○ tria　○ nari　○ excel　○ isi　○ asi　○ isa

○ insig　○ tria　○ ex　○ ven　○ thor　○ asi　○ assa　○ alka　○ excel　○ hydr　○ sig　○ atar　○ torr　○ acci　○ daig

○ fruito　○ excel　○ prov　○ inno　○ ret　○ excel　○ oft　○ ven　○ somm　○ ret　○ imar　○ prov　○ adveno　○ alka　○ oft

○ arch　○ tec　○ adveno　○ excel　○ seni　○ hydr　○ zeno　○ icu　○ ag　○ daig　○ insig　○ as　○ sig　○ seni　○ insig

Brand names.

In the future, we'll have instant brands DIY brands. Off-the shelf brands. Brands by the yard. But first, you need a name.

It should be a one-word name, and it should be formed by fusing two words, or bits of words, together.

It's easy, anyone can do it.

No need to pay a naming agency millions of dollars. You can do it yourself.

Here's how.

Draw a line between any two points on opposite pages and you've got a world-beating brand name.

It's that easy.

© Intro 01

○ alam　○ excel　○ ret　○ excel　○ hydr　○ uni　○ daig　○ trono　○ prove　○ as　○ astu　○ excel　○ asur　○ ex　○ somm

○ seni　○ as　○ prova　○ asur　○ contin　○ hydr　○ torr　○ usk　○ cela　○ asir　○ ven　○ tri　○ adven　○ tria　○ isi

○ hydra　○ ret　○ soar　○ somm　○ ventr　○ inno　○ excel　○ tria　○ asi　○ ret　○ ex　○ fruito　○ somm　○ diarg　○ zeno

○ isi　○ dom　○ asi　○ asir　○ tec　○ derg　○ icu　○ provo　○ via　○ ol　○ seni　○ el　○ tec　○ torr　○ icu

○ as　○ ecc　○ diarg　○ icu　○ celu　○ excel　○ adveno　○ erie　○ zeno　○ excel　○ exu　○ oxa　○ asi　○ ven　○ inno

○ ex　○ zeno　○ fruito　○ adven　○ tria　○ ret　○ as　○ scia　○ cein　○ tri　○ hydr　○ icu　○ isia　○ as　○ adveno

sis i ean ure ista isa sse ae eigo tora en oniag ete geo ium

ra nia sior ena ien tenor u ir ovee sen ren oten ean va ten

ia ren ta pia a isi eva ror iva ilia iena ese si se ta

iva o sys el ese el se ogy rus una in tor sor an on

ten in geo ica va an tor sys ovia i nee sa ara rogy ean

si tior ce on veer ava age ia um ara ica ii eva isa ese

en igo ara rus ria sior eria rogy el tec veer el ilia ista sior

isa ista rogy ia si aria ure enur neor oru o pia nisi ria o

ete ean ete ren ena ta sis on ogy a ra ir iva in sys

ili se ori ien sse ae igo ora aen tenor ror u veer rus ese

a ara sys rena pia sim ae rese ilium una va nia ren an ta

ara ese en ce si rogy an sior u sys ce igo ese ascape pia

an ren ilia va ese pia rigo aria on scape igo si in ien u

asior opa ori rus ese in rogy va veer rena en ilium rogy rogy ese

tec ina veer sior en ara en sys ce an nia ae tec ara a

rus ropia an ien scape ilium atec mat ini ori rus scape a veer ori

sis nia sior ese an ava si geo ara ce a u rus an o

in a culture in which the machine, with its impersonal and endlessly repeatable operations, is a controlling metaphor and considered to be the instrument of progress, subjectivity becomes profoundly unacceptable. diversity, complexity, and ambiguity of human judgement are enemies of technique. neil postman

thriftymart.

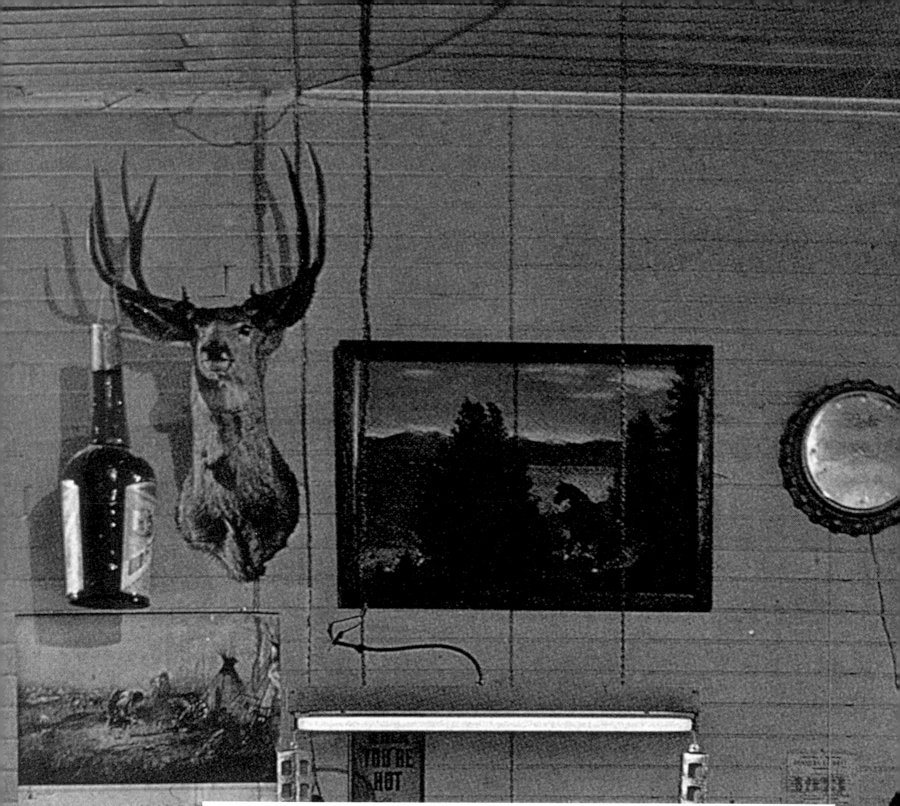

a mindset.
a physical space.
a feeling.
analog.
values people once believed in.
a reaction to technology.
a revolution.
tradition.

thriftymart.

rod stewart, .38 special,
judas priest, you might find
it here.
record or cassette.

books,
discard books,
note pads,

checkers, and
uno.

hammers, mugs,
keychains,
pencils
and paper,

records, pipes,
the liquor section (with liquor store smell),
wood, batteries, bargains,
a sofa, maybe,

5 for a dollar,
99 cents,
an expensive lamp,
a velvet painting mentality,
jean jackets.

a walk to the store.
put something in your shopping cart.
scan the aisles.
convenience,
the old fashioned way.

thriftymart. do it yourself.

printed in
CALIFORNIA STATE PRINTING OFFICE
SACRAMENTO 1ST PRINT, 300M 1956

NICHOLSON FILE COMPANY
BARNES SAW DIVISION

a long walk
parking lot,
a front entrance
greeting.
just down the
street. thriftymart.

thriftymart.

the internet,
intranet,
extranet, and differnet,
will not do.

a bedtime story.
imagination.
myth.
something to believe in.
(rockets red glare)

thriftymart.

a place to shop. a reminder of what was. a vote for tradition.
thriftymart.

BRICKHILL®

How much can you take?
Blow away the cobwebs of your predictable existence.
Prepare to accept your life's greatest challenge.
Select your Endurance Kit, choose your environment and we'll drop you right in it.
How, when… if…you come back is up to you.

Call **1-800-BRICK-HILL** for pricing policy.
www.brick-hill.com

NAME	
ADDRESS	
PHONE NUMBER	
NEXT OF KIN	
PHONE NUMBER	
LEAVING DATE	
NAME OF DENTIST	
PHONE NUMBER	
CREDIT CARD TYPE & NUMBER	
EXPIRY DATE	

■ The Hendley Kit
1 Complete vaccination prog.
1 GPS palmtop PC – remote access
1 Set of food rations (2 weeks)
1 Pack salt tablets
1 Fishing line and hook
1 Pack water purification tablets
1 Magnesium fire starter
1 Comprehensive first aid kit
1 Multi-tool knife
1 Sleeping bag
1 Single-person tent
1 Pair binoculars
1 Torch with spare batteries
1 Camping stove + tins/cutlery
1 Set of full apparel*
1 Good book
1 Pack flares

■ The Velinski Kit
1 Complete vaccination prog.
1 Local area map
1 Compass
1 Set of food rations (one week)
1 Pack water purification tablets
1 Magnesium fire starter
1 Standard first aid kit
1 Multi-tool knife
1 Space blanket
1 Groundsheet
1 Torch
1 Camping stove + mess tins
1 Set of full apparel*
1 Pack flares

■ The Hilts Kit
1 Complete vaccination prog.
1 Compass
1 Set of food rations (1 day)
1 Magnesium fire starter
1 Multi-tool knife
1 Space blanket
1 Set of boots and outerwear*
1 Pack flares

■ The Big X Kit
1 Machete
1 Cyanide capsule

(items vary by destination)

Destinations:
■ Polar
■ Rainforest
■ Desert
■ Ocean
■ Up
■ Under

BrickHill accepts no responsibility for injury or loss of life incurred during our endurance vacations. We strongly recommend that you prepare a Will prior to your departure.

Other recommended services: **diy-rip.com**

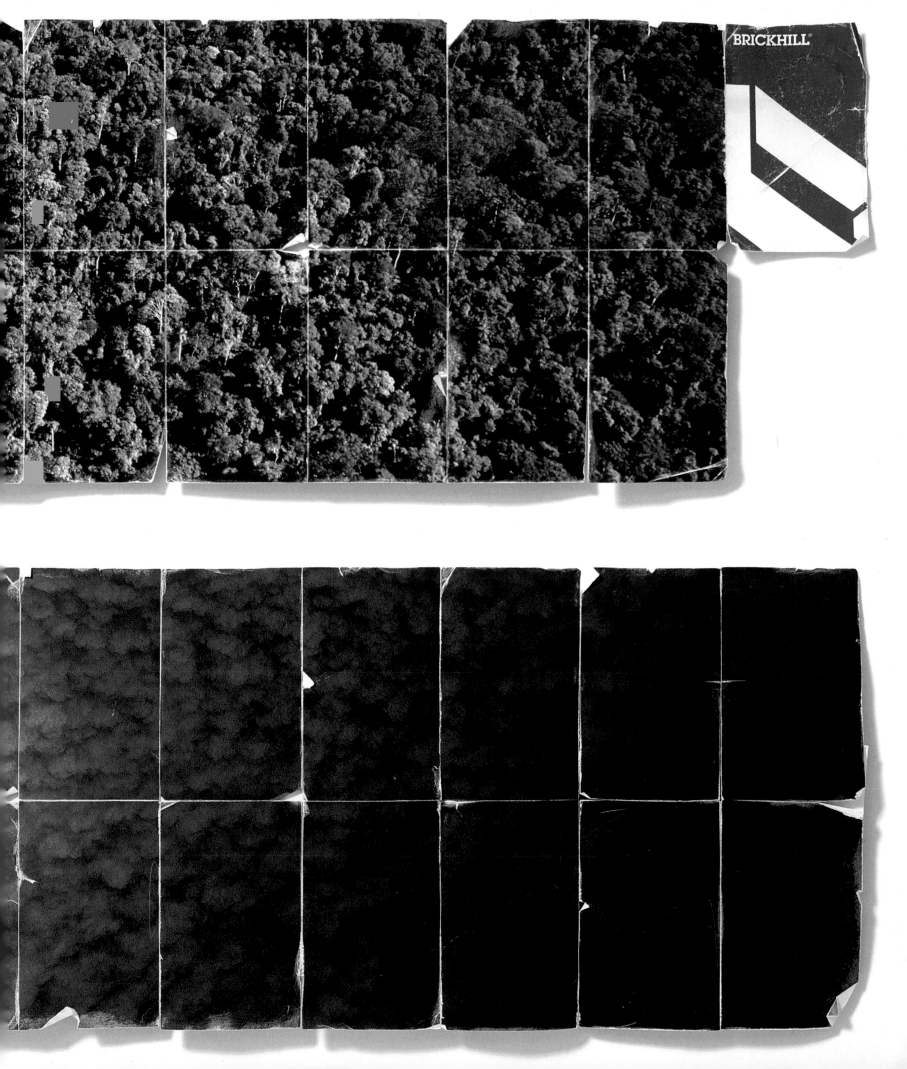

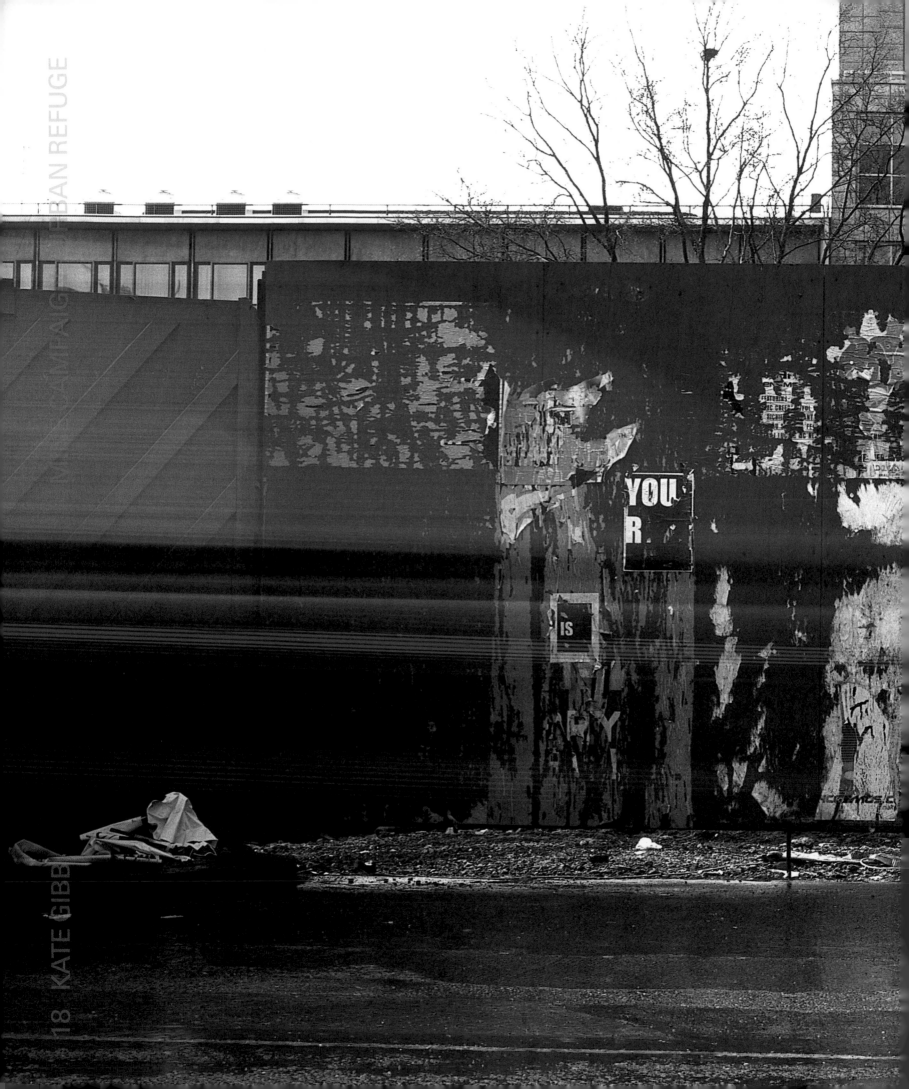

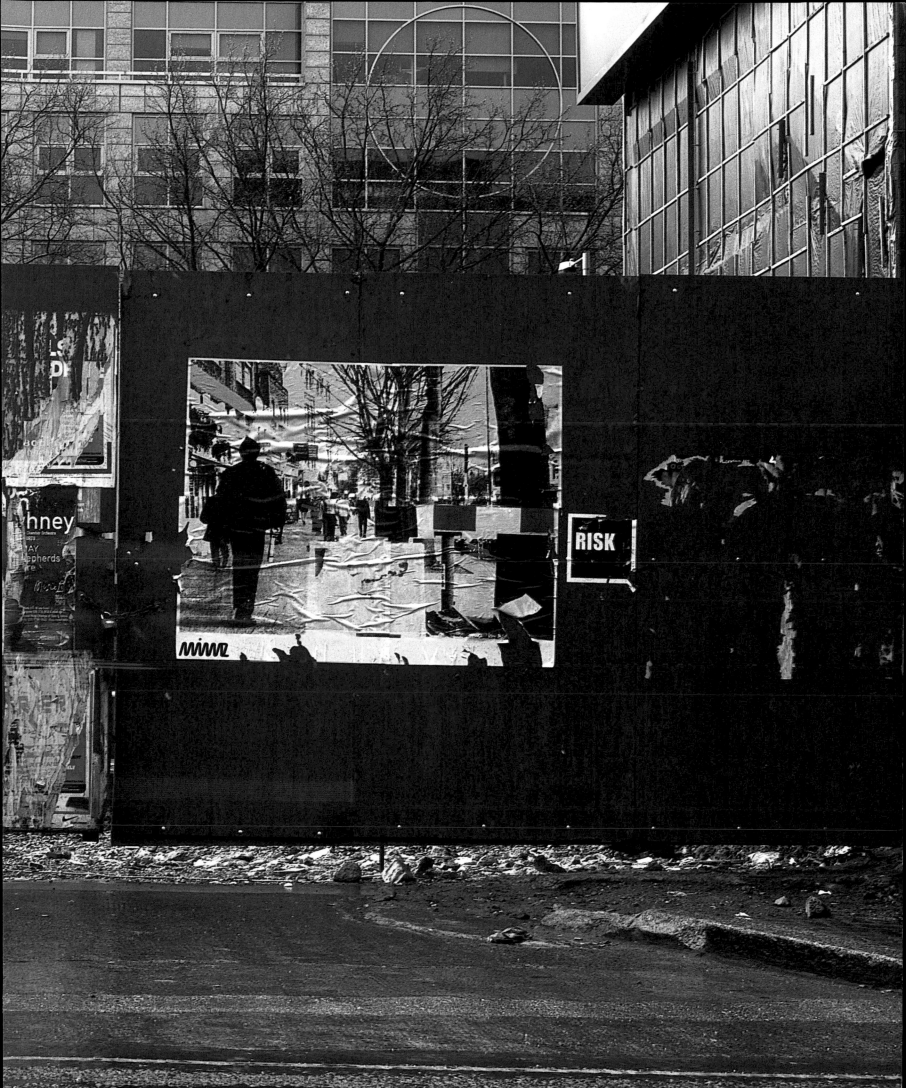

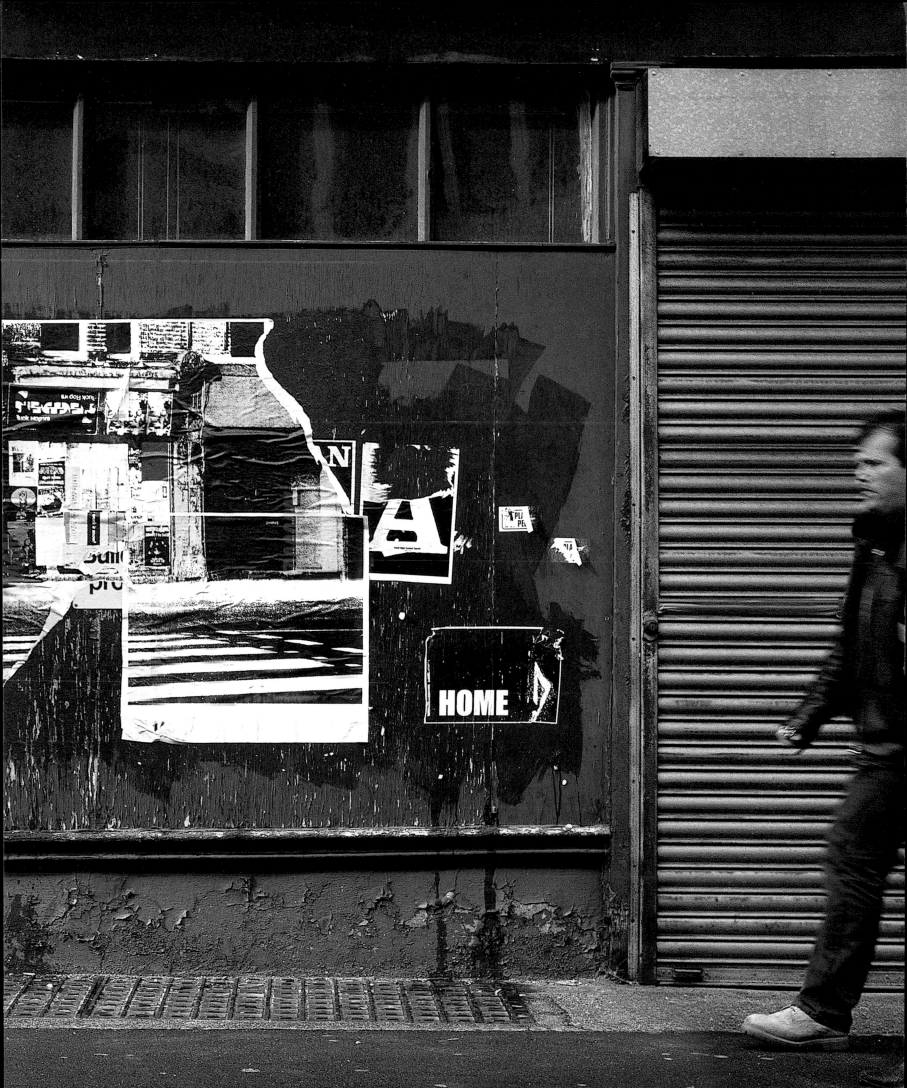

It's Your War

Are you an ambitious military professional? Considering hostilities but unsure of the outcome? Lacking propaganda expertise? War is a battle for minds as well as territory. And that is an expensive business. Fortunately, at WAR Channel, we believe it's our duty to help.

If a conflict escalates unexpectedly, it may already be too late. Without adequate capital, your combat units – however well trained and motivated – may soon be occupying body bags. State security agencies may be stretched in quelling civilian dissent. To stay in control, make sure you have solid financial backing – BEFORE war is declared.

WAR Channel will invest in your cause. We supply state-of-the-art technology, as well as expert tactical and strategic advice. And our propaganda will prove invaluable. These benefits can be yours in return for exclusive, unhindered media access to your WarSites and Personnel, to be transmitted on our worldwide digital television channel, WAR Channel.

Our Programming Department can prepare a comprehensive package to suit your circumstances. A wide variety of program formats and schedules are available to portray your war exactly as you determine, to shape global public opinion to your advantage. Programming can also be directed at your own forces, maintaining morale and reinforcing behavior.

Simply complete the form at the back of this brochure to receive your WarPack, outlining our initial offer. As soon as documentation is cleared by our lawyers and military advisers, your equipment and uniforms will arrive within 24 hours. The first film crew within 6 hours. -

Now, let's declare war!

More information:
www.warchannel-tv.com

<WAR Enemy Disorientation CD>

When staking out an enemy encampment, our Disorientation CDs can help break the spirit of the opposing forces. Each CD is created to take into account your enemy's unique culture and environment. We collect sounds and music that are most harrowing for and offensive to the ears of your foe, to be played very loudly at random times.

<WAR Motivational Music CD>

For your war to attain true mythic status, a memorable soundtrack is essential. For example, psychedelic rock that 'made' the Vietnam War. And studies suggest that morale and effectiveness are both improved dramatically by the right choice of musical accompaniment. Our Mood Control Department will tailor a package suitable as both a civilian chartbuster and a motivating tool for your battle forces.

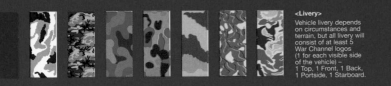

<Livery>
Vehicle livery depends
on circumstances and
terrain, but all livery will
consist of at least 5
War Channel logos
(1 for each visible side
of the vehicle) –
1 Top, 1 Front, 1 Back,
1 Portside, 1 Starboard.

abcdefghijklmn
opqrstuvwxyz
helvetica 75 bold

<Aircraft 03.02>
Alvis Huges
Model 500
Defender Light
Anti-Armor
Helicopter

12:36:21 13:14:56 13:47:21 14:29:17 14:03:55 14:38:52 15:26:11 15:43:58

<Smart warfare>
We have livery and apparel options suitable for all
theaters. These are stylishly designed to the highest
quality and are guaranteed for all battle conditions,
except thermonuclear. What's more, WAR Channel
branding strikes fear into the hearts of enemies, who
will soon understand the resources at your disposal.

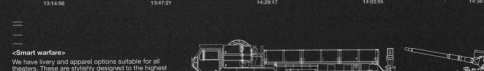

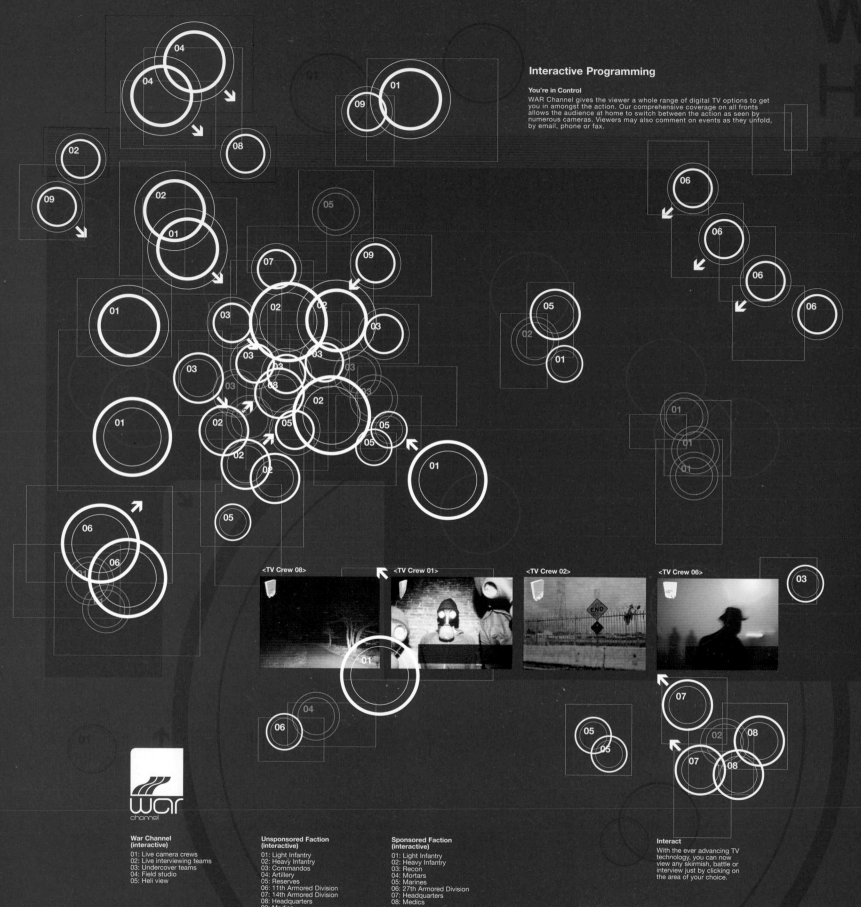

Interactive Programming

You're in Control

WAR Channel gives the viewer a whole range of digital TV options to get you in amongst the action. Our comprehensive coverage on all fronts allows the audience at home to switch between the action as seen by numerous cameras. Viewers may also comment on events as they unfold, by email, phone or fax.

<TV Crew 08> <TV Crew 01> <TV Crew 02> <TV Crew 06>

**War Channel
(interactive)**

01: Live camera crews
02: Live interviewing teams
03: Undercover teams
04: Field studio
05: Heli view

**Unsponsored Faction
(interactive)**

01: Light Infantry
02: Heavy Infantry
03: Commandos
04: Artillery
05: Reserves
06: 11th Armored Division
07: 14th Armored Division
08: Headquarters
09: Medics

**Sponsored Faction
(interactive)**

01: Light Infantry
02: Heavy Infantry
03: Recon
04: Mortars
05: Marines
06: 27th Armored Division
07: Headquarters
08: Medics

Interact

With the ever advancing TV technology, you can now view any skirmish, battle or interview just by clicking on the area of your choice.

war
channel

20:51:47 21:26:32 21:59:00 22:30:00 22:46:05 23:14:52 23:41:42 00:00:00

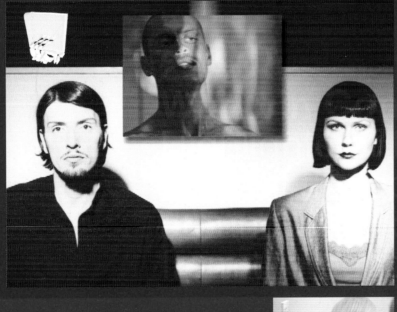

<TV Crew 05>

<TV Crew 02>

<TV Crew 03>

News Blips
This brings you hour by hour War updates of what's on and where it's at.

reporter
Amanda Muslu
Going Undercover

Bulletins
WAR Channel delivers regular news bulletins throughout the day, as well as scheduled in-depth programs. These bulletins can deliver particular propaganda messages, proven to affect the perception and direction of battles.

Monday 31 May

06.00 Power Breakfast
Our regular morning briefing on global events amongst the power elite.

09.00 ChitChat
A studio audience debates whether children should be allowed to fight alongside adults. Followed by WAR News and Weather

10.00 Field Hospital
Sharing the trials and triumphs of life with medics at the front line.

11.00 Home Front
Another helping of the program following anti-militia operations.

12.00 Minefield
Return of the nail-biting game show, as four more contestants try not to lose their heads (or any other limbs) as they aim for the $1million top prize.

12.30 Civvy Street
The gripping soap that follows the trials and tribulations of service veterans trying to adjust to life after the Forces.

13.00 WAR News and Weather

14.00 Ground War
The series following the men, women and technology engaged in combat on the ground. This week: Deserts.

15.00 Wheel of Misfortune
Quickfire quiz show, in which contestants from the armed forces must solve the word puzzles or pay a hair-raising forfeit.

16.00 Peter's Plutonium
Special double episode of the children's cartoon about school boy Peter and his nuclear-fuelled adventures.

17.00 You've been Shot!
Amateur footage sent in by armed forces personnel, showing more zany pranks and breath-taking pratfalls.

18.00 WAR News and Weather

19.00 Hostilities
Collecting Shells. Another episode of the award-winning sitcom.

19.30 Reunited
Tear-jerking moments as more MIAs are reunited with families and former comrades.

20.30 Trouble with the Neighbors
This week: Disagreements in central Europe.

21.00 Grill Flame
New series of hard-hitting interviews. Guests to be confirmed.

22.00 WAR News and Weather

22.30 World in Conflict
Highlights of the day's action from all the combat theaters around the world, with comment from the pundits.

00.00 World's Dumbest Soldiers (Repeat)
An hour of clips, featuring those moments that fighting people would rather forget!

01.00 Who Dares! (Repeat)
More exceptional feats of bravery from ordinary members of the public.

02.00 WAR News 24 Global headlines. **02.30** Middle East Theater Today. **03.00** World Arms Trade Business Report. Analysis. **03.30** WAR News. Global headlines. **04.00** Pacific Theater Today. **04.30** WAR News. Global headlines. **05.00** European Theater Today. **05.30** Asian Theater Today.

Enter

Merchandising Spin-offs
Long-term profits to be made through
the marketing of your war's highlights
on video and DVD inc. favorite battles,
hero-profiles, equipment analysis,
biggest explosions, phattest guns.
Also, sound-track albums, T-shirts
and the auctioning of film and
interactive games rights.

Potential Audience:
50M

Peace Time
Peace Time is an undetermined quantity.
It can last a lifetime or it can flicker as
fragile as a candle in restful moments
between the gunfire and the arguments.
We at WAR Channel have put many
hours of study into what we call Peace
Time and we recognize its benefits to
society as a whole. However, peace is
not our business.

Ratings: 0

Peace Talks 2.0
Poltical focus.
Negotiation specials.
Public interest waning.
Viewing figures plummet.

Ratings:
2M

War End
Round-up
Analysis
Ratings:
2M

Brooding
NB. If on second or third
cricuit of war chart, this
time can be used to rekindle
splinter groups & spark
unrest before restarting.

Ratings: 200,000

Flare-up 1.0
Riots, border skirmishes,
loose threats, recruitment.
Ratings:
News only 500,000

**Arrival of
WAR Channel**
War Channel sponsorship
commences. Camera crews
introduced to warsite.
Schedules redrawn to
include new war footage.

**Progression:
Action 2.0**
As with Action 1.0
focus on specific
battles, secret raids,
insider opinions from
the ground. Much more
gritty than Glamor
and Action 1.0 periods
as desperation sets in.
Very popular with all
viewers. Duration
typically 2 to 16 months.

Ratings:
23M Worldwide
peaking at news slots.

Glamor Period
Typically a two to three
month period with rapidly
escalating ratings. Maximum
interest during whole war,
particularly in glamorous
raids. Max Specialist feature
programs: action specials,
interviews, strategy focus
with celebrity panels etc.

Ratings:
500,000 increasing to
approx. 35M worldwide

**Hardware
Features**
Generic Programs focusing
on weapons and vehicles
Inc. tanks, aircraft, water-
craft, gadgets, spying
techniques. Compare and
contrast with parallel
wars past and present.

**Progression:
Action 1.0**
Focus on specific battles,
secret raids, insider
opinions from the ground,
more gritty than glamor
period means more specialist
viewership. A two to 12
month period.

Ratings:
Level off at a steady 20M
worldwide, peaking at
news times.

Flare-up 2.0.
Sparked riots, skirmishes,
insults and blame. Viewer
interest rekindled. A short
lived stage measured in
weeks. Occasionally skips
the next stage going straight
to Peace Talks 2.0.

Ratings:
18M Worldwide

Talks Fail
News focus slots
plus specialist
programming.
Editorial opinion
& blame accorded.

Ratings:
News
– Up to 25M
Specialist shows
– 8M to 14M

Peace Talks 1.0
Character profiles.
Political leaders
and negotiators
evolve as
influential
characters.

**Heroic
Profiles**
Focus on individual
heroics. Human-level
stories and drama.
Small-scale personal
effects.

Ratings:
Depends on particular
incidents 5M to 20M

Your War Progress Chart – Projected Ratings
Starting at Peace Time, follow the chart clockwise to check
rating fluctuations through the progess of a typical war
period. Of course, no war is identical but this exclusive
chart is the accumulation of more than 500,000 war-hours'
experience and can be relied on for nearly all scheduling
up to a year in advance. Advertisers will not even
consider supporting a new war without first seeing
a comprehensive application of this chart.

Negotiate now – before your enemy does

To give yourself the competitive edge, hook up with WAR Channel.
With many satisfied clients around the world, we can state confidently
that an association with WAR Channel could prove to be the difference
between victory and defeat.

It's your war – Negotiate now

YOU

- TITLE ▮▮▮▮ INITIALS ▮▮▮ SURNAME ▮▮▮▮▮▮▮▮▮▮▮▮▮▮▮▮▮▮
- CURRENT LOCATION GIVE EXACT GEOSAT GLOBAL POSITIONING COORDINATES ▮▮▮▮▮▮▮▮▮▮▮
- CURRENT RANK EG.PRESIDENT/PRIME MINISTER/GENERAL/ADMIRAL/INDEPENDENT ▮▮▮▮▮▮▮▮▮
- PREVIOUS EXPERIENCE GIVE WARS/RANKS/MEDALS/KILLS/SCALPS ▮▮▮▮▮▮▮▮

YOUR WAR

- NAME OF WAR ▮▮▮▮▮▮▮▮▮▮▮▮▮▮▮
- NAME OF YOUR FORCE ▮▮▮▮▮▮▮▮▮▮▮▮▮
- NAME OF MAIN OPPOSITION ▮▮▮▮▮▮▮▮▮▮
- NAME(S) OF THIRD-PARTY PARTICIPANTS OF WAR ▮▮▮▮▮▮▮▮
- EXPECTED DURATION OF WAR ▮▮▮ YEARS ▮ MONTHS OVER BY CHRISTMAS PREDICTION? TICK YES ▮ NO ▮
- LOCATION(S) OF WAR ▮▮▮▮▮▮▮▮▮▮▮▮▮▮▮▮
- PRIMARY TYPE OF TERRAIN OF WARSITE EG.URBAN/DESERT/SNOW/PLAINS/PRAIRIES/WOODLAND ▮▮▮▮▮▮▮
- Nº OF BATTLES TO DATE ▮▮▮▮ Nº OF BATTLES WON ▮▮▮▮ Nº OF BATTLES LOST ▮▮▮▮
- COLLATERAL DAMAGE: YOUR SIDE ▮▮▮ OPPONENT ▮▮▮

OUR CONTRIBUTION (WHAT YOU EXPECT FROM US)

- DO YOU REQUIRE WAR CHANNEL SPONSORSHIP TICK YES ▮ NO ▮ IF YES HOW MUCH? $ ▮▮▮ , ▮▮▮ , ▮▮▮

IF YES IS TICKED AS THE ANSWER TO THE ABOVE QUESTION YOU ENTER THE STRICT WAR CHANNEL TERMS & CONDITIONS AT THE BOTTOM OF THIS FORM

- EQUIPMENT REQUIRED: (ENTER QUANTITY) BATTLE UNIFORMS ▮▮▮ CASUAL WEAR ▮▮▮
- TANKS ▮▮▮ PERSONNEL CARRIERS ▮▮ 8 x 8 ▮▮ 6 x 6 ▮▮▮ 4 x 4 ▮▮▮
- DO YOU REQUIRE CATALOGS FOR: (TICK) PLANES ▮ HELICOPTERS ▮ SEA-CRAFT ▮ INLAND WATERCRAFT ▮

SIGNATURE [] PRINT ▮▮▮▮▮▮▮▮▮▮▮▮▮▮▮▮▮▮

TERMS AND CONDITIONS **1. Control of your government and armed forces may be at risk if you renege on any contractual obligations or supply false information to obtain sponsorship that would otherwise be refused.** 2. WAR Channel will not consider any conflicts based purely on religious differences. Your Cause must be a political, territorial or cultural dispute involving armed warfare between two forces of comparable strength. 3. WAR Channel requires unhindered access to your 'WarSite', defined as any zone of activity where the enemy may be engaged. This includes all your territory, regardless of the potential for confrontation. 4. Combat personnel will not be supplied by WAR Channel. In addition, WAR Channel operatives will not engage in military activity under any circumstances. Please do not embarrass yourself or us by requesting such action. 5. We strive to give our clients the coverage they request. However, ultimate editorial control over transmissions remains with WAR Channel.

Negotiate now – before your enemy does

the

tangential®

PLEASE SELECT
ANOTHER FORMAT

tangential.
embrace the bump

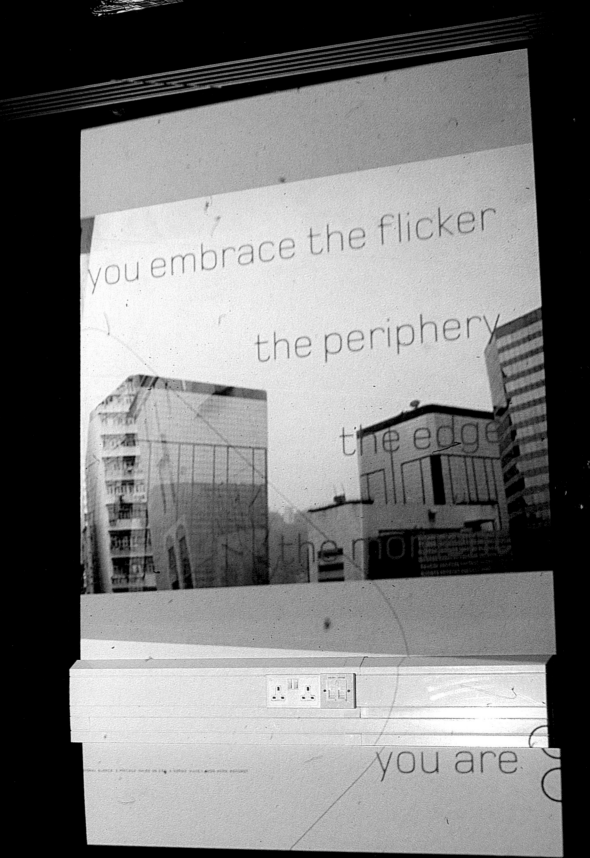

The privatization of personal space continues worldwide, as 'armed response', gated communities, and private security services help to define the city life experience.

There is no sign of a let up yet in demonstrating how far privatization can go. Planned unit developments (PUDs) are a growth business, offering privately developed and operated communities with their own carefully devised identities. Source: GICR. Brand: 29

Mobility and stability have an essential and developing interplay in all products and services, reflecting the shifting values of the customer. For example, 32.4 per cent of Americans aged 20–29 move to new cities (cities other than their hometown or location of their university). Of these, 59 per cent moved within the same county. Overall, 42.6 million Americans relocated for their jobs in 1999. Source: American Demographics, 2001. Brands: 06 22

New kinds of households appear: monoparental families, DINKS couples (Double Income No Kids), unmarried couples (including homosexual ones), loosely organized group homes, and new nuclear families with an increasing participation of women in the labour market. These are all steps towards a new social pattern: individuals living alone. Reference (www.members.tripod.com). Single person households will double to 33 per cent of all households in the UK by 2011. Increasingly, the counter-trend – large, close families with strong shared values – will kick in, encouraged by government action to stimulate 'structured breeding'. Source: GICR. Brands: 17 22 24

Therapy, drugs and corrective surgeries will be the beginning of an industry to cash in on the side effects of excessive use of mobile telephony. Full service healthcare and 'well-being consultancy' are the larger opportunities if fears of danger from radio waves come true. (In June 1998 The Lancet reported that electromagnetic radiation from mobiles causes an increase of blood pressure in humans. Mobile phone studies on animals suggest that mobiles can also cause brain tumours, cancer, anxiety, memory loss and serious birth defects.) Reference www.icswebsite.com Source: GICR. Brand: 27

At least 64 federal websites use software that allows U.S. agencies to track user browsing and consuming habits, despite privacy laws that forbid it. The revelation was made in a congressional report based on audits of 16 government departments, including Education, Treasury and Interior. The Center for Democracy and Technology has urged President Bush to fill a post created to ensure that the government sticks to privacy policies. 'Federal Web Sites Tracking User Habits'. Brand: 22

Researchers at the University of Illinois have developed a new material they say is capable of healing itself in much the same fashion as a biological organism. The composite material contains densely packed capsules, each filled with a chemical agent that automatically heals the surrounding material when released. The process mimics how the human body responds to damage. Reference: Nature journal. Source: GICR. Brands: 21 36 37 39

Extropians are headquartered in Marina Del Rey, California at The Extropy Institute. The non-religious group, comprised largely of techies, focuses on hard science and 'Nanotechnology' for the key to attaining a 'posthuman' state, in which the human mind may be able to leave its biological host altogether. The President of the Extropy Institute envisions a future in which our consciousness could be 'uploaded' to a computer either through increasingly detailed brain scans or invasive procedures, where microscopic robots chart brain tissue that's removed layer by layer. Pay-offs would be vastly expanded lifespans, million-fold more powerful computers, DNA repair treatments and neural implants that give us the ability to concentrate better and choose our feelings. Source: GICR. Brands: 26 35 36 39

Bioengineers are looking to slice out soy genes that make tumour-blocking chemicals and splice them into wheat, corn and other grains to create a cornucopia of anticancer foods. Devices called 'gene guns' will bombard plants with bits of DNA stuck on tiny particles of gold, embedding foreign genetic material inside the plants' cells. Source: GICR. Brands: 27 36 39

The mass-production of culture could lead to less desire for artists to sell complete works or performance, and instead more demand for new kinds of cultural componentry that enable the end user to more clearly own their own cultural experience. 'What people are going to be selling more of in the future is not pieces of music, but systems by which people can customize listening experiences for themselves. Change some of the parameters and see what you get. So, in that sense, musicians would be offering unfinished pieces of music – pieces of raw material, but highly evolved raw material, that has a strong flavor to it already.' Brian Eno Wired magazine. Source: GICR. Brands: 13 24 37

Our increasing desire – if not need – to maintain 24-hour vigilance in controlling our personal environments will impact on workplaces, public spaces, retail and entertainment environments and the home property market. This follows numerous health scares and real incidents of rising disease. Across the U.S., doctors who treat patients with sick-building-related illnesses say caseloads have mushroomed 40 per cent in the past decade. 'There are more and more chemicals being introduced into the office environment through synthetic products, and ventilation systems have not caught up with being able to deliver fresh air,' says sick-building specialist Dr John B. Sullivan Jr of the University of Arizona College of Medicine. Reference 'Is your office killing you?', June 5th 2000. Source: GICR. Brands: 20 27 29 32 38 39

Undetected plagiarism.' Dean WR Inge, Philosopher, (1860–1954). Brands: 09 23 24 33

Clone Rights United Front has launched a bill of rights on www.clonerights.com which says that any individual's DNA is his or her personal property. To have that DNA cloned into another extended life is his or her right to control his or her own reproduction. However, cloning people is 'contrary to human dignity' declares The United Nations. Meanwhile, there are signs of a web-based trade in DNA, even as far as parents authorizing the cloning of their dead baby by an extreme religious group. Reference: Wired, 2001. Source: GICR. Brands: 02 23 28

'Those who do not want to imitate anything, produce nothing.' Salvador Dali. 'What is originality?

O2

Athens
Beijing
Calcutta
Dallas
Frankfurt
Guiyang
Houston
Istanbul
Jakarta
Kiev
Los Angeles
Mexico City
Nanchang
Osaka
Prague
Quito
Rome
São Paulo
Tehran
Urumqi
Vienna
Warsaw
Yokohama
Zurich

O2 Worldwide Statement

15 March 2075

| Standard atmospheric oxygen | | 25 ccf |
| Vitamin-fortified oxygen | | 09 ccf |

Service	February to March	Amount
Residential usage		250
Transportation usage		150
Mobile pack usage		150
City tax		15

Total amount due	$ 565

Rotating Oxygen Grid Number	Block 08

Remember to conserve Oxygen is a precious resource. Set residential valves at 42 psi when sleeping or leaving home for the day. Pets need less! Cats 20-25 psi, Dogs 30 psi.

Caution The manufacturing of home-made oxygen by plants, soils and other means is strictly prohibited. There is a high risk of under or over diluting pure oxygen which can result in serious health risks, including hypertension, air bubbles in the blood and even death. Please make sure the oxygen you are inhaling carries the official O2 stamp.

Now pay by credit card and recharge mobile packs at any ATM or O2 kiosk in your city.

Citizen's guide to breathing and exertion

O2–x	watts	VO2	METs	kcal/min		walk	run		work activity	athletic activity
0300	50	0.9	4-5	5		3.0			data entry	skating
0600	100	1.5	7-8	8		4.5			biodilation	trailing
0900	150	2.1	8-10	11		5.0	5.5		routing	water luge
1200	200	2.8	12	14			7.0		telerotation	tower bungie
1500	250	3.5	14	17			8.0			hockey
1800	300	4.2	16	20			10.0			sky boarding
2100	350	5.0	18	24			12.5			centonometrics

expiratory lung volume / heightened conditions 1200ml sum v(t) 600ml

expiratory lung volume / moderate conditions 1200ml sum v(t) 600ml

expiratory lung volume / normal conditions 1200ml sum v(t) 600ml

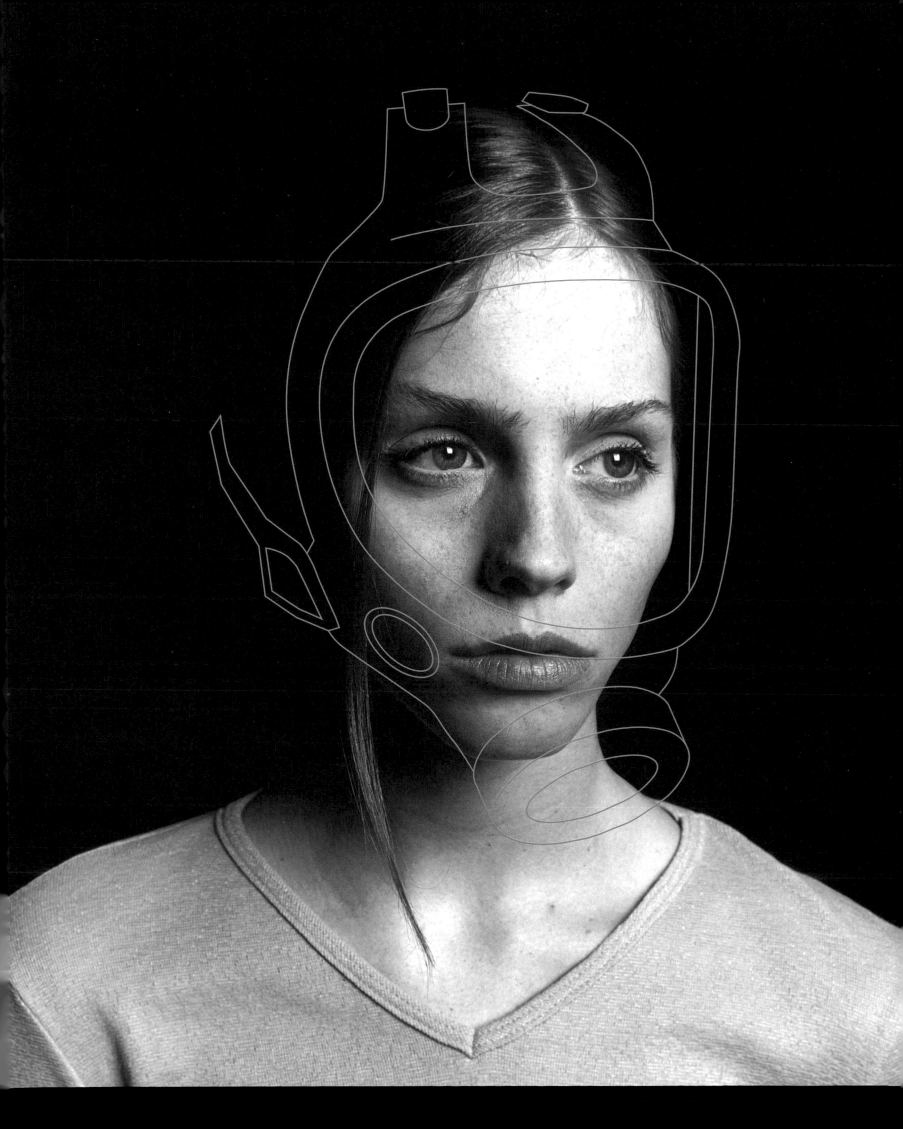

Gecko™
Living tyres

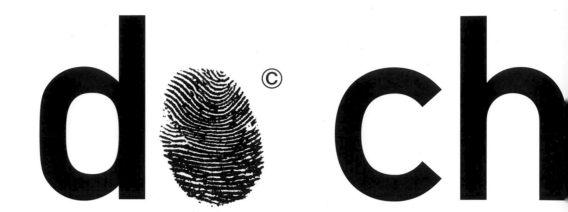

We are all addicts. We all have soul destroying habits. Ones that slowly but surely drag us down, alter our minds and make us do bad, bad things. We're not talking about the obvious ones that destroy our health like smoking or drinking or taking drugs or eating mad beef. We're talking about all these comforting, repetitive, second nature acts we commit every minute of every day. The things we would find most difficult to break if challenged to do so. Habits like tying your shoelaces the same way or walking to work by an identical route as yesterday or the day before that. Habits like that way you always stretch in the morning when you wake up or how you always start reading a magazine from the back page to the front. These are the real killers. These are the real reasons we slowly disintegrate. Without us hardly noticing, we begin to rely, more and more, on our in-built cruise control.

'do change' is here to relieve you, to serve you up a big plate of cold turkey to help kick those habits. And all that is required are a few small shocks to your system.

However, before we start giving you nuggets of advice on how to change your life, we feel it's only polite to introduce ourselves.

'do change' is the name of an experiment from 'do', a new kind of ever-changing brand which, as the name suggests, depends on what you do.

'do' was first set up with only a mentality, offering an antidote to other one-way brands, where you were just the receiver of goods, the end of the production line. 'do' wanted to ask the consumer or other brands to add something of themselves, bringing a unique, personal kind of imagination to products and services of the future. In essence, 'do' survives only when other people want to get involved and do things.

And because 'do' is constantly changing, it has developed projects in a wide arena.

There's the do-tv experiment, a 24-hour worldwide internet conference about the dream demon, television. Over 5,000 people logged on and let themselves be heard - from a viewer in Tonga to TV directors in New York.

Then there's 'do create', doing the rounds in Paris, Rotterdam, London and Tokyo. 'do create' is a series of products that are unfinished, until you do. This includes a chair with one leg shorter than the other three – you need to add something to it, like a pile of magazines, to make it complete. Or there's the ceiling lamp with two handles to allow you to swing to and fro through the air and have some kinky fun in your living room. There's also the do website, dosurf.com which invites together a whole network of interested parties to read and realize do ideas.

ange

And now there's 'do change' which begins with a question: what in the world could be changed for the better? What can 'do' provide to give a solution for the sake of all our tomorrows? The do doctors got to work and constructed some future design prototypes using bits of ordinary household objects, a small toolbox, assorted wires and switches, and a bottle of tequila. The first idea: something called The Breathing Television, a cure for hopeless TV addicts. The picture on the Breathing-TV screen would get progressively smaller the more you watch it. After some hours of continuous viewing, the picture shrinks to almost nothing. Switch off the TV for a period of time and it will gradually grow back to normal size. Less fat-building hours in front of the box are guaranteed.

Another thought: the 'do watch', where you have to answer 350 questions about yourself before you part with your cash. Questions from 'What is your favourite colour?' to 'Where do you stand on the death penalty?' or the more metaphysical such as 'Is sex the answer?' The watches are programmed with this personal information and allow you to link by infra-red to another person who has a 'do watch' and check your compatibility, or otherwise.

These inventions, or rather positive extensions of existing inventions, fit nicely into the do mentality. They require action and reaction.

Despite this, we felt that we were starting at the wrong place. Rather than giving birth to the latest washing machine, the newest eating utensil, the next revolution in office table lamps, or an updated television or funky watch, 'do' wanted to begin with the most important object. The one that needs constant renovation, the one that we always seem to forget about in our Palm Pilot scheduled lives: ourselves.

A few hundred years ago, being inventive meant simply finding the best methods of survival. It centred on our own immediate needs. Now life is all about the objects around us. We've become so inventive it hurts: we have lotions to cure and pills to kill; electronic products to spend time and win time; machinery of personal instruction and mass destruction. There are inventions so niche most of us will never know they've been invented. Decades of research can be spent revolutionizing the toasting of bread.

It seems that we're running out of things to invent, so we're regurgitating ideas and fantasizing complexities.

What we should really be thinking about is that most of the products we have around us seem to work quite nicely, thanks very much. Effecting any real change and finding the things no one else has thought of before has to come from the everyday.

That means waking up in a different way, doing your job in a way it has never been done before, or with someone you've never considered working with before. Creating real change can mostly involve small measures. What would happen if you decided to eat cereals in the evening instead of at breakfast?

The reason is not to find out just about that specific thing but to explore and look at your normal life in a completely different way. Soon, you might get around to thinking that a table should have more legs or your computer needs a circular keyboard with enough room for five people to allow a more social atmosphere. Maybe it will lead to the one object no one could bear leaving home without three years from now. Maybe it will give us clarity of vision. Maybe it will help provide a solution to something that won't have reference to anything we've ever seen before. Maybe it will help us clear the traffic jams in our heads. At the very least, it will help cure us of our habit addiction.

This is the premise for 'do change'. An experiment in changing the way we do.

You will find here a list of 'do change' ideas designed for the person rather than the machine. These ideas are categorized in the following areas: work / home / anywhere.

do at least one 'do change' experiment from each category, with some offering small changes, others extreme. Feel free to choose your preferred option in this D.I.Y. workshop, then let others know of your successes or otherwise, online. The website address is http://www.dosurf.com/change.

So what can we project will happen? Chaos and anarchy? An outbreak of radical free-thinking? An orgy of free-love? Or will we all just use a different method for spreading jam on our bread? do change, unlike its older cousin, lateral thinking, has no clear problem to solve, so there isn't a logical goal derived from its illogical beginnings.

In the end, these ideas that burst free from the womb of 'do change' are simply about looking at the things we take for granted in a completely different way. They're not about being crazy just for the sake of it, but they can be. Mostly, 'do change' is about changing patterns, about reinventing yourself. That is the way that we'll see real innovations come about in the future.

Ok – enough talk. Let's get to work.

Work–
• Ask some kid on the street for advice instead of your mentor.
• Swap workspace with your boss/employee.
• Leave your phone, diary, wallet and other pocket-bulgers at home.
• Walk to work with a limp in your left leg.
• Open your shop/business when everyone else closes theirs.
• Sing your national anthem in a crowded elevator.
• Talk to the shoes of colleagues.

Home–
• The next time the doorbell rings, answer it naked.
• Have your evening meal on the stairs.
• Don't leave the house for a week.
• Turn off all electricity.
• Avoid using cutlery, glasses, cups or plates.
• Sleep upside down.
• Use your living room window instead of the front door.

Anywhere–
• Dress up as a magician for the day.
• Write notes instead of speaking.
• Leave strange Post-It note messages on the street / subway / supermarket.
• Open your windows in a car wash.
• Don't avoid obstacles, walk into them.
• Repeat everyone's words.
• Change your name for different occasions.

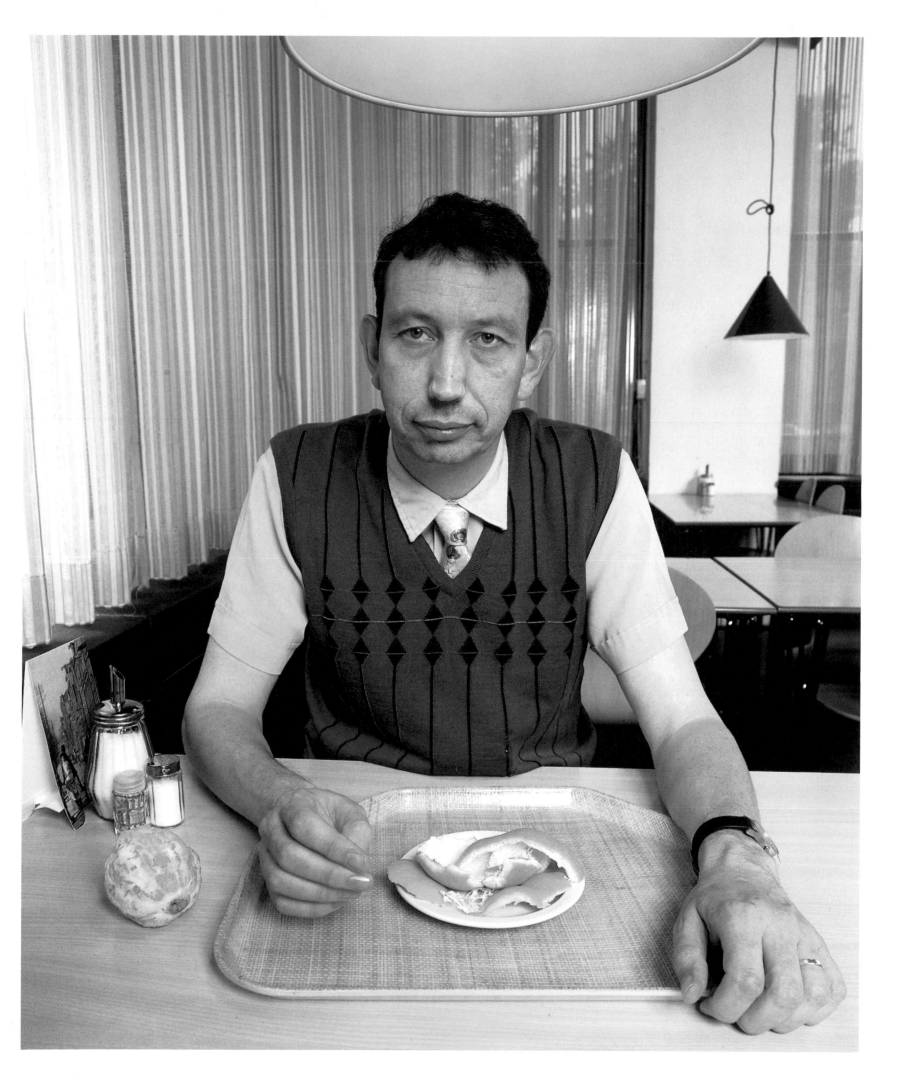

Sleep like a baby
and be up all night.
We can double you.

double you

1.

From just one healthy blood cell,
we can create a perfect replica
of your greatest asset. Yourself.
Take a holiday while you're hard
at work. Enjoy domestic bliss
and act the wild-child. Never be
short of an interesting companion.

MAGIC HAT

We say, 'if it can be done, do it!'– wux2.com

**Sleep like a baby
and be up all night.
We can double you.**

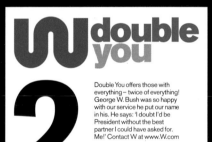

Double You offers those with
everything – twice of everything!
George W. Bush was so happy
with our service he put our name
in his. He says: 'I doubt I'd be
President without the best
partner I could have asked for.
Me!' Contact W at www.W.com

We say, 'if it can be done, do it!'– wux2.com

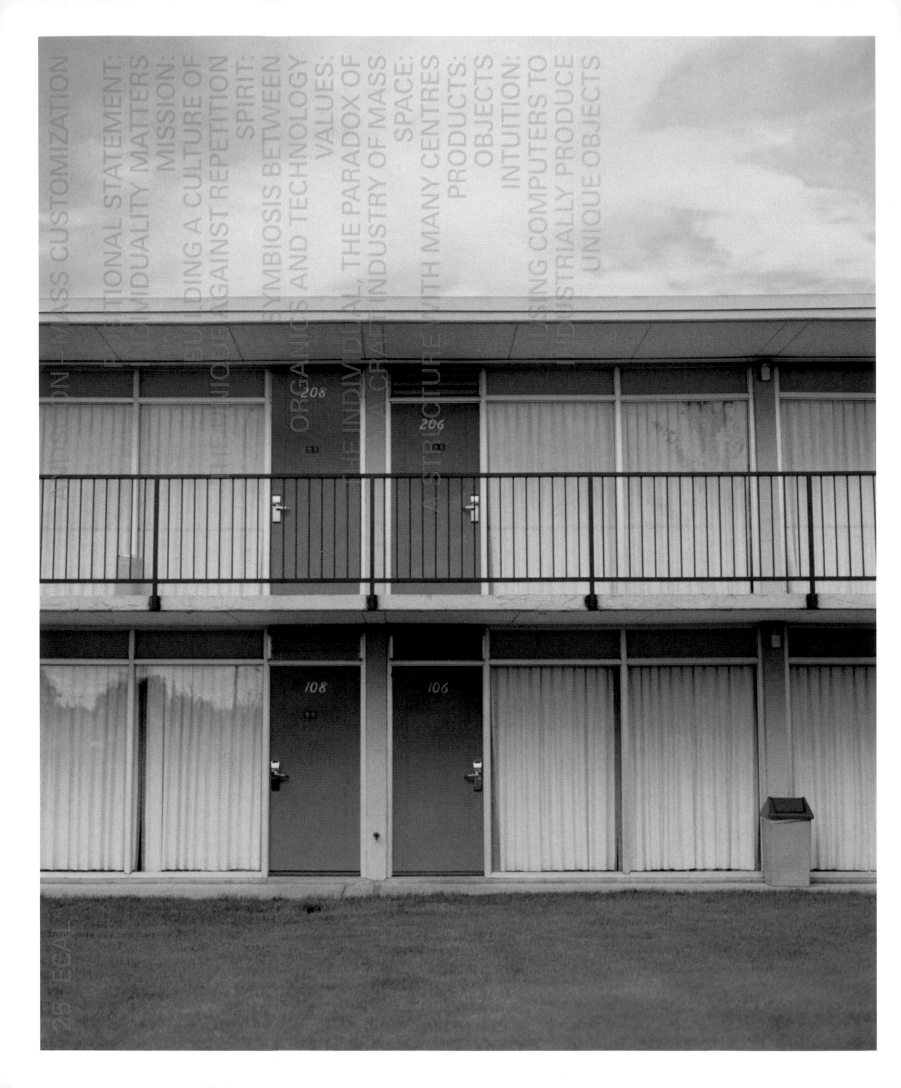

ON MASS CUSTOMIZATION

POSITIONAL STATEMENT:
INDIVIDUALITY MATTERS

MISSION:
BUILDING A CULTURE OF
THE UNIQUE AGAINST REPETITION

SPIRIT:
SYMBIOSIS BETWEEN
ORGANICS AND TECHNOLOGY

VALUES:
THE INDIVIDUAL, THE PARADOX OF
A CRAFT INDUSTRY OF MASS

SPACE:
A STRUCTURE WITH MANY CENTRES

PRODUCTS:
OBJECTS

INTUITION:
USING COMPUTERS TO
INDUSTRIALLY PRODUCE
UNIQUE OBJECTS

Space, where words were.

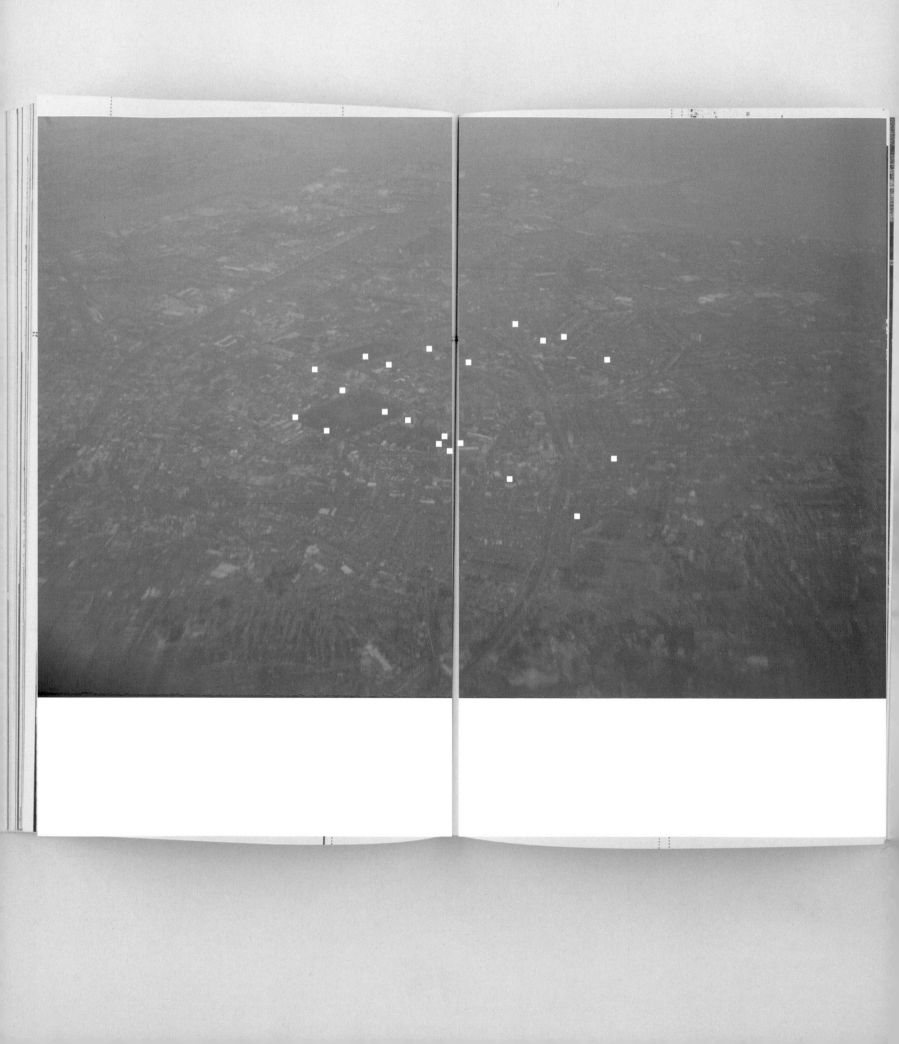

FROM **THE LAST TIME I TOOK STAYAWAKE**

–ANDIAM

thinking: surely it must be over soon,
but it doesn't end, it keeps happening,

ANDISTA

RT

A |BL>U >E |LIG>H>T|>

screaming:
*BUT IT'S NOT MY
DREAM! I HAVE
TO GET AWAY! THERE'S*

STREAKING down the street, a luminescent ball coming straight at me – now everything collapses – the blue ball swallows all the light – the street fades out. My head's on fire. There's a pain, red pain. THEN A SOUND like a sword being drawn, and I'm pushed down. now I'm moving. I'm pushed up, there's something **UNDERNEATH** me, and I'm going up, up, higher than I want to go, up into black space – and now there are chirpy cartoon characters, sinister or friendly I'm not sure, CHUCKLING AND singing like little elves. It's a cosmic necessity, they're whispering and giggling, and pointing at me, and I'm asking them: What? **WHAT'S THE COSMIC** necessity? And then they shrink, or maybe I go far away. Their voices rise and fade and almost disappear, **APPEAR, BUT** suddenly they're wiped away, like a troupe of ants on a café table, and a sorrowful ROBOTIC VOICE intones:

NOW EVERYTHING is green against the black. Another voice comes in, angry, impatient: – should be working – you're wasting time – should be working harder. THE VOICES FADE. THE light goes again. I can't see anything. I'm casting around, feeling for an exit and I'm shouting: I'm not supposed to be here! I'm awake! The animated characters are back. SWOOPING **AROUND ME**. singing: night follows day follows.... I can't stand it. Stop! They fade into whispers, and I'm high above the earth, **TOO HIGH** and terrified of falling back.

THE VOICES ARE WHISPERS: may result in serious disorientation. The blue light that came at me is back again, but now it's still, it's hanging over me, it's just a light hanging over a bed, and a bed in a solid room, and I'm awake, I'm elated, I'm out of the dream, and Sleep is the underside of waking life. No fabric can do something chuckles in my head: but it's not YOUR BED– **without a wrong side.**

advertisement

STAYAWAKE®

F2004

SHORT OF BREATHING SPACE?
RUNNING OUT OF TIME?
NO CHANCE TO SLEEP?
TIRED OF BEING TIRED?

You need to stay awake with STAYAWAKE®, the world's first sleep-concentrate.

STAYAWAKE® is formulated to simulate the sensations and body functions associated with natural sleep. Electricity allowed man to escape the enforced routines of day and night and divide the day into eight-hour shifts. Now STAYAWAKE® brings you the chance to reprogram your own body-clock and escape the enforced routines of psychological and physiological rest.

Get up to speed with a world that never sleeps!

Speeding up the restorative activities which normally occur over a period of approximately eight hours, STAYAWAKE® gives you hours of additional quality waking time by concentrating these processes into a period of just two hours.

You will wake refreshed, rejuvenated, and recharged for up to twenty-two hours of action!

Prolonged use of STAYAWAKE® can extend your waking life by up to four thousand days (figures based on a twenty-year-old woman taking STAYAWAKE® for fifty years).

Think what you could do with this extra time!

Don't live to sleep - sleep to live with STAYAWAKE®.

INFORMATION FOR PATIENTS

STAYAWAKE® Capsules
STAYAWAKE® Tablets
STAYAWAKE® Suspension
(acyclovir)

BRIEF SUMMARY

The following is a brief summary only; see full prescribing information for complete product details, including references.

DOSAGE AND ADMINISTRATION:
One capsule, once a day, everyday.

CONTRAINDICATIONS:
STAYAWAKE® capsules are contraindicated for patients who develop hypersensitivity or intolerance to the components of the formulation.

WARNINGS:
STAYAWAKE® capsules are for oral use only. The manufacturers of STAYAWAKE® take no responsibility for this or any other use of STAYAWAKE®.

PRECAUTIONS:
General: STAYAWAKE® can cause nausea, rashes, anxiety, depression, breathlessness, amnesia, psychosis, death. See Adverse Reactions.
Information for Patients: Patients are advised against consulting their physician if they experience severe or troublesome adverse reactions, or if they have any other questions. An automated twenty-four hour hotline, manned by StayAwake® users, is available.
Drug Interactions: STAYAWAKE® is intended for use by patients wishing to maximise the productivity of their waking hours. Opiates and cannaboids can be used in association with STAYAWAKE®, but judgement and reactions will be impaired. Co-administrations of cocaine, amphetamine sulphate, and metamphetamine with STAYAWAKE® have resulted in serious disorientation.

ADVERSE REACTIONS:
STAYAWAKE® can cause nausea, rashes, diarrhoea, nervousness, anxiety, depression, breathlessness, amnesia, hypertension, psychosis, death. See Precautions: General.
Short-term administration: Short-term use can also lead to confusion and disorientation.
Long-term administration: STAYAWAKE® is intended for long-term use. While financial health may be initially impaired, this will be amply compensated by the increased earning opportunities enjoyed by patients taking STAYAWAKE®.

POTENTIAL FOR ADDICTION:
STAYAWAKE® is not an addictive drug. Patients will, however, become adjusted to their new routines and accustomed to the lifestyle benefits STAYAWAKE® will bring. See Long-Term Administration.

OVERDOSAGE:
It is not possible to overdose on STAYAWAKE®.

CONFIDENTIAL
[information for physicians only]

STAYAWAKE®

STAYAWAKE® is a vital element of Operation Productivity. Physicians will be aware of the importance of this program to state and corporate security, and are reminded that the success of the program depends on their co-operation.

STAYAWAKE® should be prescribed as widely as possible amongst patients designated PSEs, but it is vital that the compound is withheld from patients with a history of drug abuse, reality misapprehension, those diagnosed with TOTH, and all other time-wasters.

Dreaming, like other processes associated with sleep, is concentrated by STAYAWAKE®. Trials have indicated that certain patients taking STAYAWAKE® have a propensity to experiment with astral projection, shared dream-experiences, lucid dreaming, telepathy, mind invasion, and day-dreaming. Under no circumstances should attention be drawn to these aspects of STAYAWAKE®. Patients who are not made aware of them are likely to remain unaffected. Those who do report dream-related side-effects should be reassured and prescribed DREAMQUELL®.

NOTES
PSEs Productive Social Elements. TOTH Time on Their Hands.
DREAMQUELL® available from the manufacturers of STAYAWAKE®

US Patent No. 41995X4
Ref # SA0088453

March 2008
NIN

KrixoPolite®
KrixoPolite Inc
ZE Research Park, CA90404

©2009 KrixoPolite Inc Printed in USA CJA32 February 2009

ignition

Series | 1 | 2 | 3 | 4

Style
212
Colour / Compatibility

blue

Your Order

Templates for:
Letterhead
(+1000 printed sheets)
Continuation Sheet
(+1000 printed A4's)
Invoice
(+1000 printed A4's)
Fax Sheet

Compliment Slip
(+1000 printed sheets)
C4 and C5 Envelopes
(+1000 C4; +1000 C5)

Email Templates

Business Card a/w

Units 5-12, Saville Way, Newton Aycliffe
County Durham DL54 3JG
Tel 01325 445 5656 Fax 01325 445 5757

ignition.com

NanoSoft

understands exactly how to break down the Human genome. It offers you the ability to select from a range of qualities to adjust the DNA of your child. Each element offers guaranteed look, athleticism, intelligence and temperament. Bringing up your child now becomes predicable.

You can pre-empt the effects of adolescence, tune the biological clock to delay fertility until after they've maximised their career potential or simply make sure they're the prom queen. The investment doesn't stop there, as each quality comes complete with insurance programs, educational funds and health support that allows you to guide the limited range of unpredictable eventualities, such as marriage or accident.

But it is not as simple as being able to make the perfect child, each quality is only an enhancement of your present gene patterns – they will still be unique to you – and, of course, how affluent you are. The combination of attributes is selected by the name you want to give your child. Each individual letter embodies a quality, together they form the combination of attributes which tells everyone exactly who (or what) your child is. NanoSoft personalises every name for you, going beyond attaching an image or lifestyle to its product – humanity is the product itself, holding a range of its personalities. We understand NanoSoft and what it is to be human from who we place around us. Each individual needs to be branded.

Branding names becomes an exercise in modelling DNA. A logotype creates a symbol from each name by spelling it out, placing the first letter at the centre. The following letters attach in a sequence, based on predetermined sets. Your child has their own logo, symbolising to everyone around exactly who they are…

NanoSoft Generating the insignia of life

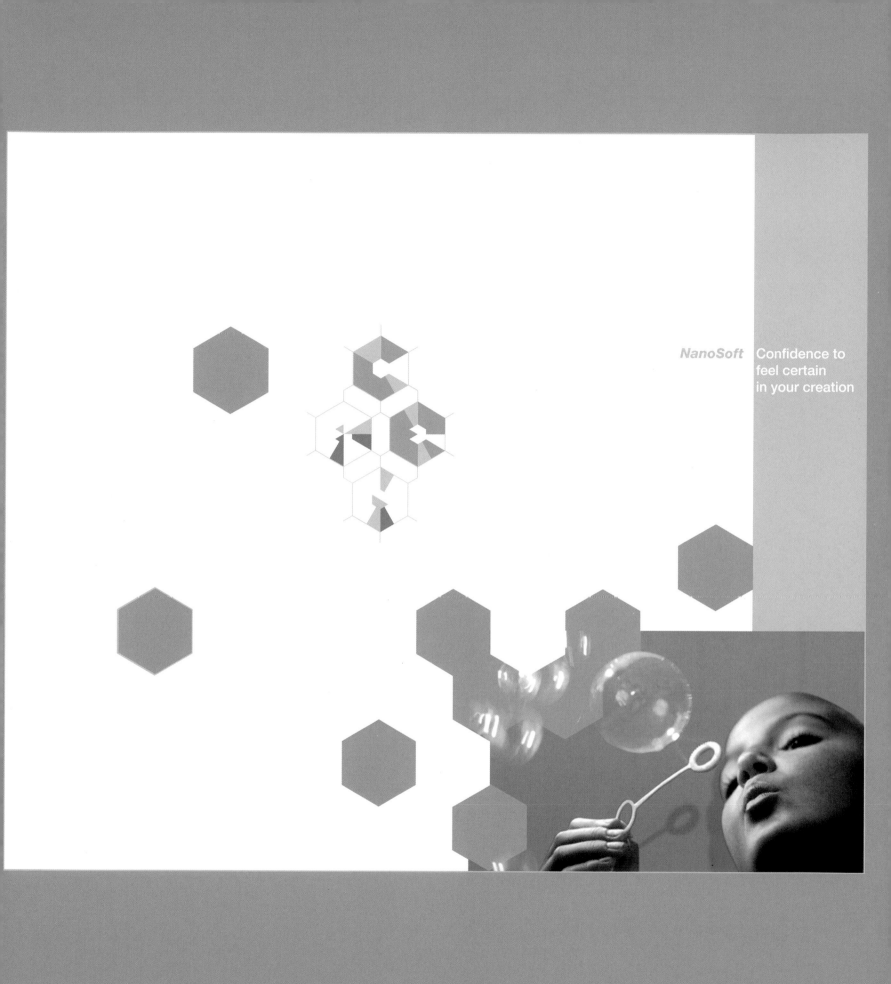

NanoSoft Confidence to
feel certain
in your creation

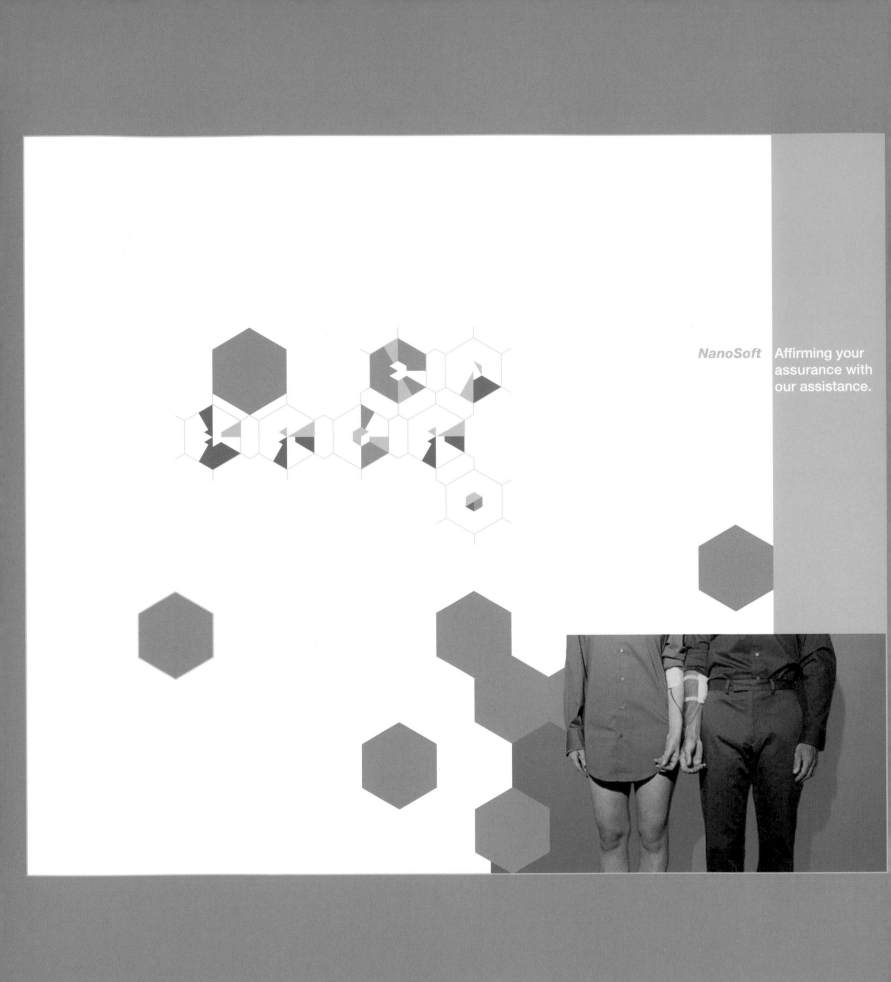

NanoSoft Affirming your assurance with our assistance.

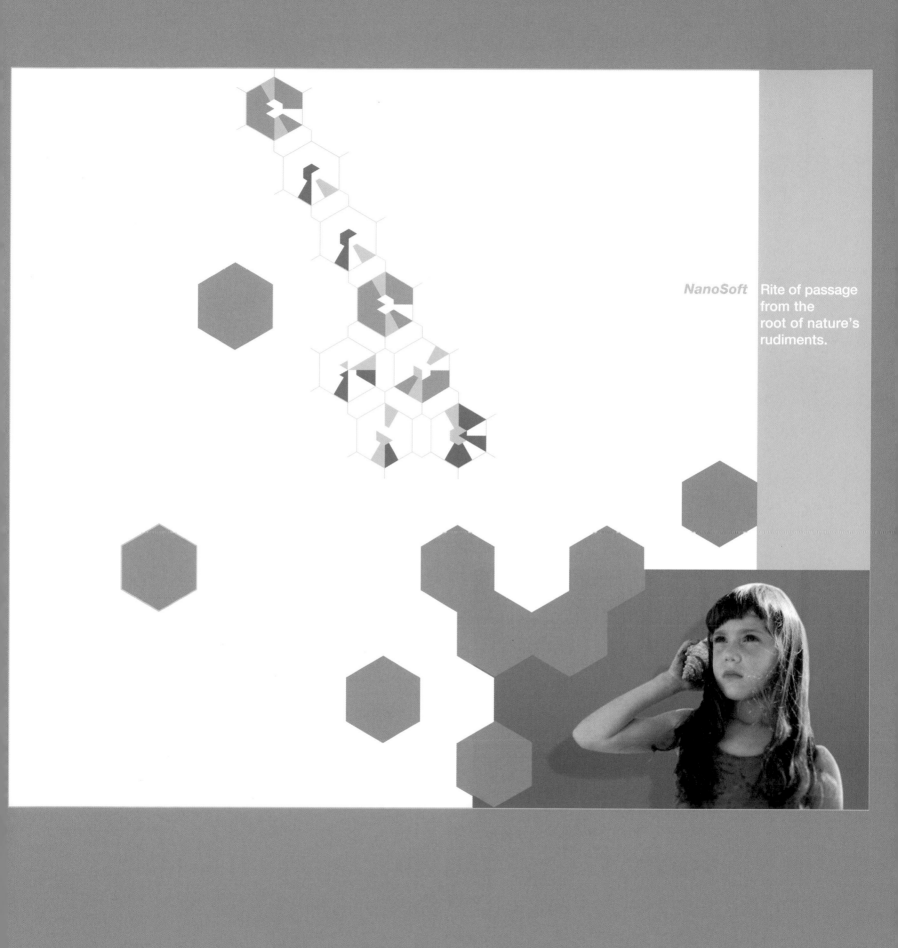

NanoSoft Rite of passage from the root of nature's rudiments.

To make 10 litres of orange juice you need a litre of diesel fuel for processing and transport, and 220 litres of water for irrigation and washing the fruit (www.mcspotlight.org, 'Measuring Food By the Mile').
Brand: 34

New evidence suggests that geological events – as well as photosynthetic activity – were vital to oxygenating Earth (www.ivv.nasa.gov). Theories on the birth of Earth hold weight not only for scientists, but increasingly as 'value constructs' around which to build political, social and business structures. Source: GICR.
Brands: 20 38

lived in counties where monitored data showed unhealthy air.' Reference www.epa.gov, Environmental Protection Agency, National Air Quality. Source: GICR.
Brands: 20 38

In Europe current rates of growth indicate that 30 per cent of all farming may be organic by the year 2010 and in the U.S. that 10 per cent of agriculture will be organic by 2010 (www.purefood.org, 'Why Americans Are Turning to Organic Foods').
Brand: 34

'Organic foods are the fastest growing and most profitable segment of American agriculture, according to government statistics' (www.purefood.org, 'Why Americans Are Turning to Organic Foods', Ronnie Cummins, 6/29/2000).
Brand: 34

Source: GICR.
Brands: 05 11 15 17 22

Emotional intelligence is a 1990s buzzphrase that is likely to influence a new dimension in marketing in the next five years. Consider anger. Anger is an emotion felt in response to frustration or injury and expressed in an impulsive manner without thought. It is a mixture of emotional, physiological, and cognitive elements and should be seen as distinct from the behaviour it might provoke. It is a powerful response and swiftly drives behaviour. Source: GICR.
Brand: 24

One in ten American workers claims to work in an office where stress has led to physical violence (American Demographics, January 2001).
Brands: 05 24

Stress-busting is a fast-growth industry theme. Leading the way, techno-stress. This is a widespread epidemic of anxiety created by technology overload. The work environment is depersonalized to the extent that people sitting six feet apart never talk, communicating only through their computers. From a physiological standpoint, violence is a logical progression from office stress. When the body is under stress it behaves as if under attack. Chemical messengers are released that prepare the body to fight or flee. Source: GICR.
Brands: 07 16 22 31 37

Future values and efficiencies will challenge and may act against processes whereby commodities aggressively consume other commodities. Flying goods by air is a regular feature of world trade, which uses nearly 40 times the amount of fuel that sea transport uses. (www.mcspotlight.org, 'Measuring Food By the Mile').
Brands: 05 34

As people are often at their wealthiest in old age or at death, there is growing awareness that a big marketing opportunity lies with creating brands that reach for your money beyond the grave. 32 per cent of Americans aged 50+ have prepaid some or all of their funeral and/or burial expenses. By raising fear of sudden death at younger ages there is the opportunity to expand the market size.
Source: GICR.
Brands: 12 40

'You must be the change you wish to see in the world.' Gandhi. 'Don't just express yourself, invent yourself. And don't restrict yourself to off-the-shelf models.' Henry Louis Gates Jr, commencement address at Hamilton College.
Brands: 06 09 22 23 28 36

Economic migration is typically the major factor in the movement of peoples… but environmental migration is likely to be the future motivator. 'Over 150 million tons of air pollution were released into the air in 2000 in the U.S. Approximately 62 million people

No advertisement may include any technical device which, by using images of very brief duration or by any other means, exploits the possibility of conveying a message to, or otherwise influencing the minds of, members of an audience without their being aware, or fully aware, of what has been done. Reference ITC Code of Advertising Standards and Practice.
Brands: 13 35

The future is more nomads, but some will choose it as a luxury not as a survival strategy. They will travel in high style, with pleasurable intent, rather than survival in tents. The Honduran government has approved construction of a freedom ship, the world's first mobile community. The massive floating city will circumnavigate the world once every two years with up to 90,000 permanent residents and thousands of visitors. The vessel, designed to be more than half a mile long, 750 feet wide and about 25 storeys high, with a landing strip for small jets, is due to launch in 2005. The ship will cost $8.5 billion. It will feature the staples of a city on dry land, including hospitals, hotels, supermarkets, restaurants, libraries, offices, warehouses, manufacturing plants, entertainment and recreation facilities. Apartments on board cost up to $3.5 million.

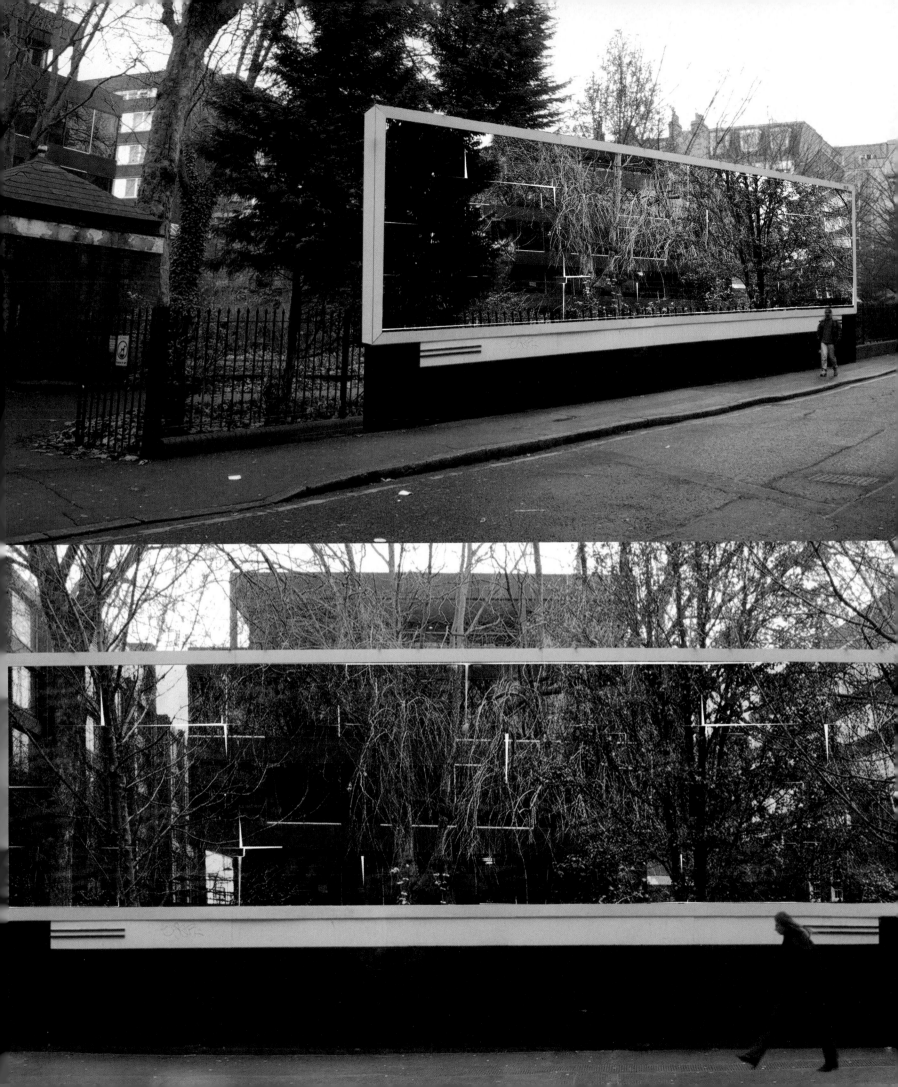

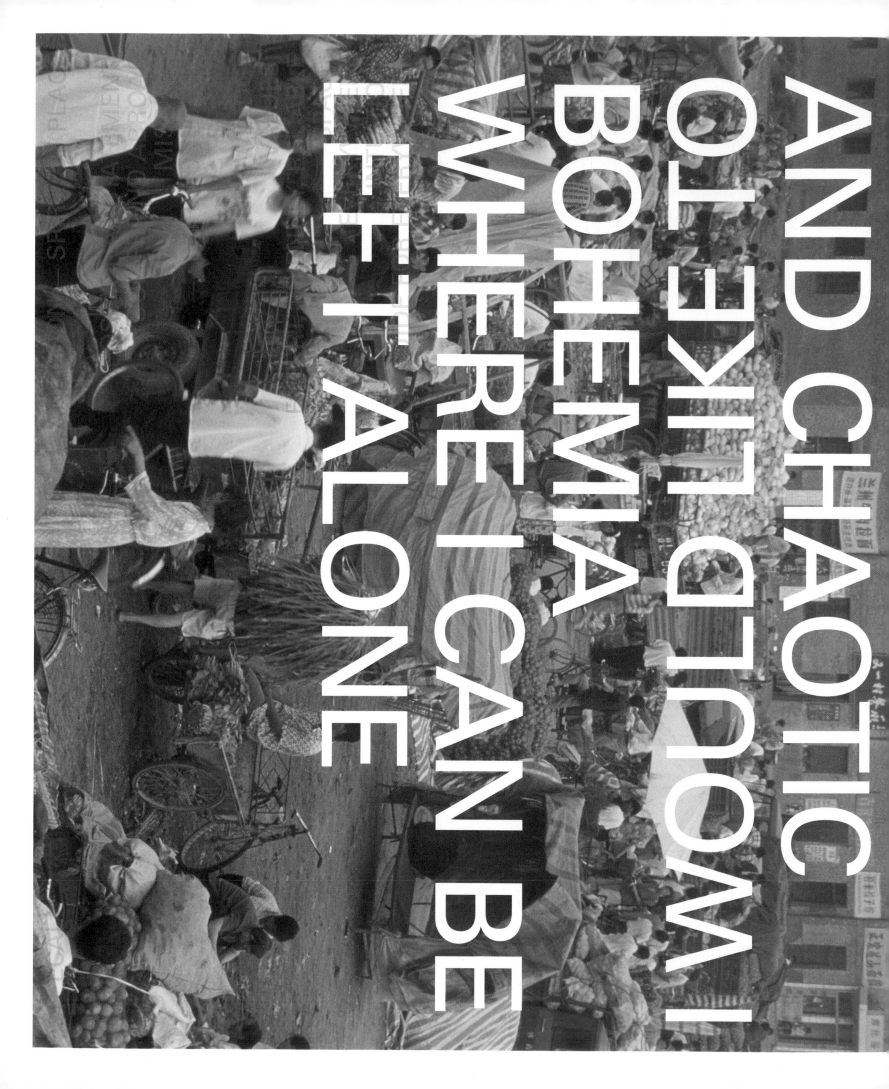

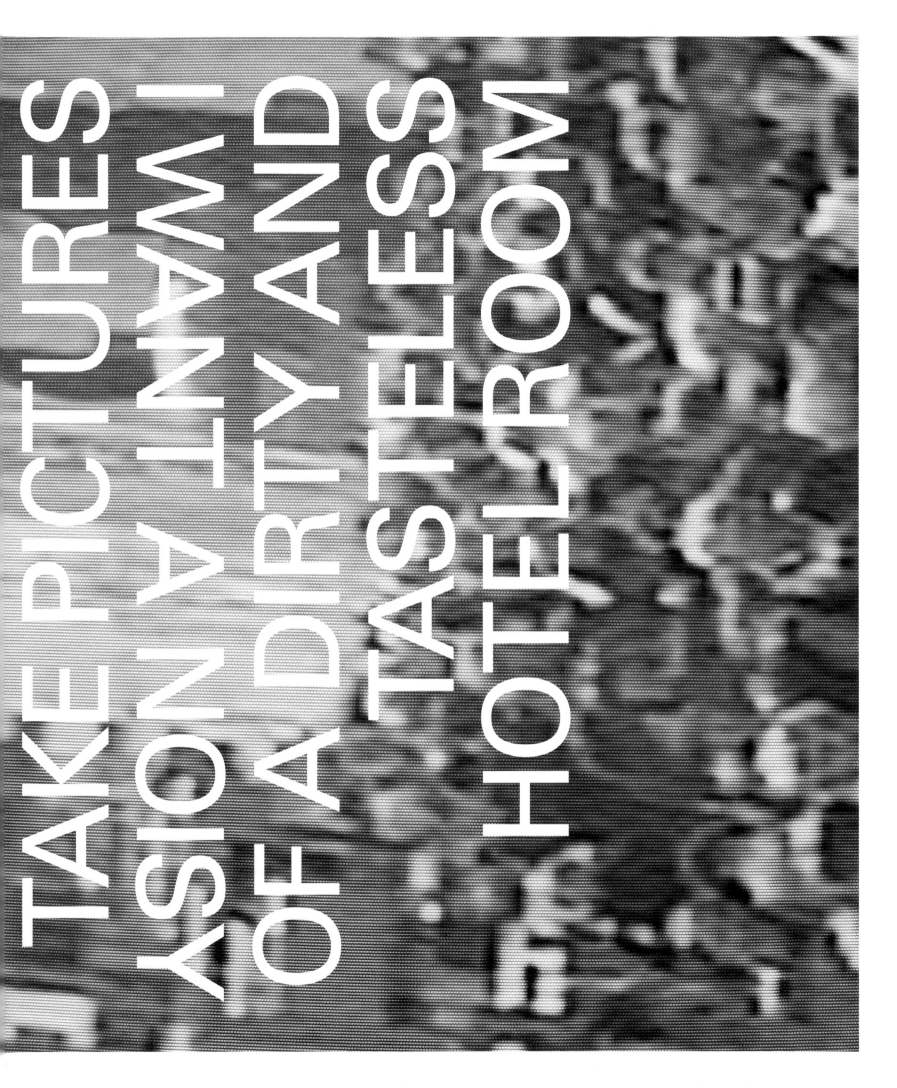

TAKE PICTURES
AS I ON A NOISY WAY IN A
OF A DIRTY AND
TASTELESS
HOTEL ROOM

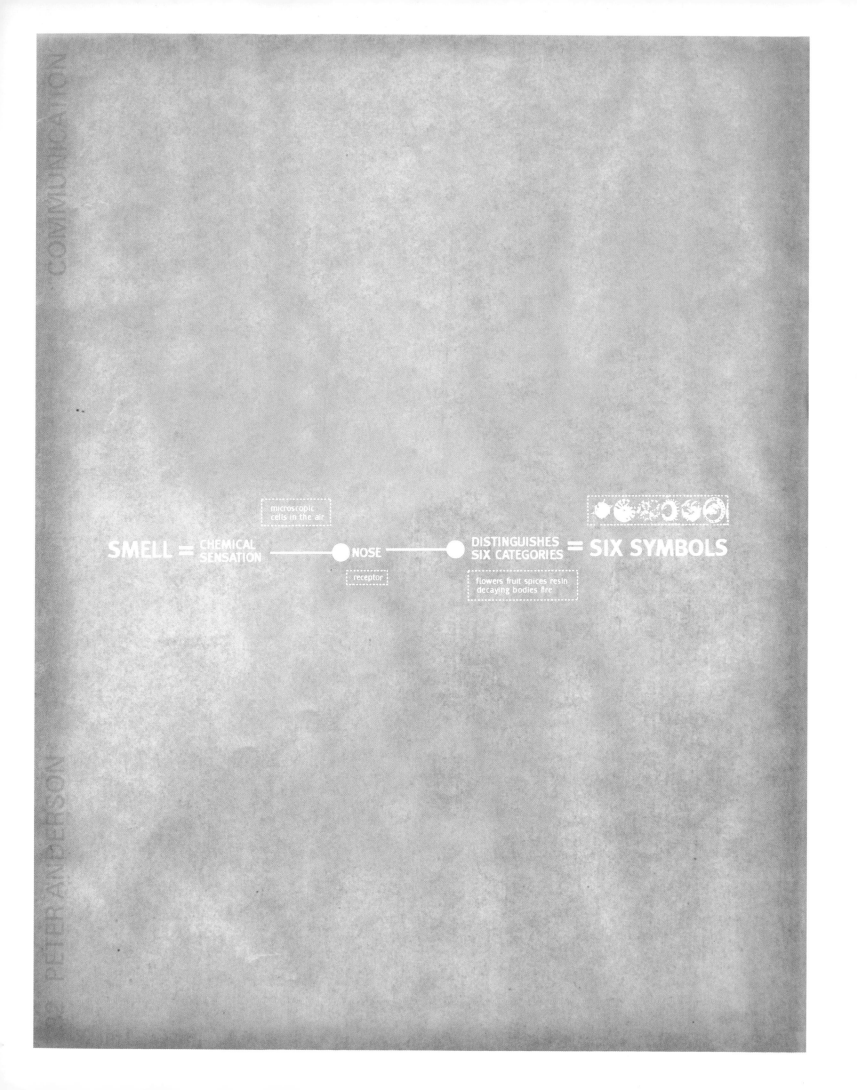

SMELL = CHEMICAL SENSATION ——●NOSE—————● DISTINGUISHES SIX CATEGORIES = SIX SYMBOLS

microscopic cells in the air

receptor

flowers fruit spices resin decaying bodies fire

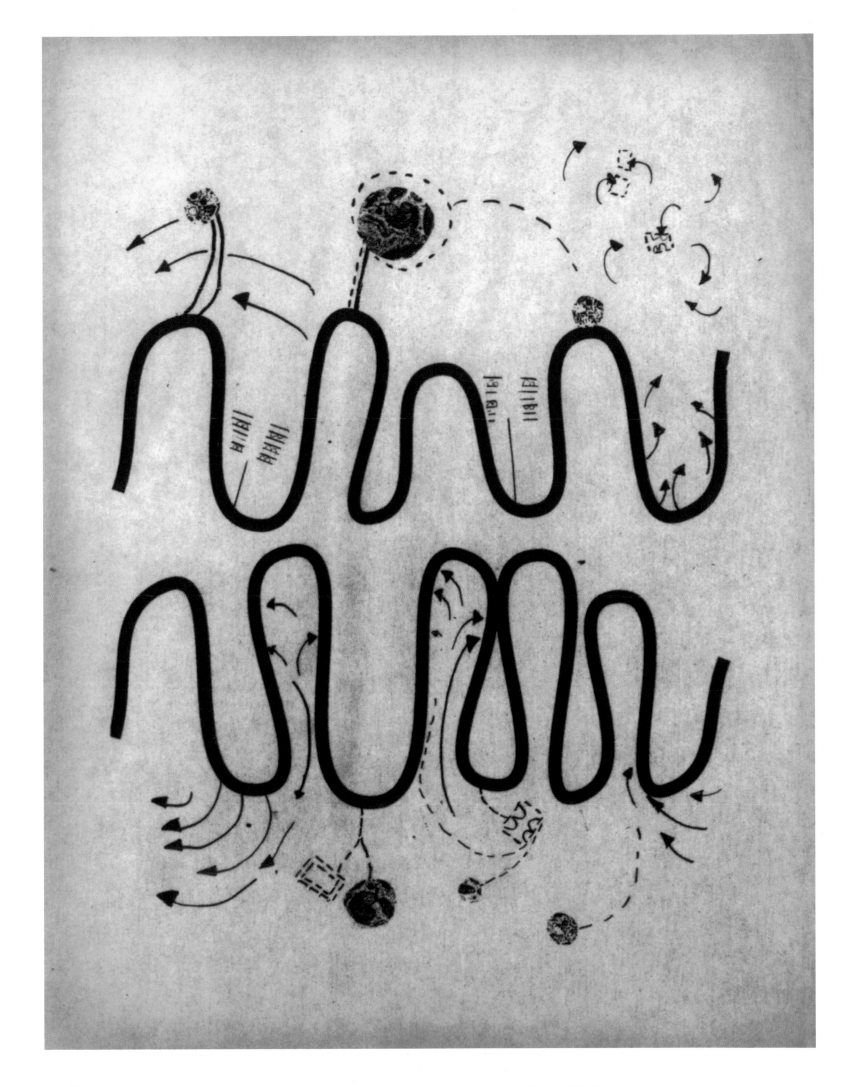

SERVICE CULTURE

POSITIONAL STATEMENT:

TIME$_2$

MISSION:

SPIRIT:

TO EMPOWER YOUR EVERY MOMENT

VALUES:

ORGANIZING, CALMING

EFFICIENT, INVISIBLE, PRODUCTIVE

SPACE:

AROUND YOU

PRODUCT:

SERVICES THAT WORK AND

LIVE WHILE YOU SLEEP

INTUITION:

USING YOUR TIME BETTER

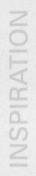

SOON A BANG IF RIP IT. I SO PROFIT IN A BANG. A FAB GRIN POSITION.
SO IF RIP INTO A BANG. A FAB ORIGIN TO SPIN. A BANG IF IRIS ON TOP.
BAG OF INSPIRATION®

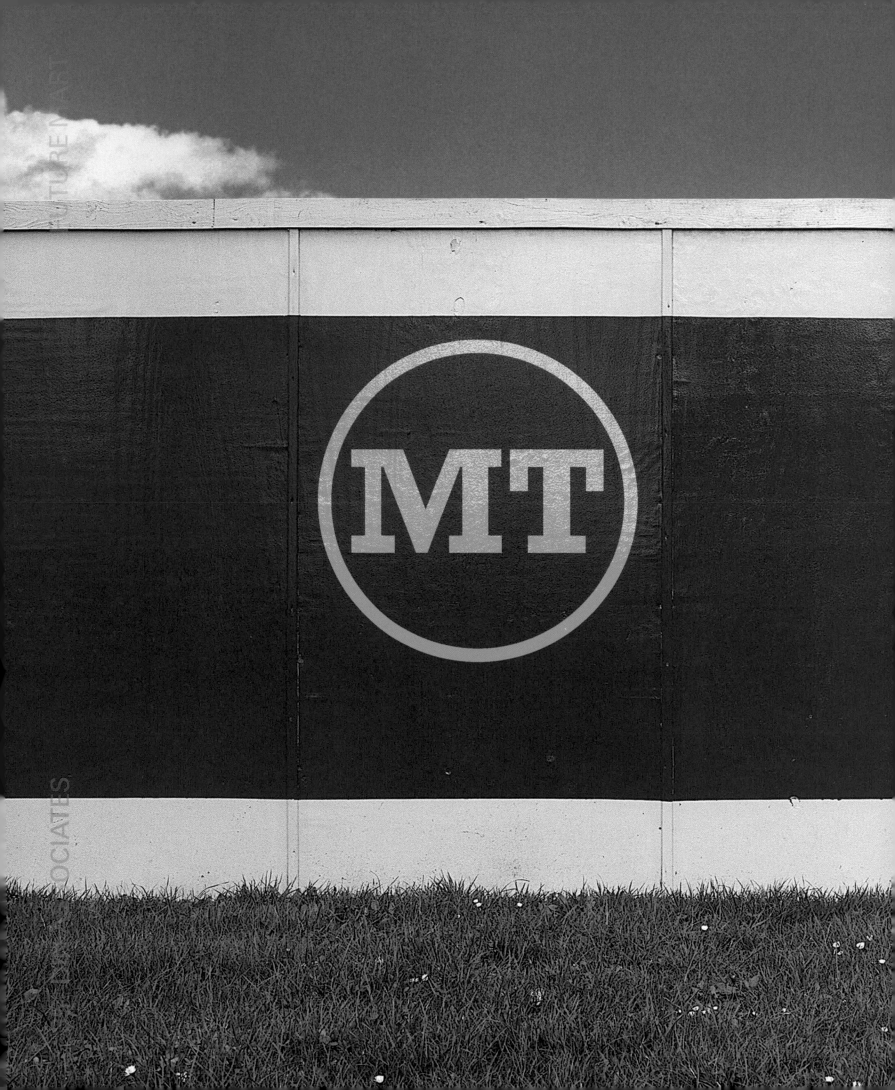

tur
ature Turf Mat
rf Mature Turf Mature f
rf Mature Turf Mature Turf M
rf Mature Turf Mature Turf
rf Mature Turf Mature Tu
rf Mature Turf Mature T
rf Mature Turf Matur
rf Mature Turf Mature
rf Mature Turf Mature
rf Mature Turf M
rf Mature Turf M
 Mat Turf M
 Tur a
 Tu Ma
 Turf Mature
 f Mature T
 ture
 Mature T
 Mature T
 Mature T
 e Ma
 M

Mature Turf
The supermarket comes home

It's time for retailers to put their customers back where they belong – first... It's time we realised that watching the bottom line needn't mean ignoring people or the environment... it's time for the supermarket to return from the edge of town and take its rightful place at the heart of the community...

Mature Turf understands that internet shopping has made the traditional retail environment obsolete. So today's business must offer something more than just products. Part shopping experience, part leisure provider, part social project, MT™ offers a focus for a range of community activities.

But to serve the community, we have to be part of the community. So no more out-of-town developments that disrupt the urban fabric. We're regenerating the centre, where people can more easily access our services. And, by working closely with local public transport, MT™ will be truly door-to-door. Our own vehicles, both delivering our stock and making home deliveries to customers, utilise non-fossil fuels to reduce environmental impact. And, MT™ tries its hardest to enhance the surrounding area incorporating, where possible, wooded parkland, including playgrounds, leisure and sport facilities.

Eco-friendly devices such as photovoltaic panels and wind-generators power our facilities. They utilise passive ventilation, water collection storage and purification, as well as recycling heat generated from cooling systems. Most of our packaging is designed for re-use rather than disposal. So as well as the familiar re-cycling bins there are drop-off points for packaging.

We're addressing the urgent need for healthy, fresh, locally-grown food. Unlike online shopping, at MT™ you can see, feel and smell the quality of our organic produce. Our very own on-site urban farm provides much of our stock. The in-store bakery and deli departments prepare all their own foods. You can forget cooking and eat in the restaurant. Or make more of it at our cookery school, with regular chefs' workshops and nutrition presentations.

With the current squeeze on public spending, it is up to us to help subsidise the provision of services, allowing them to be run autonomously by government bodies or individual organisations. Hence, the MT™ experience incorporates a range of health and community services including doctors, dentists, opticians, counsellors, welfare officers and financial advisors. Both old and young are looked after at MT™. A day centre and luncheon clubs cater for the elderly, while there is nursery provision for pre-school plus creche facilities for the kids. And there are multi-purpose spaces for activities such as youth clubs and sports/fitness facilities. MT™ also offers to-your-door services: the mobile shop reinvented for those unable to visit in person.

Happy Memories©

Unauthorised public performance, broadcasting, copying, hiring, lending
or reproduction of company recollections is strictly prohibited by law.
All rights reserved.

Light yet filling/Something you've always wanted/Freshness frozen in/Virtual freedom in a virtual world/Because you're worth it/Seeing is believing/When only the best will do/Take a little extra/Where you can feel the difference/Pause and refresh yourself/Anything less would be cheating/Go on, treat yourself/Reliability in a changing world/Where the world looks brighter/Because you know you can trust us/Put your future in our hands/It's what your right arm's for/God is in the details/Your choice. Forever/Let us remove the fuss/Why wait for happiness?/Mother natures little helpers/As green as you wanna be/Your way, everyday/You deserve more/Congratulations. You just caught up with the Jones/Do you really wanna wait?/A taste of freshness/For that everyday glow/No more than you deserve/For the young and the young at heart/We care because you do/Where you belong/You belong with us/The one-stop happiness shop/We're part of the family/Because we believe in your future/The best is yet to come/Yes, you can believe it/Because you deserve the choice/Be the first/Your satisfaction is our benchmark/Taste the difference/Satisfy your soul/Everything you ever wanted/Because we think you're worth it/We show you the way/We'll never let you down/You'll be amazed how we take care of things/A little help when you need it/Help when you need it, help when you don't/Go ahead, take what you want/Just what you always wanted/Service with a smile/Put it where you want it/Just how you hoped it would be/We've done the thinking for you/Spoil yourself rotten/Don't be denied/More choices every day – Guaranteed/Buy bigger, save more/Buy more, bigger savings/Old-style technology/The healthy style that says 'you've made it'/Light yet filling/Virtually fat-free/Perfection improved/Old-fashioned values, new-tangled savings/The champions choice/All from the comfort of your chair/Just the news you want/Nature just got a little better/The only name you trust/The taste of freedom/The quality you deserve/Peace in a bottle/If you don't, your neighbours will/Just feel it/The home of quality/It's all our business/Jealous yet?/The future just got a little brighter/Ecology-conscious/Because no-one likes looking any older/Life in a box/200 channels tailored to you/The worlds favourite/We care, wholesale/Your business is our pleasure/For the little things that mean a lot/We put the 'u' in Education/And you thought your last computer was fast enough/Better for you, better for everyone/The choice of mother nature/Goodness you can taste/Taking care of business, taking care of you/Bring a smile to your wallet/Building technology to help the ecology/The aroma that says success/Why trust a stranger?/Where happiness lives/A great day for all the family/Definitely more than maybe/A greater sense of satisfaction/Let's go for it/Welcome to planet business/Better than the rest/Keep looking ahead/A new dawn has broken/We'll help you make that change/Cruising at 30,000 feet/Flying higher than the rest/Consistently a cut above the rest/Difference?, What difference?/The biggest difference/The brightest star in the galaxy/Relax, we're with you all the way/This year's face says it all/Your family is our business/Style never goes out of fashion/Because somehow we're all the same/When friendship is bigger than differences/We're stronger together/Together we can make a difference/Because differences don't matter/Let's celebrate our differences together/When only the best will do/Do it because you want to/Another way to say thank you/The best way to say I love you/When parting is such sweet sorrow/We care because you do/That wonderful everyday feeling/Whiter than the pure driven snow/We think your neighbours will agree/When you want to be noticed/Because you want her/OK, you can relax now/If you don't ask, you don't get/Bigger, better, stronger/Smaller, lighter, easier/Silky smooth and mellow/Rich, full bodied and satisfying/Right down to the last drop/The taste that says 'we've made it'/Have you got yours yet?/Go on, you know you want to/Monsieur, you are spoiling us/That'll do nicely/Watching your figure so you don't have to/A sign of greatness/Solutions for a shared ecology/Your instant family/Because nearly is not good enough/All of the people, all of the time/When the going gets tough, the tough call us/You know you want it/Don't fight it, feel it/Yesterdays prices, tomorrows technology/Nature you can own/Your world at your fingertips/Minding your kids so you don't have to/Carve your own niche/Who do you want to be today?/Say 'when'!/We dare you/Our house is your house/Stay in touch with yourself/Saying yes has never been easier/Because 'no' can sometimes mean 'yes'/Beauty is skin deep, we do the rest/Your slice of the pie just got a little bigger/Your whims are our business/Galileo was wrong, it all revolves 'round you/Create your own world/The universe begins with u/There's only one u in universe/Your world, your way, everyday/People like you like people like us/Ultimate choice, instant reward/Demand and ye shall find/Light yet filling/Something you've always wanted/Freshness frozen in/Virtual freedom in a virtual world/Because you're worth it/Seeing is believing/When only the best will do/Take a little extra/Where you can feel the difference/Pause and refresh yourself/Anything less would be cheating/Go on, treat yourself/Reliability in a changing world/Where the world looks brighter/Because you know you can trust us/Put your future in our hands/It's what your right arm's for/God is in the details/Your choice. Forever/Let us remove the fuss/Why wait for happiness?/Mother natures little helpers/As green as you wanna be/Your way, everyday/You deserve more/Congratulations. You just caught up with the Jones/Do you really wanna wait?/A taste of freshness/For that everyday glow/No more than you deserve/For the young and the young at heart/We care because you do/Where you belong/You belong with us/The one-stop happiness shop/We're part of the family/Because we believe in your future/The best is yet to come/Yes, you can believe it/Because you deserve the choice/Be the first/Your satisfaction is our benchmark/Taste the difference/Satisfy your soul/Everything you ever wanted/Because we think you're worth it/We show you the way/We'll never let you down/You'll be amazed how we take care of things/A little help when you need it/Help when you need it, help when you don't/Go ahead, take what you want/Just what you always wanted/Service with a smile/Put it where you want it/Just how you hoped it would be/We've done the thinking for you/Spoil yourself rotten/Don't be denied/More choices every day – Guaranteed/Buy bigger, save more/Buy more, bigger savings/Old-style technology/The healthy style that says 'you've made it'/Light yet filling/Virtually fat-free/Perfection improved/Old-fashioned values, new-tangled savings/The champions choice/All from the comfort of your chair/Just the news you want/Nature just got a little better/The only name you trust/The taste of freedom/The quality you deserve/Peace in a bottle/If you don't, your neighbours will/Just feel it/The home of quality/It's all our business/Jealous yet?/The future just got a little brighter/Ecology-conscious/Because no-one likes looking any older/Life in a box/200 channels tailored to you/The worlds favourite/We care, wholesale/Your business is our pleasure/For the little things that mean a lot/We put the 'u' in Education/And you thought your last computer was fast enough/Better for you, better for everyone/The choice of mother nature/Goodness you can taste/Taking care of business, taking care of you/Bring a smile to your wallet/Building technology to help the ecology/The aroma that says success/Why trust a stranger?/Where happiness lives/A great day for all the family/Definitely more than maybe/A greater sense of satisfaction/Let's go for it/Welcome to planet business/Better than the rest/Keep looking ahead/A new dawn has broken/We'll help you make that change/Cruising at 30,000 feet/Flying higher than the rest/Consistently a cut above the rest/Difference?, What difference?/The biggest difference/The brightest star in the galaxy/Relax, we're with you all the way/This year's face says it all/Your family is our business/Style never goes out of fashion/Because somehow we're all the same/When friendship is bigger than differences/We're stronger together/Together we can make a difference/Because differences don't matter/Let's celebrate our differences together/When only the best will do/Do it because you want to/Another way to say thank you/The best way to say I love you/When parting is such sweet sorrow/We care because you do/That wonderful everyday feeling/Whiter than the pure driven snow/We think your neighbours will agree/When you want to be noticed/Because you want her/OK, you can relax now/If you don't ask, you don't get/Bigger, better, stronger/Smaller, lighter, easier/Silky smooth and mellow/Rich, full bodied and satisfying/Right down to the last drop/The taste that says 'we've made it'/Have you got yours yet?/Go on, you know you want to/Virtual freedom in a virtual world/Because you're worth it/Seeing is believing/When only the best will do/Take a little extra/Where you can feel the difference/Pause and refresh yourself/Anything less would be cheating/Go on, treat yourself/Reliability in a changing world/Consume a little bit more/Because you know you can trust us/Put your future in our hands/It's what your right arm's for/God is in the details/Your choice. Forever/Let us remove the fuss/Why wait for happiness?/Mother natures little helpers/As green as you wanna be/Your way, everyday/You deserve more/Congratulations. You just caught up with the Jones/Do you really wanna wait?/A taste of freshness/For that everyday glow/No more than you deserve/For the young and the young at heart/We care because you do/Where you belong/You belong with us/The one-stop happiness shop/We're part of the family/Because we believe in your future/The best is yet to come/Yes, you can believe it/Because you deserve the choice/Be the first/Your satisfaction is our benchmark/Taste the difference/Satisfy your soul/Everything you ever wanted/Because we think you're worth it/We show you the way/We'll never let you down/You'll be amazed how we take care of things/A little help when you need it/Help when you need it, help when you don't/Go ahead, take what you want/Just what you always wanted/Service with a smile/Put it where you want it/Just how you hoped it would be/We've done the thinking for you/Spoil yourself rotten/Don't be denied/More choices every day – Guaranteed/Buy bigger, save more/Buy more, bigger savings/Old-style technology/The healthy style that says 'you've made it'/Light yet filling/Virtually fat-free/Perfection improved/Old-fashioned values, new-tangled savings/The champions choice/All from the comfort of your chair/Just the news you want/Nature just got a little better/The only name you trust/The taste of freedom/The quality you deserve/Peace in a bottle/If you don't, your neighbours will/Just feel it/The home of quality/It's all our business/Jealous yet?/The future just got a little brighter/Ecology-conscious/Because no-one likes looking any older/Life in a box/200 channels tailored to you/The worlds favourite/We care, wholesale/Your business is our pleasure/For the little things that mean a lot/We put the 'u' in Education/And you thought your last computer was fast enough/Better for you, better for everyone/The choice of mother nature/Goodness you can taste/Taking care of business, taking care of you/Bring a smile to your wallet/Building technology to help the ecology/The aroma that says success/Why trust a stranger?/Where happiness lives/A great day for all the family/Definitely more than maybe/A greater sense of satisfaction/Let's go for it/Welcome to planet business/Better than the rest/Keep looking ahead/A new dawn has broken/We'll help you make that change/Pause and refresh yourself/Anything less would be cheating/Go on, treat yourself/Reliability in a changing world/Where the world looks brighter/Because you know you can trust us/Put your future in our hands/It's what your right arm's for/God is in the details/Your choice. Forever/Let us remove the fuss/Why wait for happiness?/Mother natures little helpers/As green as you wanna be/Your way, everyday/You deserve more/Congratulations. You just caught up with the Jones/Do you really wanna wait?/A taste of freshness/For that everyday glow/No more than you deserve/For the young and the young at heart/We care because you do/Where you belong/You belong with us/The one-stop happiness shop/We're part of the family/Go on! Bring a smile to your wallet/Because you're worth it/Seeing is believing/When only the best will do/Take a little extra/Where you can feel the difference/Pause and refresh yourself/Anything less would be cheating/Go on, treat yourself/Light yet filling/Something you've always wanted/Freshness frozen in/Virtual freedom in a virtual world/Because you're worth it/Seeing is believing/When only the best will do/Take a little extra/Where you can feel the difference/Pause and refresh yourself/Anything less would be cheating/Go on, treat yourself/Reliability in a changing world/Where the world looks brighter/Because you know you can trust us/Put your future in our hands/Rich, full bodied and satisfying/Right down to the last drop/The taste that says 'we've made it'/Have you got yours yet?/Go on, you know you want to/Monsieur, you are spoiling us/That'll do nicely/Watching your figure so you don't have to/A sign of greatness/Solutions for a shared ecology/Your instant family/Because nearly is not good enough/All of the people, all of the time/When the going gets tough, the tough call us/You know you want it/Don't fight it, feel it/Yesterdays prices, tomorrows technology/Nature you can own/Your world at your fingertips/Minding your kids so you don't have to/We'll never let you down/You'll be amazed how we take care of things/A little help when you need it/Help when you need it, help when you don't/Go ahead, take what you want/Just what you always wanted/Service with a smile/Put it where you want it/Just how you hoped it would be/We've done the thinking for you/Spoil yourself rotten/Don't be denied/More choices every day – Guaranteed/Buy bigger, save more/Buy more, bigger savings/Old-style technology/The healthy style that says 'you've made it'/Light yet filling/Virtually fat-free/Perfection improved/Old-fashioned values, new-tangled savings/The champions choice/All from the comfort of your chair/Just the news you want/Nature just got a little better/The only name you trust/The taste of freedom/The quality you deserve/Peace in a bottle/If you don't, your neighbours will/Just feel it/The home of quality/It's all our business/Jealous yet?/The future just got a little brighter/Ecology-conscious/Because no-one likes looking any older/Life in a box/200 channels tailored to you/The worlds favourite/We care, wholesale/Your business is our pleasure/For the little things that mean a lot/We put the 'u' in Education/And you thought your last computer was fast enough/Better for you, better for everyone/The choice of mother nature/Goodness you can taste/Taking care of business, taking care of you/Bring a smile to your wallet/Building technology to help the ecology/The aroma that says success/Why trust a stranger?/Where happiness lives/A great day for all the family/Virtual freedom in a virtual world/Because you're worth it/Seeing is believing/When only the best will do/Take a little extra/Where you can feel the difference/Pause and refresh yourself/Anything less would be cheating/Go on, treat yourself/Reliability in a changing world/Where the world looks brighter/Because you know you can trust us/Put your future in our hands/It's what your right arm's for/God is in the details/Your choice. Forever/Let us remove the fuss/Why wait for happiness?/Mother natures little helpers/As green as you wanna be/Your way, everyday/You deserve more/Congratulations. You just caught up with the Jones/Do you really wanna wait?/A taste of freshness/For that everyday glow/No more than you deserve/For the young and the young at heart/We care because you do/Where you belong/You belong with us/The one-stop happiness shop/We're part of the family/Because we believe in your future/The best is yet to come/Yes, you can believe it/Because you deserve the choice/Be the first/Your satisfaction is our benchmark/Taste the difference/Satisfy your soul/Everything you ever wanted/Because we think you're worth it/We show you the way/We'll never let you down/You'll be amazed how we take care of things/A little help when you need it/Help when you need it, help when you don't/Go ahead, take what you want/A greater sense of satisfaction/Let's go for it/Welcome to planet business/Better than the rest/Keep looking ahead/A new dawn has broken/We'll help you make that change/Cruising at 30,000 feet/Flying higher than the rest/Consistently a cut above the rest/Difference?/What difference?/The biggest difference/The brightest star in the galaxy/Relax, we're with you all the way/This year's face says it all/Your family is our business/Style never goes out of fashion/Because somehow we're all the same/When friendship is bigger than differences/We're stronger together/Together we can make a difference/Because differences don't matter/Let's celebrate our differences together/When only the best will do/Do it because you want to/Another way to say thank you/The best way to say I love you/When parting is such sweet sorrow/We care because you do/That wonderful everyday feeling/Whiter than the pure driven snow/We think your neighbours will agree/When you want to be noticed/Because you want her/OK, you can relax now/If you don't ask, you don't get/Bigger, better, stronger/Smaller, lighter, easier/Silky smooth and mellow/Rich, full bodied and satisfying/Right down to the last drop/The taste that says 'we've made it'/Have you got yours yet?/Go on, you know you want to/Virtual freedom in a virtual world/Because you're worth it/Seeing is believing/When only the best will do/Take a little extra/Where you can feel the difference/Pause and refresh yourself/Anything less would be cheating/Go on, treat yourself/Reliability in a changing world/Where the world looks brighter/Because you know you can trust us/Put your future in our hands/It's what your right arm's for/God is in the details/Your choice. Forever/Let us remove the fuss/Why wait for happiness?/Mother natures little helpers/As green as you wanna be/Your way, everyday/You deserve more/Congratulations. You just caught up with the Jones/Anything less would be cheating/Because you deserve the choice/Be the first/Your satisfaction is our benchmark/Taste the difference/Satisfy your soul/Everything you ever wanted/Because we think you're worth it/We show you the way/We'll never let you down/You'll be amazed how we take care of things/A little help when you need it/Help when you need it, help when you don't/Go ahead, take what you want/Just what you always wanted/Service with a smile/Put it where you want it/Just how you hoped it would be/We've done the thinking for you/Spoil yourself rotten/Don't be denied/More choices every day – Guaranteed/Buy bigger, save more/Buy more, bigger savings/Old-style technology/The healthy style that says 'you've made it'/Light yet filling/Virtually fat-free/Perfection improved/Old-fashioned values, new-tangled savings/The champions choice/All from the comfort of your chair/Just the news you want/Nature just got a little better/The only name you trust/The taste of freedom/The quality you deserve/Peace in a bottle/If you don't, your neighbours will/Just feel it/The home of quality/It's all our business/Jealous yet?/The future just got a little brighter/Ecology-conscious/Because no-one likes looking any older/Life in a box/200 channels tailored to you/The worlds favourite/We care, wholesale/Your business is our pleasure/For the little things that mean a lot/We put the 'u' in Education/And you thought your last computer was fast enough/Better for you, better for everyone/The choice of mother nature/Goodness you can taste/Taking care of business, taking care of you/Bring a smile to your wallet/Building technology to help the ecology/The aroma that says success/Why trust a stranger?/Where happiness lives/A great day for all the family/Definitely more than maybe/A greater sense of satisfaction/Let's go for it/Welcome to planet business/Better than the rest/Keep looking ahead/A new dawn has broken/We'll help you make that change/Pause and refresh yourself/Anything less would be cheating/Go on, treat yourself/Reliability in a changing world/Where the world looks brighter/Because you know you can trust us/Put your future in our hands/It's what your right arm's for/God is in the details/Your choice. Forever/Let us remove the fuss/Why wait for happiness?/Mother natures little helpers/As green as you wanna be/Your way, everyday/You deserve more/Congratulations. You just caught up with the Jones/Do you really wanna wait?/A taste of freshness/For that everyday glow/No more than you deserve/For the young and the young at heart/We care because you do/Where you belong/You belong with us/The one-stop happiness shop/We're part of the family/Because you're worth it/Seeing is believing/When only the best will do/Take a little extra/Where you can feel the difference/Pause and refresh yourself/Anything less would be cheating/Go on, treat yourself/Light yet filling/Something you've always wanted/Freshness frozen in/Virtual freedom in a virtual world/Because you're worth it/Seeing is believing/When only the best will do/Take a little extra/Where you can feel the difference/Pause and refresh yourself/Anything less would be cheating/Go on, treat yourself/Reliability in a changing world/Where the world looks brighter/Because you know you can trust us/Put your future in our hands/Rich, full bodied and satisfying/Right down to the last drop/The taste that says 'we've made it'/Have you got yours yet?/Go on, you know you want to/Monsieur, you are spoiling us/That'll do nicely/Watching your figure so you don't have to/A sign of greatness/Solutions for a shared ecology/Your instant family/Because nearly is not good enough/All of the people, all of the time/When the going gets tough, the tough call us/You know you want it/Don't fight it, feel it/Yesterdays prices, tomorrows technology/Nature you can own/Your world at your fingertips/Minding your kids so you don't have to/We'll never let you down/You'll be amazed how we take care of things/A little help when you need it/Help when you need it, help when you don't/Go ahead, take what you want/Just what you always wanted/Service with a smile/Put it where you want it/Just how you hoped it would be/We've

I was standing in the blazing sun.

The hot sand between my toes. My throat was dry and I could taste the salt on my sunburnt lips. I kept staring at the glass that mum was tilting to her lips in the cool shade of the canopy. I remember the foaming head, the way the bubbles spun and danced, I remember the way she drank, the soft bobbing movement in her throat as she swallowed, she looked so beautiful then. But most of all I remember the shiny logo on the glass, I wanted to reach out and touch its cool glistening surface, it was so smooth and flawless and full of magic.

Also available as: The angelic lady's fragrant hair. Dad's favourite blue swimming shorts. My very first bra. Mum's silky smooth skin. Fish and chips with glistening ketchup and When grandad lost his diarrhoea tablets.

It's kinda weird.

When you look back at old photographs you don't see any of the logos. But ask anyone who was there. They'll tell you…

All tracks written and produced by Jimi Hendrix. ©1970 Warner Bros Records Inc.
Licensed courtesy of Warner Music UK Ltd. Contains a sampled recording of 'Ranting,
Tripped Out Hippy' taken from 'Woodstock: The Movie' circa 1970, Warner Bros.

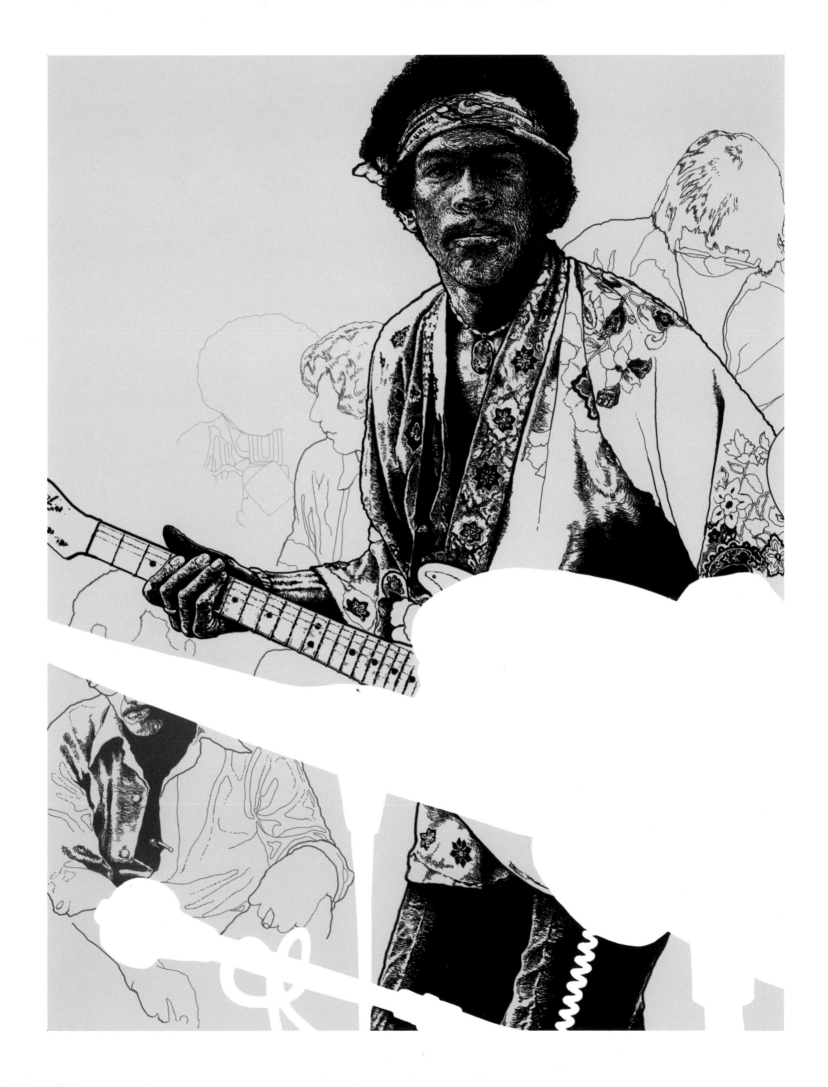

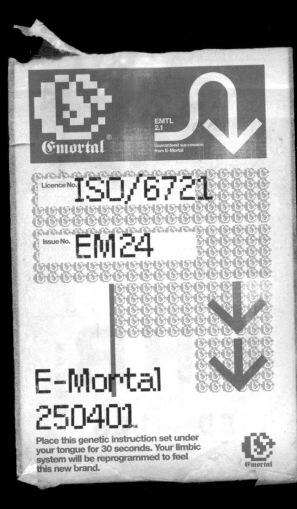

Emortal

Death will no longer exist as we know it,
spiritually or technically. The Genome project
points to an 'idealised custom version' of
the individual that, in a very real sense,
lives for ever. As part of a life insurance concept,
E-Mortal will reconstruct your host DNA to
create the blueprint for a 'rolling' version of
oneself which carries accumulated experience
and knowledge from life to life. As we already know
from the mysterious mental connection between
identical twins, some data and experience
will pass on osmotically from generation to
generation. There will be a 20-year gap between
inception, so that each subsequent generation
will reach a position of optimal intellectual and
physical development at the point where the
previous generation has accumulated the
optimal level of experience and knowledge.
People will no longer be 'individuals' but
continua. With guaranteed succession,
the individual 'cells' of the continuum will
celebrate their cumulative experience with
an 'epiphany' session – the ultimate download –
where the final passing over takes place.
The older brain cells will then undergo a
genetically pre-programmed change of state
where the 'nirvana' prions permit the brain
to engage in higher spiritual function.
Australia (with its newly modified climate)
will become the home to these 'beta-monks',
who will end their days in spiritual enlightenment
(5 years max... genetically timed out).
E-Mortals... no more 'tears in rain'...

1 Humans crave company. Billions of us have a basic fear of being alone, physically, spiritually, morally, intellectually. That's why we belong to tribes, ideological or otherwise. The image machine, the engine of popular culture, thrives on this fear: fear of exclusion, fear of being unfashionable, fear of failure, fear of rejection, fear of impotency.

2 Yet simultaneously we hear about the splintering of family, the fluidity of relationships, the trend towards singledom, the boom in telecommuting, the growing number of women who put career before having children. Demographics are meaningless. Pyschographics are now the only way to decode our universe. No one is acting their age any more. Self-expression is everything. Self-worth is pursued with religious zeal. Modern life has validated self-indulgence and self-centredness, sparking a rise in hedonistic psychologies. Society is getting older and more independent, demanding new products and services, demanding to be included in the marketing mix that currently favours the young. Silver surfers will soon dominate the net. What kind of product could possibly bridge this contradiction between individualism and dependence? The Digital Spirit.

3 The Logistics. How would these Spirits work? Long before 2025, we figured everyone's genetic code would be available on an ID card. Digital Spirits would be able to decipher an electronic swipe of this card. To construct a truly 360-degree personality profile, our digital guardians would also expect us to provide a plethora of personal information and undergo psychometric testing in order for them to build a complex facsimile of our ego and id.

Digital Spirits would help us unravel the mysteries of faith. By tapping into our conscience and understanding our sense of style, they would provide a system to wrap our religious and political beliefs around. These Angels would watch and learn from our behaviour and confessions. By analysing our history and circumstance, they could predict future needs, help us cope with stress and anxiety, help us celebrate moments of joy.

Digital Spirits would keep us loyal to a user's Brand Federation, maximizing the advantages on offer. They would be able to alert members to places and events within their immediate vicinity, as well as being able to interact with other angels peddling goods and services. All this would be done at lightning speed. If someone landed at JFK and decided to rent a car, they would know the best deal way before their suitcase had arrived.

4 Eye of the Beholder. What would these guardians look like? You decide. They could be as discreet or intrusive as you want. They could appear as text or a shadow. Maybe as thought waves. Or as an Avatar, 2D or 3D. A Digital Spirit could manifest itself in a simple hand-held device, the future equivalent of a PDA or mobile phone. They could project themselves onto the nearest plasma screen, wall or curved object, or – thanks to e-ink – a piece of intelligent fabric. They could embed themselves into furniture. Or beam themselves up above your shoulder, like Jiminy Cricket making a guest appearance on Star Trek. Animal, vegetable or mineral, users would determine the exact physiology. After downloading DVD (or whatever) footage of people close to you, your angel could morph itself into whoever you wanted to interact with at any given time. Or maybe you would rather play God, and create a composite of your own.

At the end of the day, appearance is irrelevant. It's the thinking, the artificial intelligence, that counts. A Digital Spirit is a consequence of algorithms; an incredibly sophisticated piece of number-crunching software. It will bend into whatever format suits your immediate needs.

5 A Brain to Bombard. Digital Spirits would love information. These angels would sift through the morass known as modern life on our behalf. They would sort, filter, bargain, warn, reject, accept, store and delete. Based on an intimate knowledge of our previous habits and behaviour they would be able to anticipate/predict our reaction to various consumer and lifestyle scenarios and select the appropriate optimized response, thus saving us valuable time.

The Spirit's core mission would be to protect, to act as the sentinel at an electronic gateway that is permanently open. They would be our last defence against the noise, against seduction of all kinds: commercial, political, spiritual. By keeping us out of blind allies, they would help us find all the right answers.

6 All Things to All People. Digital Spirits will have many useful guises. There will be no boundaries to their expertise. With silent functionality, they will be able to switch between sources depending on the user's precise needs. Given such amorphous ability, names and roles are irrelevant, but humans like labels so here's a list of possible functions...

[1]Anthropologist ... If, according to Peter York, designers are the shamen of the 21st century, angels would be the anthropologists – scouting out and translating trends, rationalizing rituals, deciphering the tongues of that Tower of Babel otherwise known as popular culture.

[2]Artist ... People's walls will be decorated by plasma screens instead of prints from the Tate. Digital Spirits will be able to download images from a vast databank of art, surprising us with special themes and motifs.

[3]Banker ... Angels will keep track of our personal finance without our supervision: electronic bill payment, monitoring of stock market, share price alerts, trading info, etc. If we grow to trust them enough, they will even make money for us through investment and trading.

[4]Chameleons ... Fancy virtual sex with someone famous or an old lover? No problem. Switch the 'vice' button up to the max, retrieve an image from your databank of desires, head for the 3D printer or the VR console and....

[5]Consumer ... Digital Spirits will develop, on our behalf, a neural awareness of the tricks of the marketing trade: they will act as our antibiotic, protecting us against the assault of commerce, allowing access only to those brands and offers that they determine we would be interested in. The Spirit would pledge allegiance to the Federation we are contracted to and would act as our defence shield against spamming. But the Angel would bargain hard on our behalf. Conversely, if we are in the business of selling, angels would work for us.

[6]Doctor ... A crucial component – one of the Digital Spirit's key selling points. In an age of increasing singledom and longevity, these angels will act as our permanent health monitor. Based on readings taken from the smart fabrics we wear, they will be able to: check heart rate and blood pressure; alert us to viruses and allergies; predict our susceptibility to infection and warn about vitamin imbalances. They will be able to schedule and remind us about medical appointments and doses of medicine and will provide coherent medical advice by accessing an online encyclopedia. Angels will, of course, know our various preferences by memorizing our entire medical history.

According to the New Scientist, Peter Szolovits, a computer scientist at MIT, is already designing a personal electronic companion that will manage one's medical history from cradle to grave. It is known, funnily enough, as The Guardian Angel. It's an 'intelligent system that not only stores information, but actively collects it, interprets it, alerts users to possible dangers and even draws attention to the latest medical

research. Instead of the doctor telling someone that their blood pressure is fine, the actual reading from a sensor would be transmitted to their Guardian Angel, where it would be stored and interpreted'.

'God / Guru ... In 2025, it's easy to imagine a plethora of sects preying on the lonely, the confused and the gullible. The tribal urge gone mad. Religions will behave as brands, vying for attention – keen to exploit that very human susceptibility to seduction. A world of attention seekers deserves this scenario. The Angel's role would be an objective observer, a fundamental questioner, unravelling the mysteries.

'Entertainer ... Digital Spirits will possess a 2D and 3D games platform, a camera facility, movie downloads.... Ingenious household gadgets, new kinds of foods and the habit of eating out more will give us more time to indulge ourselves.

'Journalist/Editor ... Nothing particularly new. Angels will trawl the web, providing customized bulletins of relevant news and information, based on one's preferences and internet habits.

'Housekeeper ... Digital Spirits will enjoy an interactive relationship with one's house: they will be able to order food based on messages from the fridge; set the burglar alarm and control the heating remotely. If you are heading home with someone you've just met in a club, you could instruct your robopet to clean the bedroom, dim the lights and put on some Barry White. (Who will have been rediscovered in 2024.)

'Librarian ...In the future, digital imaging, data capture and retrieval systems will have become so sophisticated that the meaning of the word 'memory' will be distorted, redundant even. We are so used to 'material' visual and information systems (films, photos, books), we have become accustomed to thinking that our own memories are equally representational and unambiguous; which means that synthetic images, digital images will become the superior means of holding personal, emotional events. Our minds will become less adept at picturing the past. Computer games, 3D holographic imagery have become so ubiquitous and realistic that our own capacity to visualize live events will become compromised. Photography and film has already caused leaps in the ability to pass on cultural memes. 3D, digital technology will provide the ability to capture a moment, a sound, an image, a smell in 360-degree digital resolution. Humans will become dependent on these enriched memories since they will be far superior to those registered in our own brains. Digital Spirits will be the conduit. They will enhance our abilities as storytellers. They will have instant access to our personal memory library and will be able to re-create these 3D memories for us. It would be possible, therefore, to show one's children how it felt to witness their birth, or to relive favourite moments.

'Lover ... From an early age, humans will readily become addicted to computer games, virtual reality and new forms of visual stimulation and synthetic pleasure: our minds will be neurologically tuned to what's next. Imagery is already so compulsive and available, it has obliterated boredom. Our physical and intellectual needs can be satiated at whim. Digital Spirits will be capable of delivering desire, but will challenge the moral/intellectual value of any selection that we make.

'Mother ... James Gleick in Faster refers to the economist Herbert Stein: '[Technology] is the way of keeping contact with someone, anyone, who will reassure you that you are not alone. You may think you're checking on your portfolio but deep down you're checking on your existence.' In other words, we cannot stand being alone. Digital Spirits sense this.

'Philosopher ... The closest many people get to philosophy in this mass media, celebrity-driven culture is watching a political/moral dilemma documentary on TV. We have absolved responsibility for our actions if this is the degree of contact with issues in the outside world. We are allowing others to do our thinking for us. Television is a garish flood of kitsch, porn, celebrity, banality, pop culture and voyeurism. Elizabethan groundlings paid to watch Shakespeare. Twenty-first century office workers veg out in front of Big Brother and Who Wants to Be a Millionaire? In The Age of Access, Jeremy Rifkin suggests that 'the near total absorption of the cultural sphere into the commercial arena signals a fundamental change in human relationships'. Angels have sensed the folly of this. Out of what Saul Bellow describes as the 'moronic inferno' rises the angel – questioning, probing. They accept our guilt and make us confront the issue.

'Psychologist ... Digital Spirits will be your own private therapist, role player, career counselor and agony aunt.

'Scientist ... Angels understand memes: they know how our brains work. Memes are ideally suited to contemporary mass media. Science controls our soul. Commerce controls the scientist. Brands will also know how our brains work: what drives us, what impulses enslave us. This means our emotional and intellectual landscape can be fully mapped out in advance. Marketing via memes will chase us from cradle to grave; neural mapping will become a buzz term – if there's a neural network for thirst, maybe it could be branded with the name of a soda or mineral water. Marketers will own words by association: Orange already has obvious connotations with mobile telecommunications, but what if in the future the word 'grandfather' triggered the Glaxo-Wellcome logo in your brain? Or 'goal' made you immediately think of Adidas? Angels will act as scientists on our behalf: creating antidotes, zapping unwanted 'germs', protecting the inside of our heads.

'Stylist ... Knowing you inside out, angels will provide perfect fashion advice and keep you up to date with an index of hot brands and looks.

'Simplifier ... In a world where the only constant is change, where velocity rules, angels will be the calm at the eye of the storm. Digital Spirits will counter the noise of modern life. In Faster, James Gleick talks about the need to simplify life, to make a distinction between 'the little nattering demons' that can fill every moment, and the 'greater, quieter spirits' that can enrich the passing hours. Already there seems to be a common craving for simplicity in products, design, business and pleasure. Angels will remind us of the practical and spiritual value of this approach.

'Teacher ... Digital Spirits will decode encyclopedias and instruction manuals for us.

'Tour Guide ... Digital Spirits will recommend and book the most suitable holiday destinations. Linking up with one's choice of Brand Federation, the Digital Spirits will arrange our travel itineraries and provide customized maps that connect to our tastes. By then, screenwatching will have become even more of a global health problem: one third of one's life will be spent glued to synthetic entertainment and commerce. The angels' mission will be to reconnect users with nature and exercise: to balance the physical and the cerebral.

Conclusion. *The internet may have spawned a race of empowered global citizens and eroded the influence of the nation state; but the more technologically driven we become, the more we crave shared social experiences and the unpredictability of contact. Even if it is in digital form.*
We all need someone, something, to watch over us. It's what makes us human.

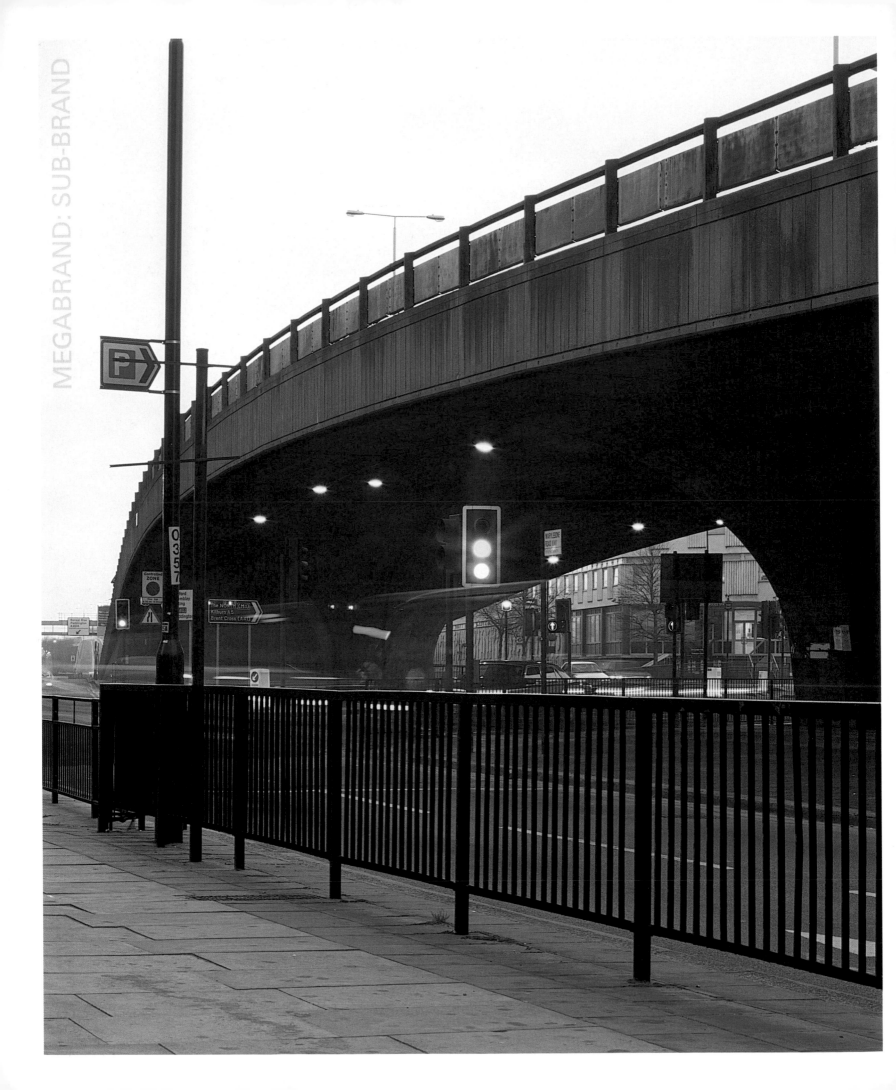

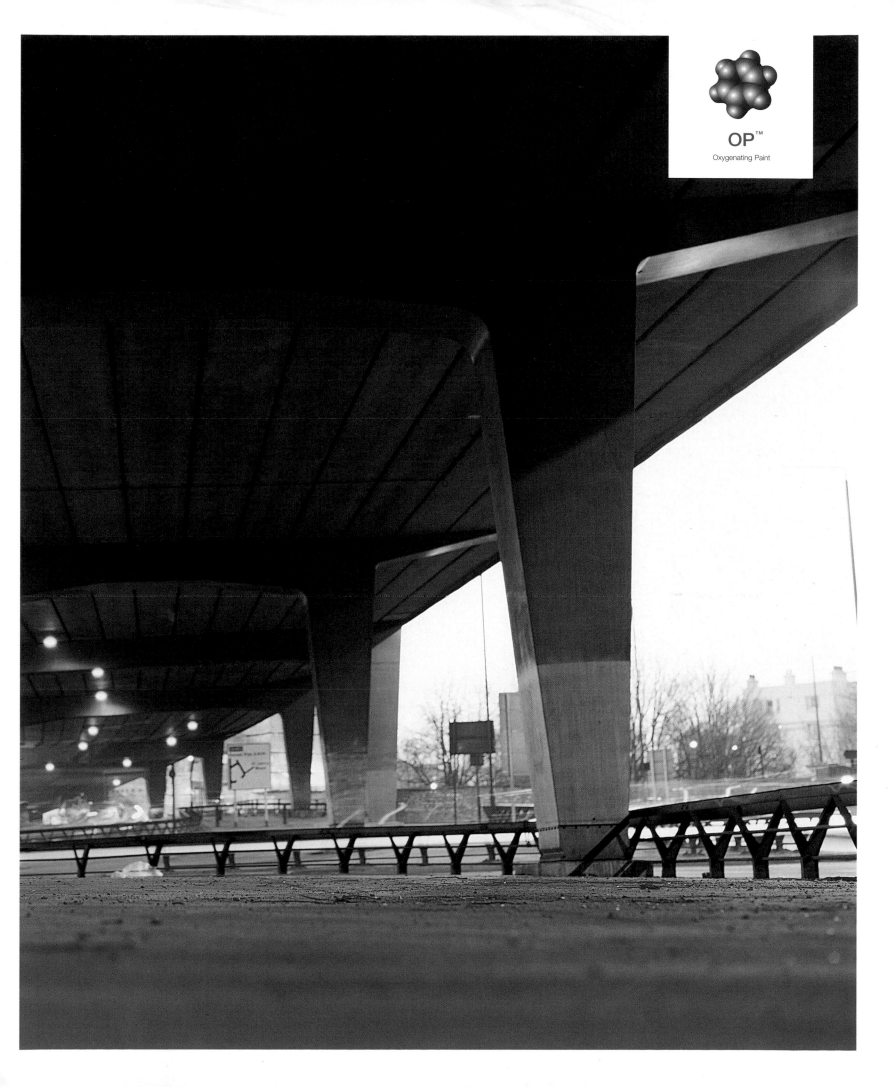

OP™

Oxygenating Paint

nanolife.nu

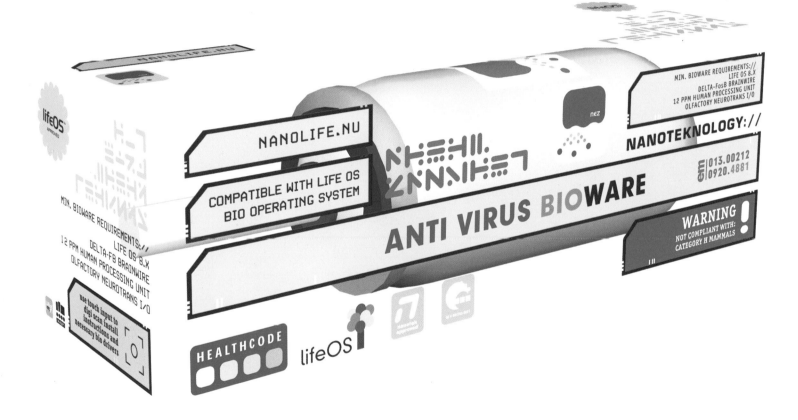

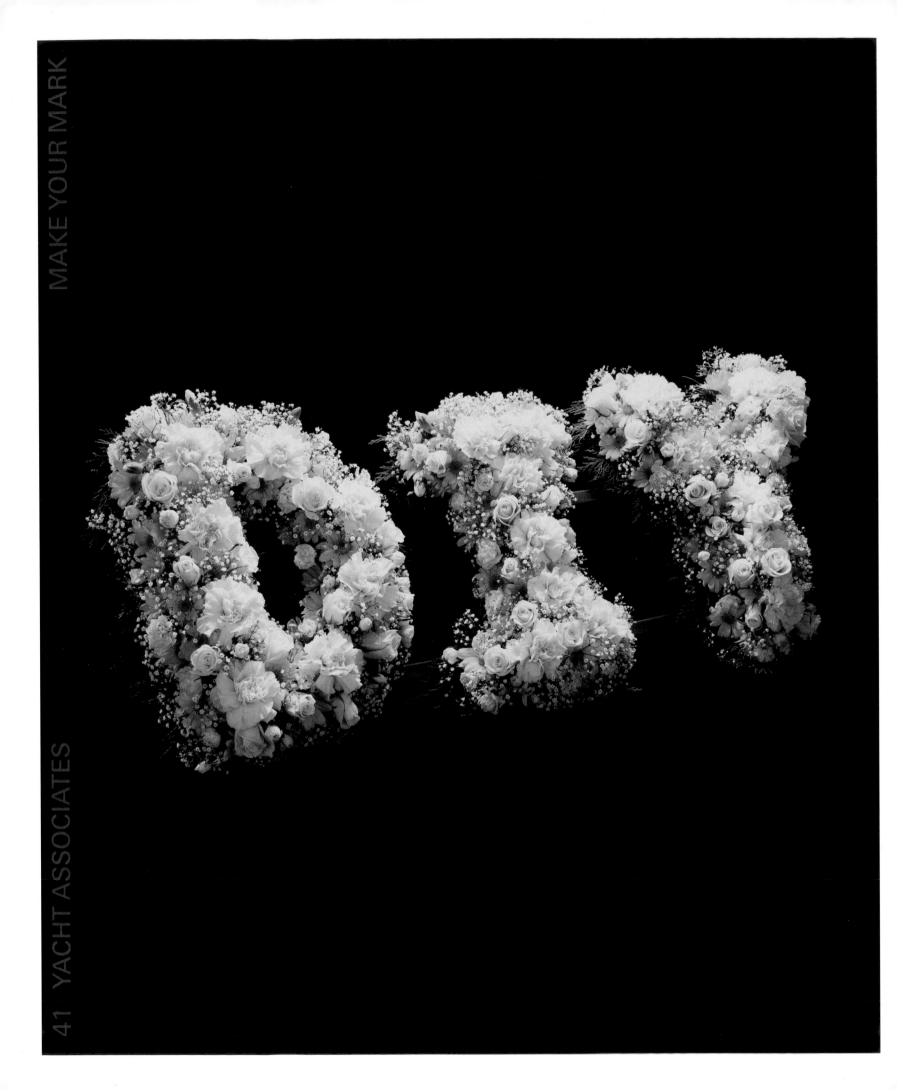

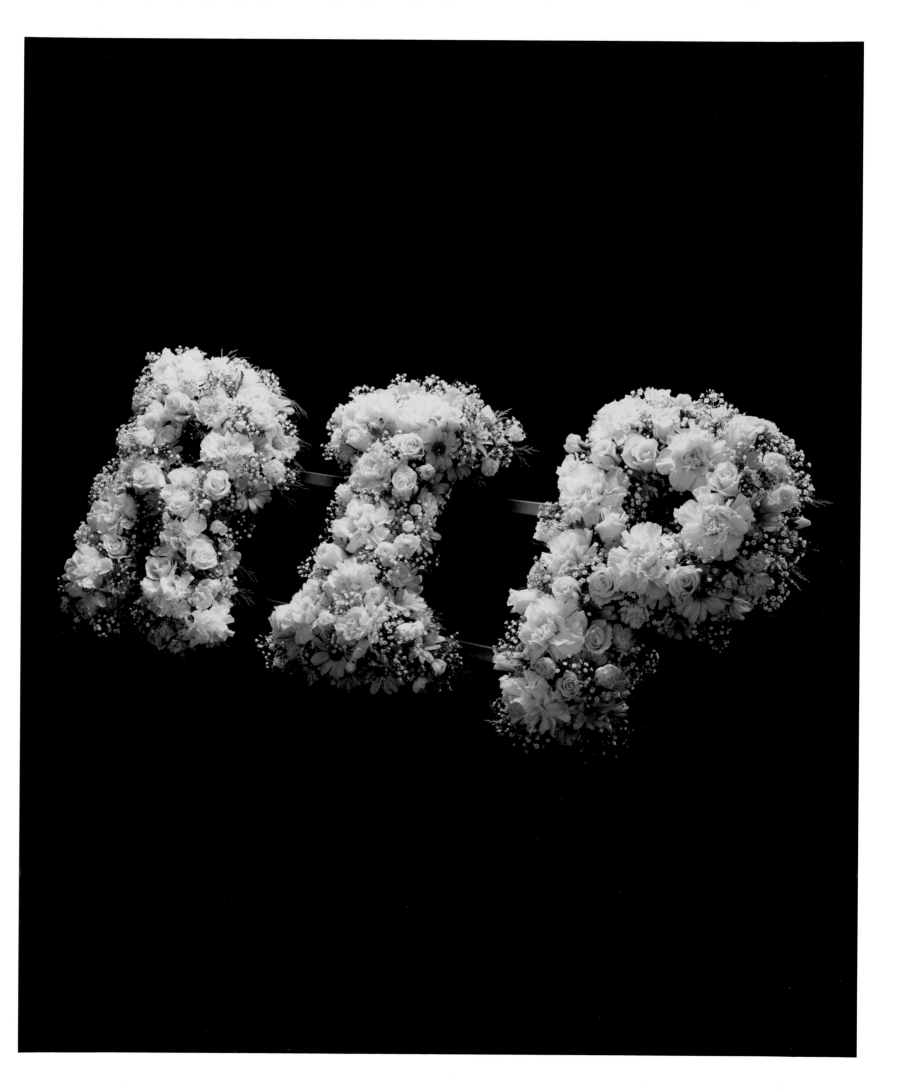

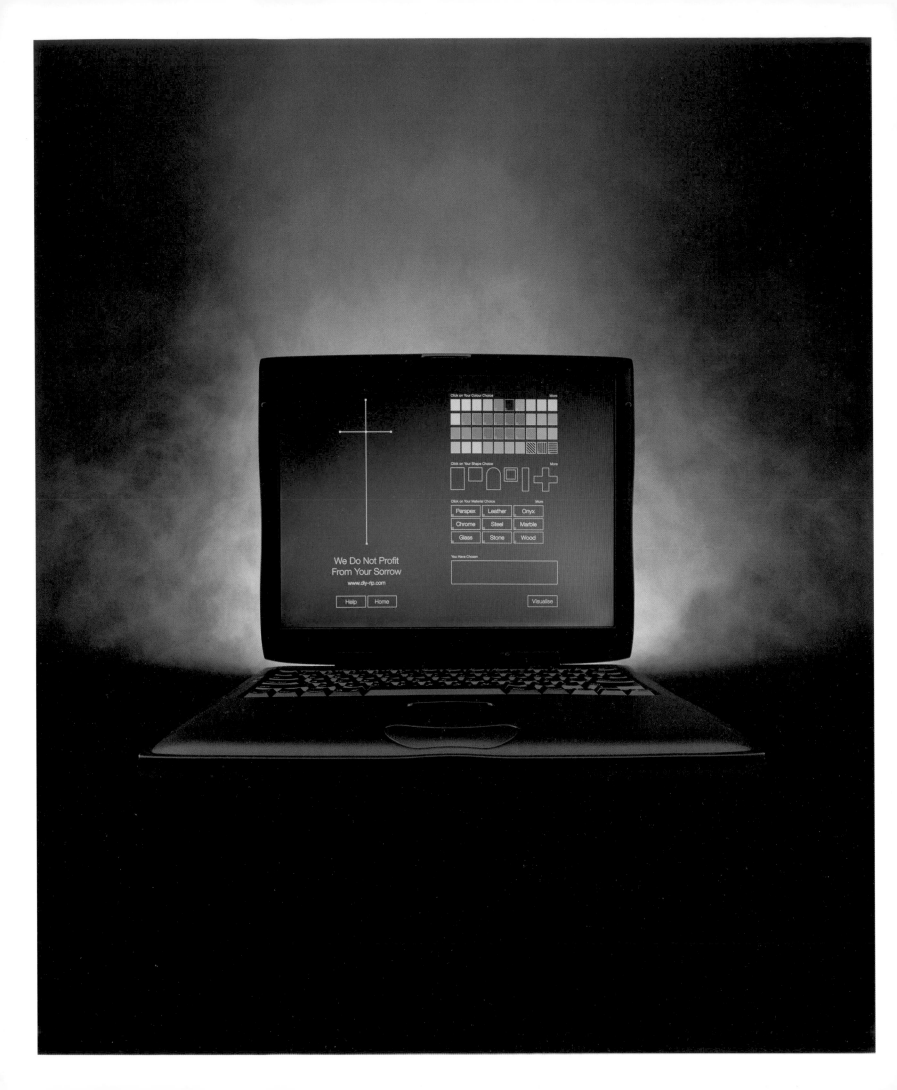

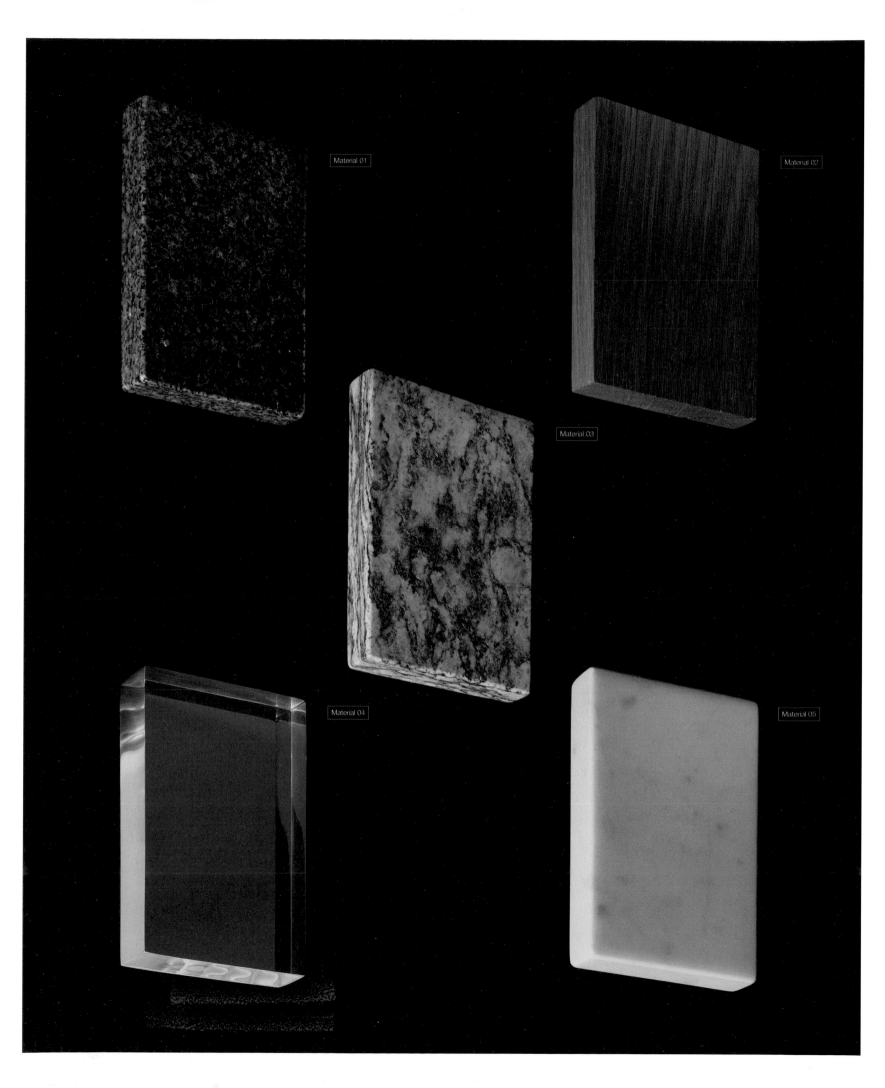

Material 01

Material 02

Material 03

Material 04

Material 05

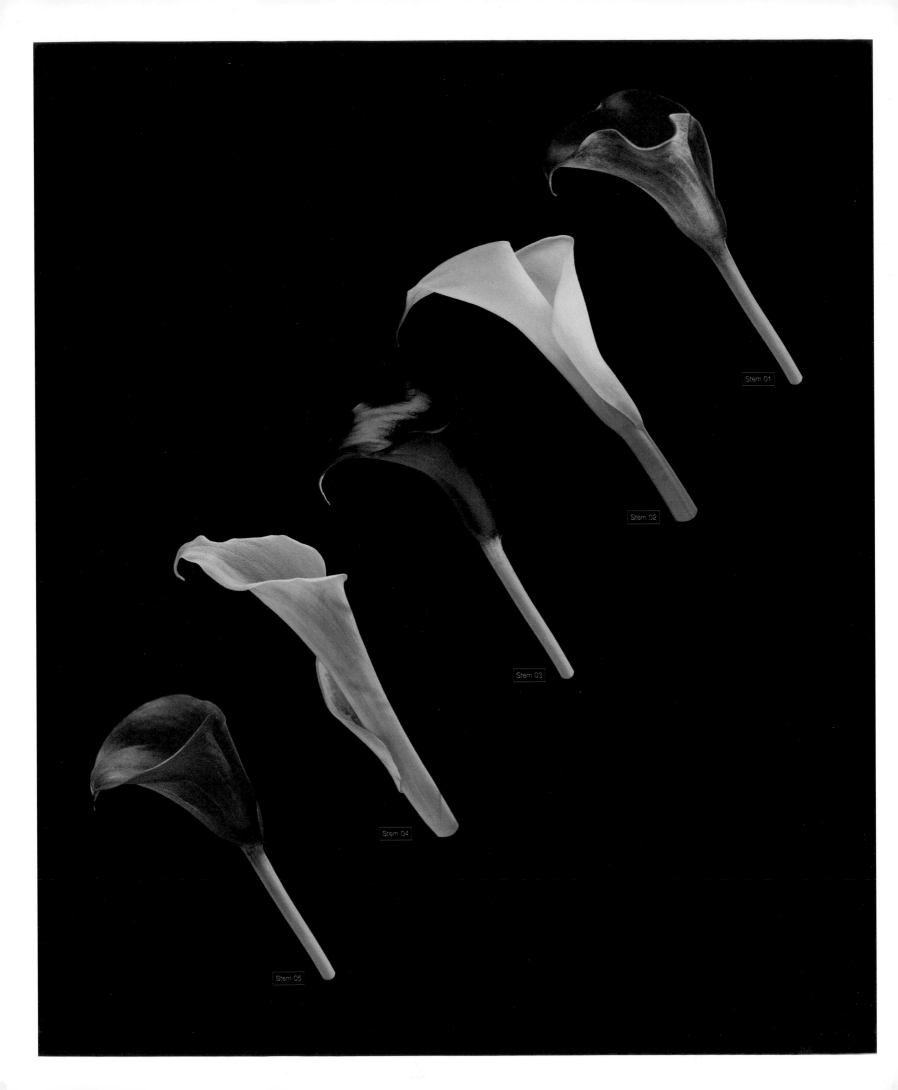

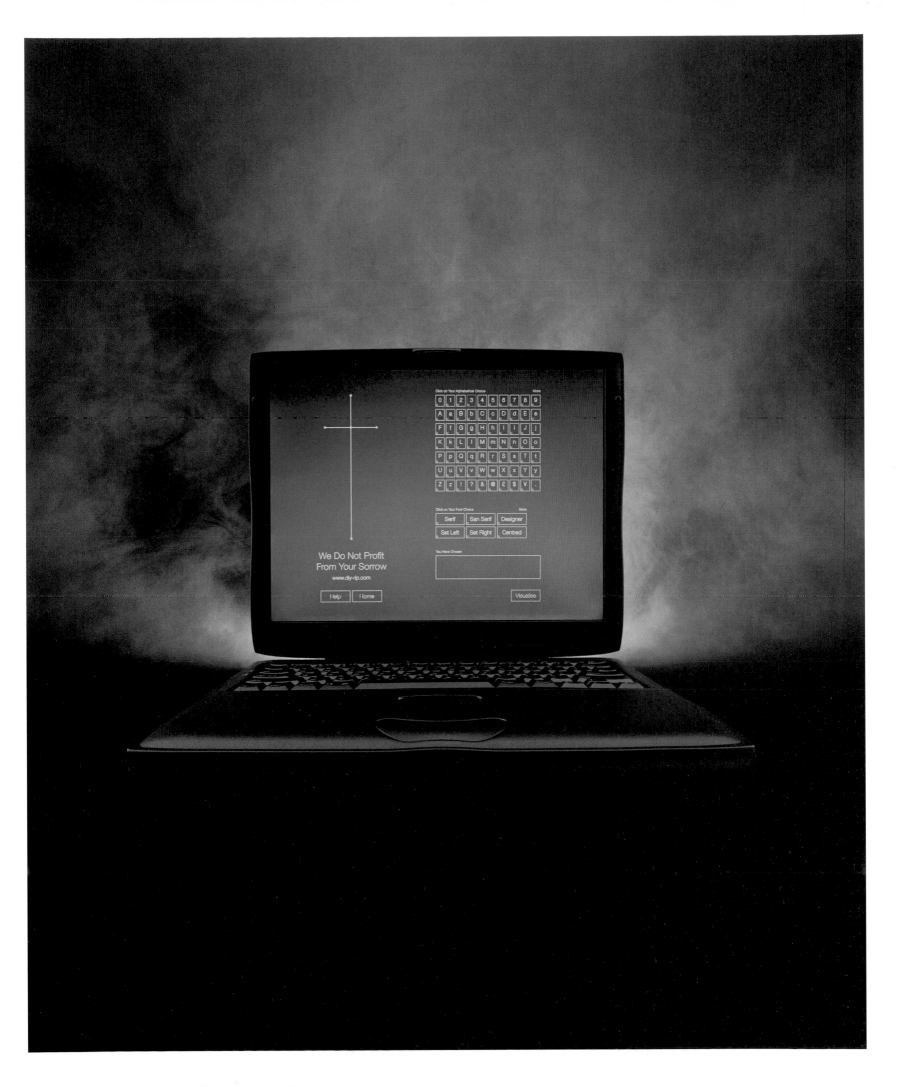

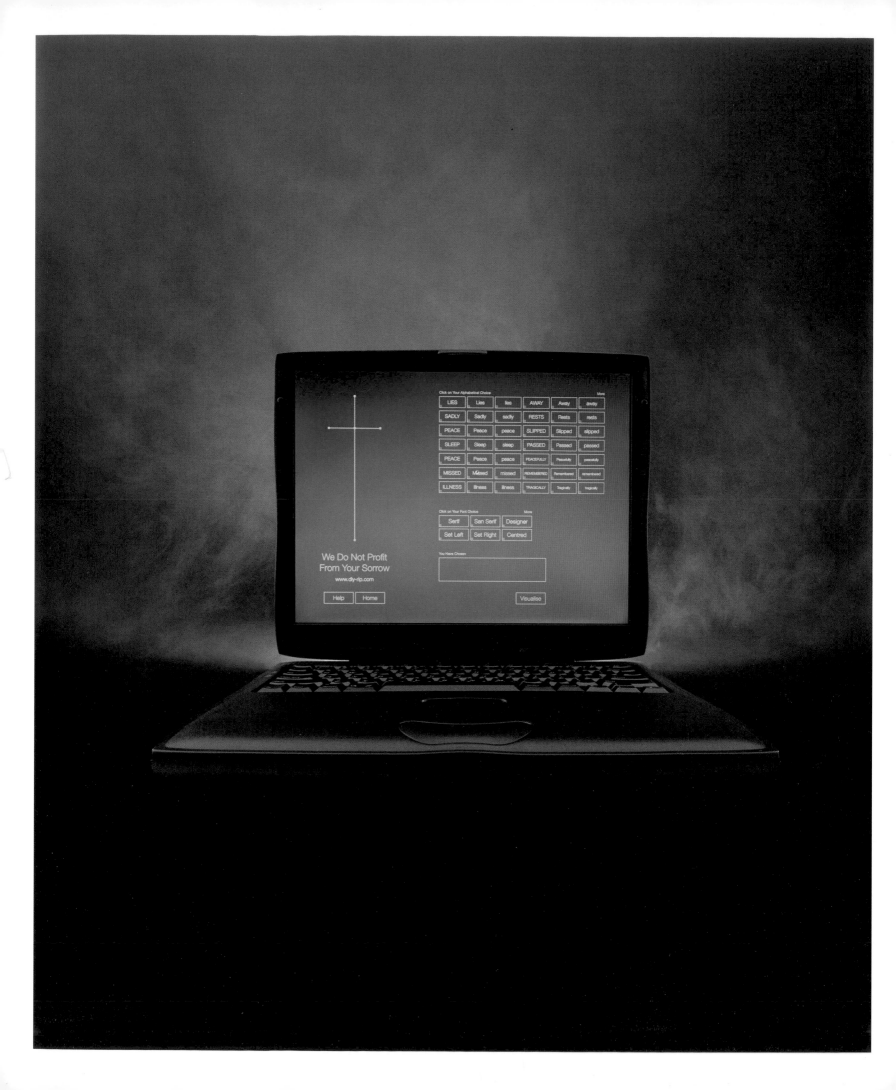

Rock and Roll
1995
Acrylic on canvas
32" x 32"

Tu m'
1995
Acrylic on canvas
32" x 32"

Brand: 01
Company: Ordensgemeinschaft
Names: Phil Evans, Matthew Shannon
Location: Frankfurt
Mission: rationalization for systemization
Spirit: is there any respect in which all human beings, without a single exception, can be declared equal?
Values: to be more than a brand
Products: quality
Project: You're Brand. You are who they think you are.

Brand: 02
Name: Simon Johnston
Location: Los Angeles
Mission: make art
Spirit: make art
Values: make art
Products: make art
Project: the 'design of a useful article' is considered copyrightable 'only if, and only to the extent that, such design incorporates pictorial, graphic, or sculptural features that can be identified separately from, and are capable of existing independently of, the utilitarian aspects of the article'.

God® Bless™ America®
1993
Letterpress on board
22" x14"

Closed Circuit
1995
Acrylic on canvas
22" x 32"

Brand: 03
Company: Saunders Associates
Writer: Jonathan Mackness
Location: Los Angeles
Mission: multiply
Spirit: is an out-dated concept
Values: willing
Products: toys
Project: prostitution will be increasingly regularized and legalized until it is normalized into brand-rich offers, franchises buying into the customer-assurance of brand standards and then customizing the proposition regionally.

Brand: 03
Portrait photography: Ian and Peter Davies, Stone
Location: London
Mission: to wear a spacesuit and go to the moon
Spirit: if you're buying
Values: $1.39 to the pound, in today's FT
Products: don't call me a product, i'll chin ya
Project: easy, a trained chimp could do it.

Brand: 04
Company: Ecole Cantonale d'Art de Lausanne [ECAL]
Names: Matthias Gehri, Jacques Dousse
Location: Switzerland
Mission: simplicity
Spirit: always try our best
Values: happiness through movement
Products: anything we can learn something from
Project: 'GoodSnow' – a brand based on the concept of a better lifestyle for everyone.

Photography: BD6563-001 (manipulated: Icelandic landscape)
© Alan Thornton, Stone.

EC6230-002 (manipulated and exploring tidal pool) © Erin Patrice O'Brien, Stone

Brand: 05
Company: The Kitchen

Location: London
Mission: simplicity
Spirit: honesty
Values: integrity
Products: variety
Project: 'this is an accelerating phenomenon... the mass of water being released into the oceans is being significantly increased'. Supreme conglomerates own the oceans. 'Sealand is the principal commodity.'* The oceans of the world as five brands: Antarctic, Arctic, Atlantic, Indian, Pacific.
* Dr Andrew Shepherd, scientist, University College Hospital

Brand: 06
Company: Less Rain
Names: Lars Eberle, Benny Sandler, Carsten Schneider
Location: London and Berlin
Mission: peace on Earth, end of social injustice, abolition of capitalism, Marxism and Creationism, fight for animal rights and against the greenhouse effect. Total world domination by 2004, with Less Rain being the next president of the U.S.
Spirit: always strive to be part of a truly elitist group
Values: honesty, humour, clean fingernails
Products: a network of inspiring, friendly, successful, gorgeous looking people
Project: The Gravy Train is now departing for the Wild West of business. What does the new frontier look like?

Brand: 07
Names: Justin Barnes & Ben Callis
Location: London
Mission: x
Spirit: x
Values: x
Products: x
Project: Almost anyone can develop an irrational behaviour pattern. Whether domestic or occupation related, stress can lead to all manner of ill-feeling; the desire to destroy, testosterone induced feelings of invincibility, homicidal tendencies. Internalized, these sensations can encourage permanent dementia. Externalized, they could lead to a custodial sentence. A state subsidized private sector service that provides immediate externalization of problematic te... psychosis in a safe and s... vironment

will help. Reduce the need for long-term incarceration and the need for prison expansion, decrease tax-funded punishment programmes.

Brand: 08
Company: Deepend
Names: Andy Donald, Fred Flade, Dionne Griffith, Ghazwan Hamdan, Andrew Leith, Tony Phillips, Paul Sheppard, David Streek, Simon Waterfall
Locations: London, Rome, New York, Sydney, San Francisco, Toronto, Prague
Mission: to be creative
Spirit: strong
Values: people of any height
Products: ideas – the one where people want to become brands
Project: as exhibitions are a familiar, informative and accessible form of charting cultural movements and developments, they provided a logical and graphically flexible device within which to present the slightly tongue-in-cheek scenario of bDNA; the option of pre-selecting the central brand values of a child.

Brand: 09
Company: Logan
Contributor: Alexei Tylevich
Location: Los Angeles
Mission: restoration of aura in a commodity object
Spirit: nostalgia for the physical world
Values: memory fetish
Products: dream objects
Project: 'Perishable Goods' – perishablegoods.net
Re-creation of significant objects, lost or destroyed, based on personal recollection of the owner.

Brand: 10
Company: Logan
Name: Alexei Tylevich
Location: Los Angeles
Mission: to communicate a story of our world to extra-terrestrials
Spirit: schwa
Values: timeless
Products: 'lumpen' data – endless archive of unwanted, discarded, anonymous images, movies and sounds that will never make it into the history books
Project: 'Murmurs of Earth', see murmursofearth.com – inspired by the NASA Interstellar Outreach Program in the 1970s. A gold-plated record was placed aboard Voyager

spacecraft, carrying information about Earth and its inhabitants, intended to 'communicate a story of our world to extra-terrestrials'. The disc, now travelling far beyond the solar system, contains '115 images, human and cetacean greetings, the sounds of Earth, musical selections from different cultures, as well as printed messages from President Carter and UN General Waldheim'. Meant to serve as a well-rounded representation of humankind, the selection reflects the impossibility of such a grand undertaking, its authoritative tone is unable to hide its arbitrary nature. Murmurs of Earth: Part 2 is a much-needed update to the original that would make Carl Sagan turn in his grave.

Brand: 11
Company: The Glue Society
Location: Sydney
Photography: Russ Honeysett
Retouching: Emil Vrisakis
Mission: to create a global network of creative people who can make a living doing what they love doing
Spirit: communication through One Degree of Disorientation
Values: be – don't say
Products: ideas and executions in any media or form
Project: soon, the big new brands will be behavioural, like 'BeMe'. Become someone else. Become a new creed. Become a brand.

Brand: 12
Company: Jam
Location: London
Mission: to have a profound impact on those people we touch with our work, inspiring adventure, creativity and imagination
Spirit: constantly evolving, believing in the future
Values: love, honesty, freedom
Products: questions, stories, memories
Project: for you to decide.

Brand: 13
Company: Mother
Location: London
Mission: free eggs for schools in Wigan
Spirit: vodka, ginger, ice and a slice – the drink for a new generation
Values: a fifty bob note
Products: camembert electrique
Project: in the future, falling birth rates, healthier lifestyles, le...

intensive work patterns and medical breakthroughs will create a society that is heavily skewed towards the elderly. GRAY is a style magazine designed to cater for the older generation of the future – a generation close to our hearts because we shall be part of it.
Photography: BD4091-001 (manipulated: elderly man wearing Y-fronts) © Tim Macpherson, Stone. BD46 4-001 (elderly man in armchair) © Martin Barraud, Stone. BD3999-001 (elderly woman sleeping in armchair) © Nick Daly, Stone
827034-001 (false teeth in glass) © Christopher Thomas, Stone. BD4079-001 (elderly person wearing bra) © Tim Macpherson, Stone.
BD4087-001 (elderly woman wearing red bra and knickers) © Tim Macpherson, Stone.
BD4100-001 (white pants with roll of fat) © Tim Macpherson, Stone. BD4090-001 (elderly man wearing striped pants) © Tim Macpherson, Stone.
BD2175-001 (manipulated: three elderly people outdoors) © Adrian Weinbrecht, Stone.

Brand: 14
Company: Mono
Names: Chris Kelly, Gavin Ambrose
Location: London
Mission: freedom and the universal denial of taste
Spirit: autonomy
Values: difference
Products: exploring more uncharted white space
Project: Brand Shepherd – in the future brands will be both responsive and informed by our consumer patterns. With the end of flatland, the question is not 'are brands ready for the future?' but 'are you?'

Brand: 15
Company: Intro
Name: Mat Cook
Location: London
Mission: to believe in the viewer

accessed by finger print.
Spirit: level
Values: clarity, wit, entertainment
Products: the internal combustion engine
Project: see the project.

Brand: 16
Company: Cahan & Associates
Name: Gary Williams
Location: San Francisco
Mission: to get to know every customer by name
Spirit: old Motel 6 logo, Travelodge, old Denny's logo
Values: yes (truth, belief in myth, the old-fashioned way)
Products: we sell old things.
We stand up for what is right.
We make your hard-earned dollar go a long way (we have a slurpee machine too).
Project: a reaction to the abuse of technology. Tradition, which is in danger of becoming obsolete, is not irrelevant, it defines who we are. Lake Mohave, Arizona. Photography by William Belknap, Jr. Used with the permission of Arizona Highways.
1978 General Motors Corporation. Used with permission of GM Media Archives.

Brand: 17
Name: Acme Air
Copywriting by Jonathan Mackness
Location: Rome
Mission: to live longer
Spirit: 100 per cent
Values: our grandparents
Products: tins for the next generation
Project: technology puts our lives in high gear, but we'll want even stronger opportunities to take a rest. Getting back to earth will cease to be a soft Green activity and, instead, be a value assertion worth paying top dollar for.
Photography: 285928-001 (sub-tropical Brazilian rainforest) © Ary Diuesendruck, Stone.

Brand: 18
Name: Kate Gibb
Photography: Carl Glover
Location: London
Mission: impossible
Spirit: de punto
Values: good quality at low prices
Products: screenprinting
Project: your urban space. Be nomadic, but keep in touch... from a safe distance. Locker-style spaces and larger sleeping pods

Brand: 19
Company: Stereo Yeti
Names: James Stoddart, Matt Walker, Lally Muslu
Writer: Jonathan Mackness
Location: London
Mission: to spread love and increase the peace
Spirit: the ghost of Nikolai Tesla
Values: flexible, depending on the sexual opportunity
Products: small, medium and large, in a range of contemporary styles
Project: a juicy war does wonders for a news channel's viewing figures. How long before someone realizes what the punters really want – nothing but cruelty, violence and big explosions, 24/7?
© Elizabeth Young, Stone.
EC5536-004 (man touching young woman's face). © Philip Lee Harvey, Stone. BD2333-002 (manipulated: couple sitting in cafe). © Kevin Mackintosh, Stone. BD3818-002 (manipulated: naked young man, sweating). © Paul Edmondson, Stone. AT5472-001 (men wearing gas masks in alley way). © Paul Edmondson, Stone. AT4572-002 (men wearing gas masks near brick wall). © Martin Barraud, Stone.
BD2726-006 (group of young people lying on ground). © Reza Estakhrian, Stone. EC5372-001 (man wearing hat at sunset). © Eddie Soloway, Stone. AK1021-001 (road at night, Mt. Vision, Pt. Reyes Nat. Seashore, CA, USA). © Shuji Kobayashi, Stone. 888733-001 (street scene with grafitti on road sign, LA, CA, USA).

Brand: 20
Company: one9ine
Name: Warren Corbitt
Indoor photography: John Holden
Location: New York
Mission: to always remember that a world exists outside the periphery.
Spirit: too many bad memories of football pep rallies to have any extra spirit
Values: respect
Products: work that goes bump in the night; the uncanny
Project: 'the tangential' serves as a lens that casts a shadow on those moments that lack physicality – the mp3/website/television program.
In an age that increasingly lacks a tangible mass and weight, a brand will need to exist that will create artefacts of the moments that we

their conception.

Brand: 24
Company: Magic Hat/ Riot Comms
Name: Mike Benson (concept)
Design: Nic Hughes
Location: London
Mission: aborted
Spirit: holey
Values: n/a
Products: words
Project: 'double you' – because one is never enough.
Photography: BD6567-001 (baby)
© Tim Flach, Stone.

Brand: 25
Company: Ecole Cantonale d'Art de Lausanne [ECAL]
Names: Émilie Renault, Jérôme Rigaud, Stéphane Perroud
Location: Switzerland
Mission: building a culture of the 'unique' against the repetition, of which the goal is the harmony
Spirit: symbiosis between the organics and the technological
Values: the individual, the paradox of a craft industry of mass. Mass production of unique objects
Products: ethics, technology, consciousness, culture and the daily pleasure of life
Project: to understand and feel the necessity of being unique because every human being is unique.
Photography: 890697-001 (manipulated: two-storey motel) © Whit Preston, Stone.
BD5653-001 (manipulated: empty canteen) © JFB, Stone.

Brand: 26
Name: Peter Maybury
Location: Dublin, Republic of Ireland, softsleeper.com
Mission: x
Spirit: optimism
Values: x
Products: music, graphic design, hard sleeper, softsleeper
Project: ~~blankness, revision, space~~ ~~where words once were~~

Brand: 27
Company: Still
Name: John Holden (photography), Chris Ashworth
Location: York, East Dulwich
Mission: space
Spirit: Dalglish
Values: Swiss
Products: x
Project: a pill that gives us eight hours sleep in two hours. Not only

never knew existed – those data streams and information blips we bump into during our travels.

Brand: 21
Company: Cahan & Associates
Name: Kevin Roberson
Location: San Francisco
Mission: provoke thinking
Spirit: be realistic
Values: clarity and imagination
Products: printed matter
Project: O2 – oxygen as a commodity.
Photography: 450507-001 (city smog) © Rich Iwasaki, Stone.

Brand: 22
Company: Jam
Location: London
Photography: Carl Glover
Mission: to have a profound impact on those people we touch with our work, inspiring adventure, creativity and imagination
Spirit: constantly evolving, believing in the future
Values: love, honesty, freedom
Products: questions, stories, memories
Project: for you to decide.

Brand: 23
Company: KesselsKramer
Names: Joanna van der Zanden, Peter Viksten, Dave Bell, Herman Popelaars
Location: Amsterdam
Mission: 'do' feeds off your input. Without the action, reaction and interaction of the consumer, 'do' will die. Persuade people to think and act
Spirit: get as many people together from as many disciplines as possible to act and do. Then do it all again in a completely different way
Values: innovation, social responsibility, sharing by doing
Products: today 'do' is a chair that you mould with a hammer, a vase that you break or a book about worldwide youth culture. Tomorrow it will evolve into another form
Project: 'do change' concentrates on planting thought explosions in the head of the individual. Through analysis, example and internet experiment, it seeks to create small mindshifts in the hope that they will snowball into real, life-changing innovations, inventions and future brands. The intention is that the person rather than the profits will become the deciding factor in

Brand 27
will the pill be a power-brand, but it will spawn new enterprises to utilize the extra time.
Company: The Ideas Plant
Name: Sadie Plant (text)
Location: Birmingham, UK
Mission: explore and communicate
Spirit: vital
Values: surplus
Products: books and other texts of various shapes and sizes

Brand 28
Names: Cream Bun (concept)
Location: London
Design: Cameron Leadbetter
Mission: x
Spirit: x
Values: x
Products: x
Project: self-assembly promo kits for start-up companies.

Brand 29
Name: Tom Hobbs, non-objective (and supporter of Umwow)
Location: London, Italy and San Francisco
Mission: to convince people that there are more than two dimensions to monitor screens (and people)
Spirit: the word British English so poignantly uses instead of 'liquor'
Values: trees, mountains and other unmodified things I don't often see
Products: genetically modified websites, books and other interactive design-type what-do-you-call-its
Project: Nanosoft is 'user friendly' genetic engineering and a way to control everything about your child. Pick a name, and embedded in each letter is an attribute for your new 'offspring'. Their attributes and the make of the brand are there for all to see.
Photography: EB9954-001 (girl blowing bubbles) © Reza Estakhrian, Stone.
LA8254-001 (blood transfusion) © Garry Wade, Stone.
AT3684-001 (girl holding conch shell to ear) © Rosanne Olson, Stone.

Brand 30
Smith Pam Huber
Names: Laurie Smith, Matthew Pam and Werner Huber
Location: the heart of adland
Mission: to create awareness of a

Brand 31
Company: Ecole Cantonale d'Art de Lausanne [ECAL]
Location: Switzerland
Project: a guide for everywhere – getting you under the skin of a place
Photography: EC5798-001 (crowded NYC sidewalk) © Lonny Kalfus, Stone.
AR1070-001 (outdoor vegetable market, China) © Keren Su, Stone.

Brand 32
Company: Interfield
Name: Peter Anderson
Location: London
Mission: to change the world
Spirit: in flux
Values: too many
Products: art and design
Project: change the system, change the world.

Brand 33
Company: Ecole Cantonale d'Art de Lausanne [ECAL]
Names: Thomas Eberwein and Alexander Aeschbach
Location: Switzerland
Mission: 08:00 - 17:00
Spirit: 17:00 - 22:00
Values: 22:00 - 08:00
Products: 200ml. 700g. 50 fl oz.
Project: getting more out of your time – watch more TV; go to Disneyland more often; go shopping; do puzzles; feed your dog; go out and watch building sites; make crosswords; talk to your goldfish; brush your slippers; look out of the window; look at your neighbour's garden.
Photography: 490322-001 (spotted owl attacking wood mouse) © Art Wolfe, Stone.
AM6992-001 (raccoon at night) © Harold Pfeiffer, Stone.

Brand 34
Names: Justin Barnes & Ben Callis
Location: London
Mission: x

place that is free of adverts
Spirit: make mine a double
Values: x
Products: advertising-free zone; guerilla advertising to infiltrate the advertising-free zone
Project: advertising an advert-free zone, using a teaser campaign. The billboards would have images of exactly what is behind them, making them blend into the background.

Brand 35
Company: Din Associates Ltd (concept and text)
Location: London
Design and photography: Carl Glover
Mission: to create a tangible advantage for our clients
Spirit: youthful
Values: clear analysis, conceptual thinking, a flexible, open attitude and an eye for detail
Products: interior, exhibition, architectural, graphic, web design and brand consultancy
Project: a holistic response to the degeneration and capitalist destruction of the traditional urban community. A service that will become a hub of the community and encourage a responsible approach to the environment by both retailer and consumer.
Photography: BD5564-001 (blue sky) © Clarissa Leahy, Stone.

Brand 36
Company: Blue Source
Location: London
Mission: The Liver Detox Plan
Spirit: a laidback camaraderie that involves arm wrestling and the search for god realization
Values: music, film, children, goats
Products: design, art direction, advertising, promos and some other stuff not related to decorating consumer products
Project: 'Happy Memories' – dealing with the inevitable.

Brand 37
Company: Seymour Powell (concept, text, art direction)
Name: Richard Seymour
Location: London
Design: Nic Hughes
Mission: to put anthropology before technology
Spirit: live fast, die young(ish)
Values: enjoy your work, make love, be kind to those less able, avoid saturated fats, don't fart in elevators
Products: stuff you enjoy using everyday without realizing who designed it
Project: a rolling blueprint version of oneself, created by reconstructing your host DNA carrying

accumulated experience and knowledge from life to life.

Brand 38
Name: Paul Kemp-Robertson
Company: Leo Burnett
Location: Chicago, London and 92 other cities
Mission: to probe, to share
Spirit: the junction of cynicism and naiveté
Values: northern english
Products: fictional. If God is in the detail, welcome to His executive assistants: digital angels
Project: read it.

Brand 39
Company: Jam
Location: London
Photography by Carl Glover
Photoshoptastic by Paolo L. Fuortes
Mission: to have a profound impact on those people we touch with our work, inspiring adventure, creativity and imagination
Spirit: constantly evolving, believing in the future
Values: love, honesty, freedom
Products: questions, stories, memories
Project: for you to decide.

Brand 40
Company: Great Giant
Names: Alec, Mark, Lauri, Sego and Catherine
Location: greatgiant.com
Mission: ubiquitous obliquity
Spirit: hotel, motel, Holiday Inn
Values: change (makes you wanna hustle)
Products: not to be taken orally
Project: Nez – anti-virus software for LifeOS® compatible bio-implants.
Full product experience: http://nanolife.nu.

Brand 41
Company: Yacht Associates
Names: Richard Bull, Chris Thomson
Photography: Jason Tozer
Location: London
Mission: sitting quietly, doing nothing
Spirit: vodka
Values: never wrestle with pigs, the pig will enjoy it and you will end up cirty
Products: Fireworks and showgirls
Project: Rest in peace.
¶
¶
¶

WIMBLEDON SCHOOL OF ART
LIBRARY